Adobe Photoshop Elements 9

MAXIMUM PERFORMANCE

Unleash the hidden performance of Elements

Mark Galer
Dr. Abhijit Chattaraj

Routledge
Taylor & Francis Group

LONDON AND NEW YORK

First published 2011

This edition published 2015 by Focal Press

Published 2018 by Routledge
2 Park Square, Milton Park, Abingdon, Oxon OX14 4RN
711 Third Avenue, New York, NY 10017, USA

First issued in hardback 2018

Routledge is an imprint of the Taylor and Francis Group, an informa business

Copyright © 2011 Mark Galer and Abhijit Chattaraj.

The right of Mark Galer and Abhijit Chattaraj to be identified as the authors of this work have been asserted in accordance with the Copyright, Designs and Patents Act 1988

British Library Cataloguing in Publication Data
A catalogue record for this book is available from the British Library

Library of Congress Control Number: 2010937555

ISBN 13: 978-1-138-37207-8 (hbk)
ISBN 13: 978-0-240-52242-5 (pbk)

for Dorothy and Cathy

Contents - part 1

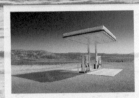
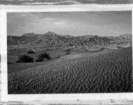
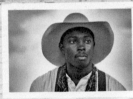
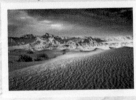
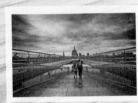
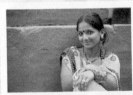

1

optimize

Contents - part 2

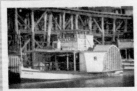
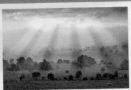

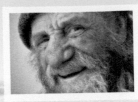
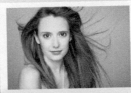

2

enhance

Contents - part 3

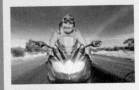
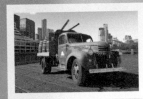

3

sites

composites

Contents - website

The supporting website http://www.Elements-MaxPerformance.com is a veritable treasure trove of supporting files for the projects in this book as well as a resource for your own creative projects. Just download the supporting files to your computer (see 'Getting Started'- page xiv). The movies are an invaluable resource, allowing you to start, stop and rewind so that the skills can be quickly and easily acquired at your own pace. The website also contains multilayered image files (PSDs) of the completed projects, JPEGs with saved selections and the master Raw files.

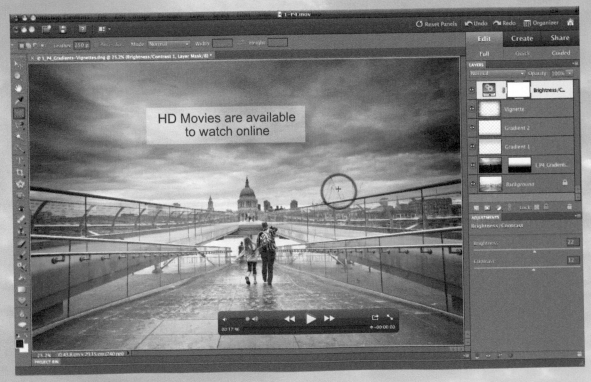

HD Movies are available to watch online

THE WEBSITE PROVIDES EXTENSIVE SUPPORT IN THE FORM OF:

- Over eight hours of movie tutorials recorded using version 9 of Photoshop Elements. These will support you through all of the projects in this book. You may need to install the QuickTime movie player by following the link on the supporting website.

- High-resolution, high-quality JPEG images to support all of the imaging projects.

- Saved selections for users interested in completing the projects in the least amount of time while achieving maximum quality.

- Camera Raw files.

- Multilayered Photoshop documents (PSD files) of completed projects.

- Adobe presets (layer styles and gradients) to enhance the performance capabilities of your Adobe Photoshop Elements software.

- Printable PDF file of keyboard shortcuts to act as a quick and handy reference guide to speed up your image-editing tasks.

website

www.Elements-MaxPerformance.com

Preface

The creative projects in *Adobe Photoshop Elements 9 Maximum Performance* are designed to provide you with the essential techniques for professional quality editing – without the need to upgrade to the full version of Photoshop. The projects are designed to unleash the hidden potential of the budget software through a series of workarounds, advanced techniques and loadable presets. Each creative project is supported by a QuickTime movie tutorial and high-resolution images – all available from the supporting website (http://www.Elements-MaxPerformance.com). This website contains all of the project images together with full and comprehensive movie support. Each project is designed to build the skills required so that any photographer can attain the status of 'imaging guru'. The magic is deconstructed using a series of easy-to-follow step-by-step projects using large clear screen grabs and jargon-free explanations. Completed multilayered project files are also available from the supporting website for those users who like to have access to the completed project for comparison and analysis.

This book will act as your guide to some of Elements' less well-known and more powerful post-production editing techniques. It will enable you to attain the same high-quality images as professionals using the full version of Photoshop. This book makes Elements a viable alternative to the full version of Photoshop for imaging professionals and enthusiasts looking to extract the maximum performance from their software.

This book is primarily concerned with the post-production stage of the creative process and demonstrates how this part of the creative process can optimize and enhance the original capture or create an entirely new image out of several images (the creation of a composite photograph or photomontage). Where appropriate the book will discuss measures that can be taken by the photographer in pre-production or production to enable the highest quality outcome as a result of the post-production stage. To ensure the best quality image from our sophisticated and professional post-production techniques we should make certain that we access quality raw materials whenever possible – 'quality in, quality out'. The vast majority of the JPEG images from the supporting website were processed from either Camera Raw files or high-quality 16 Bits/Channel scans. Many of the images featured in this book were captured using budget digital SLR and fixed-lens digital cameras, affordable cameras used to capture information-rich images.

The techniques used in this book promote a non-destructive approach to image editing wherever possible. The term 'non-destructive image editing' refers to the process of editing an image whilst retaining as much of the original information as possible and editing in such a way that any modifications can usually be undone or modified. Editing on the base layer of the image can often mean that modifications to the pixel information cannot be undone easily or at all, e.g. sharpening an image file cannot be undone once the file has been saved and flattened. It is, however, possible to sharpen non-destructively in post-production so that the amount of sharpening can be altered when the file is opened at a later date. This latter approach would be termed 'non-destructive'. When capturing images with a digital camera many users do not realize that if the JPEG file format is used image processing starts in the camera. Color correction, contrast adjustment, saturation levels and sharpening all take place in the camera. If maximum quality is to be realized the Raw format should be chosen in preference to the JPEG format, if possible. The post-production decisions can then be left to the Adobe software, allowing the user many more options.

Photoshop Elements replaced 'Photoshop LE' (limited edition – as in limited function and not availability); both of these software packages share something in common – they offer limited elements of the full version of Photoshop. Adobe strips out some of the features that would be the first port of call for some professional image editors and photographers, but this does not mean that the same level of control cannot be achieved when using the budget software. Professional post-production image editing does NOT have to be compromised by using Photoshop Elements. When editing images there is usually more than a single way to reach the destination or required outcome. With a good roadmap the Elements user can reach the same destination by taking a slightly different course. These roads are often poorly signposted, so are often inaccessible to the casual user of the software. This book will act as your guide to enable you to attain a broad range of sophisticated post-production image-editing skills through a series of creative projects designed to circumnavigate the missing features.

Photoshop Elements IS a viable alternative to the full version of Photoshop for most professional image-editing tasks. Many professionals may disagree with this statement, as a quick glance at the Elements package may result in a long list of the elements that are missing rather than taking a long hard look at the elements that remain (a case of 'the glass is half empty' rather than 'the glass is half full'). After more than a decade of professional image editing I have learnt that there is more than one way to create an image. There is no 'one way'. In short, it is possible to take a high-quality image file and work non-destructively to create an image which is indistinguishable from one that has been optimized using the full version of Photoshop. This book does not aim to outline every tool in your kit (a paintbrush doesn't really require an owner's manual and some of the automated features are sometimes more trouble than they are worth). It just deals with how to adapt the tools you do have to perform the tasks you didn't think you were able to. It aims to show you that Elements is better equipped than you were led to believe. Photoshop Elements really is the proverbial wolf in sheep's clothes.

mark galer

Location image by Dorothy Connop

Getting Started

Most users of this book will have some experience of digital imaging and Photoshop Elements, but just check the following to make sure all is in order before you start.

Following orders

The commands in Photoshop Elements allow the user to modify digital files and are accessed via menus and submenus. The commands used in the projects are listed as a hierarchy, with the main menu indicated first and the submenu or command second, e.g. Main Menu > Command. For example, the command for applying a Levels adjustment would be indicated as follows: Enhance > Adjust Lighting > Levels. If you get stuck or are unclear, watch the movie from the supporting website and follow my mouse cursor to help you find what you are looking for.

Calibrate your monitor

If your images are going to look good everywhere – not just on your own monitor – it is advised that you calibrate your monitor (set the optimum color, brightness and contrast). I recommend that you use a 'Hardware White Point' or 'Color Temperature' of 6500 °K (daylight) and a gamma of 2.2.

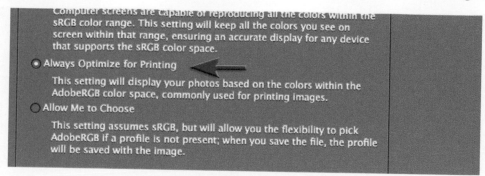

Color settings

The colors are kept consistent between devices such as cameras, computers and printers through the use of color profiles. If you intend to print your images you would be advised to go to Edit > Color Settings and then click on the radio button that says 'Always Optimize for Printing'. Elements will now use the larger Adobe RGB profile instead of the smaller sRGB profile.

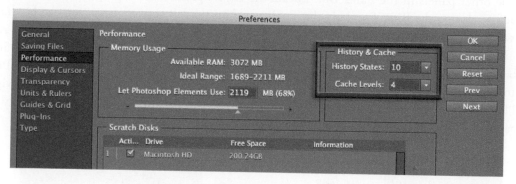

Memory

You will be working on images in excess of six megapixels (the supporting website provides high-resolution images for ALL of the creative projects in this book). This professional level of image editing can place a strain on a computer's working memory or RAM. It is advised that you install at least two gigabytes of RAM (four gigabytes or more is not considered excessive when editing very large image files) so that the image editing you are about to undertake does not begin to crawl. Shut down any other applications that you are not using so that all of the available memory is made available to Photoshop Elements. Photoshop Elements keeps a memory of your image-editing process that it calls the 'History States'. The default setting in the General Preferences (Edit > Preferences > General) is 50 History States. Allowing the user to track back 50 commands, or clicks of the mouse, can again place an enormous strain on the working memory. I would recommend that you lower this figure to 20 for most editing work. This can be readjusted without restarting the software should you wish to increase Photoshop's memory for your editing actions. Just remember that the more memory you dedicate to what you have just done, the less you have available for what you are about to do. In Preferences > Performance you will see the Available RAM and the Ideal Range that can be assigned to Photoshop Elements. Adjust the slider so that you are using the top of the suggested range. Photoshop Elements will also be using your 'scratch disk' or hard drive in the image-editing process so be sure to keep plenty of gigabytes of free space available.

Give yourself some elbow room

I recommend that you keep the Photo Bin and Panel Bin closed until you need them (go to Window > Panel Bin). This will maximize the area on your screen for viewing the image you are editing. Only the Layers panel is used all of the time in advanced image editing. In the default mode it is stacked with the other panels in the Panel Bin. Locate the Layers panel and drag it out into the working area before closing the Bins. Similarly the Tools panel on the left side of the screen can be dragged to new locations so that it can be close to the action. I prefer to view the image in a window rather than in Maximize mode. This allows me to see the additional information that is displayed in the title bar together with the magnification. I like to view my images at 50% or 100% (Actual Pixels) to gain a more accurate idea of the image quality. This information is also available in the Navigator panel but, as I use keyboard shortcuts for moving and zooming in and out of images, I usually keep this panel closed as well.

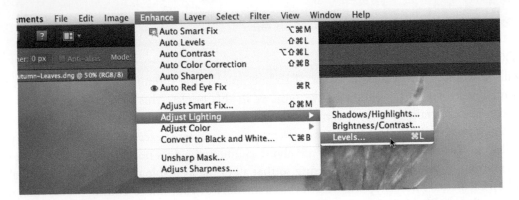

Keyboard shortcuts

Many commands that can be accessed via the menus and submenus can also be accessed via keyboard shortcuts. A shortcut is the action of pressing keys on the keyboard to carry out a command (rather than clicking a command or option in a menu). Shortcuts speed up digital image processing enormously and it is worth learning the examples given in the study guides. If in doubt use the menu (the shortcut will be indicated next to the command) until you become more familiar with the key combinations. See the 'Shortcuts' sections at the end of the book for a list of the most frequently used shortcuts.

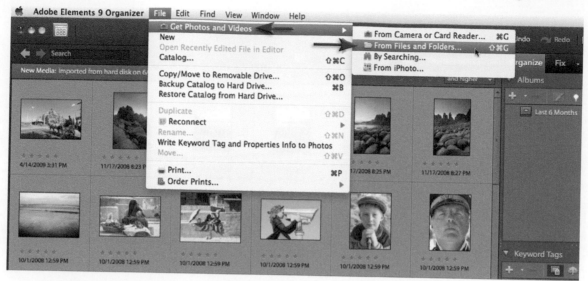

Accessing the support images and movies

Download the images and the movies for the projects you want to complete by going to http://www.Elements-MaxPerformance.com and then clicking on the Maximum Performance link. Place your downloaded images and movies into a new folder on your computer. Then go to File > Get Photos and Videos in the Organizer workspace (the little camera) and choose the From Files and Folders option. Then locate the files you have downloaded and would like to import.

IMPORTANT: You may need to install the QuickTime movie player that is available from the link on the supporting website before watching the movies in the Organizer workspace.

When the Get Photos and Videos dialog box opens make sure the Automatically fix Red Eye option in not checked and then click on the Get Photos button. Your images or movies will be imported and organized. Click on the Folder Location option from the Display menu in the Organizer window (top right-hand corner) to see the images as a collection. Use the keyboard shortcut Ctrl/Command + I to open any image in the Editor workspace. Double-click on any movie icon to watch the movie within the Organizer workspace.

part **1**

optimize

Project 1

Adobe Camera Raw

Adobe Camera Raw (ACR) is the gateway for opening Raw images into the main editing space of Photoshop Elements, but ACR is also a great space for optimizing images quickly and easily. Many of the basic tasks such as straightening and cropping images, correcting exposure and color balance can all be achieved faster and more easily than by performing these same tasks in the main editing space of Photoshop Elements.

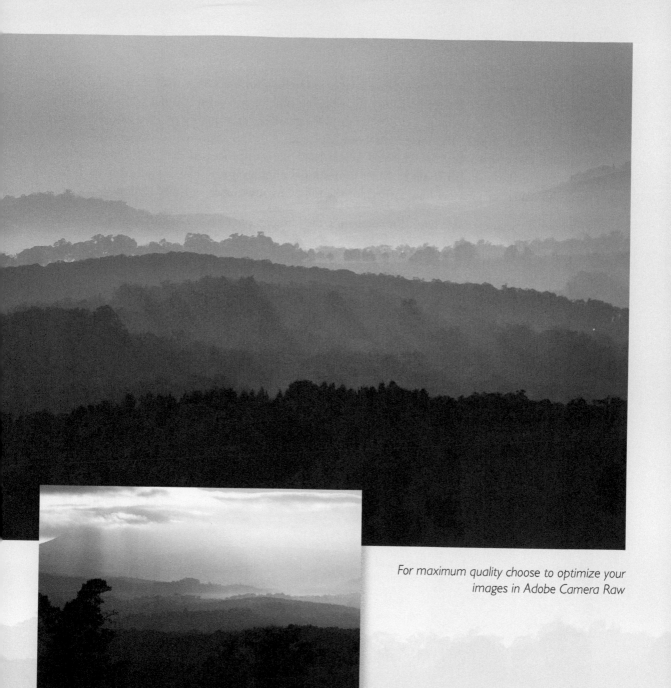

For maximum quality choose to optimize your images in Adobe Camera Raw

One of the best-kept secrets of Photoshop Elements is that you can also open JPEGs into the ACR editing space to access these user-friendly editing tools. If you have not yet explored the ACR interface, or are having trouble breaking old habits, then the following project is designed to make you think again.

The Raw advantage

Most professional photographers capture images in the Raw format rather than the JPEG format. The Raw format offers greater flexibility in achieving different visual outcomes while ensuring a high-quality finished result. The JPEG file format can offer great quality so long as only minor editing is required after the image has been captured. A JPEG captured in-camera should be considered as a print ready file while a Camera Raw file is unprocessed data that can be edited extensively in Photoshop Elements. Most professional photographers have switched from JPEG capture to using the Camera Raw format for the following reasons:

1. Extended dynamic range (great for combating the photographer's worst enemy – subjects where the lighting contrast is high).
2. Higher bit depth: having access to 12, 14 or even 16 bits per channel instead of 8 results in higher quality if you have to 'fix' the image after capture.
3. Flexible editing (why worry about the correct camera settings before you shoot when you can set them after?). The processing, that is normally done by the camera (white balance, saturation, sharpening, etc.) can be carried out in Photoshop Elements after you have returned from your shoot.

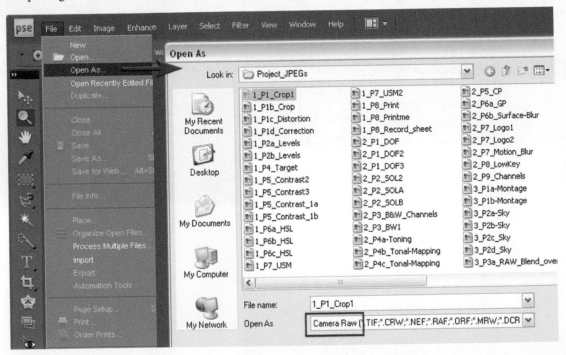

Editing JPEGs in Adobe Camera Raw

For photographers who are choosing to work with JPEG images rather than using Raw images, the Adobe Camera Raw (ACR) space still offers an advantage over the main editing space of Photoshop Elements for quick and easy editing. Adobe Camera Raw can be considered as the 'Quick Fix' space for professionals and keen amateur photographers alike. You can open JPEG images in ACR from the Edit space of Photoshop Elements to take advantage of the powerful tools in this editing space. Just go to File > Open As (Windows) or File > Open (Mac). Browse to the JPEG you want to open and then in the Open As menu choose the Camera Raw option.

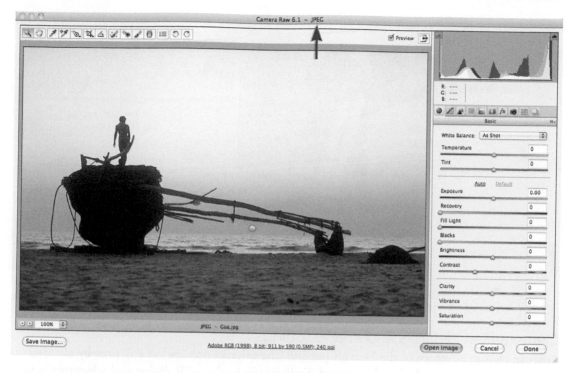

When the JPEG opens in Camera Raw you can utilize simple controls to optimize and enhance the color and tonality of your images. It is important to remember, however, that JPEGs are recorded by the camera at a lower 'bit depth' to Raw images so they are less able to withstand extreme adjustments before the quality becomes compromised. JPEG files also offer the photographer less chance of being able to recover highlights that were slightly overexposed in-camera.

Adobe Camera Raw – A non-destructive workspace

Adobe Camera Raw is a completely nondestructive workspace. Any changes that you make to your image in ACR can be completely undone, allowing the file you are working on to be returned to its original state (as recorded by the camera). Even if you crop your image in ACR, the pixels are never discarded – just temporarily hidden from view. Photoshop Elements simply records any change made in ACR as a list of processing instructions (XMP metadata) that is used to modify the preview. Every time a Raw image is displayed in ACR these processing instructions are applied to the image. Changes can only be permanently made to the actual pixels of the image file if the images are saved from the main editing space or processed (File > Process Multiple Files). When the user clicks 'Done' in the main editing space, Photoshop Elements will remember the changes you have made to the image. The changes are stored in a 'central cache' or memory bank that is, in turn, saved on your computer's hard drive. Adobe Camera Raw refers to this central cache to remember how you last processed the Raw file the next time you open it. If you want another computer running Photoshop Elements to be able to preview these changes you can hit the Save Image button in the ACR dialog and save your Raw file as a DNG file. Any changes you made in ACR will now be written directly to the file as well as the central cache.

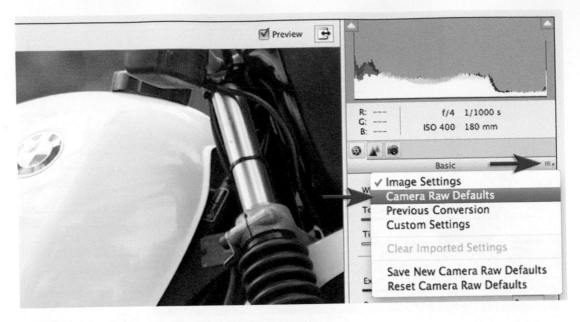

Camera Raw defaults and image settings

You can choose to return to the Default preview (the original preview) at any time by clicking on the button in the top right-hand corner of the Basic tab in the ACR dialog and selecting Camera Raw Defaults from the drop-down menu. If you choose Image Settings in this menu the preview will revert to the version that started the current editing session. This will include any changes you made to the image the last time the Raw file was opened in ACR.

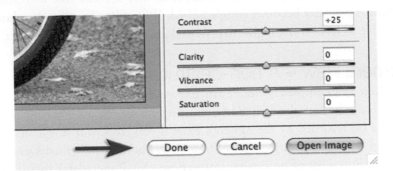

Done, Cancel or Open Image

Choosing Done in the bottom right-hand corner of the ACR dialog will save any changes you have made to the file or files open in ACR to the central cache and close or 'dismiss' the ACR dialog. If you choose Cancel the ACR space will close without modifying the previews, while choosing Open Image will open the selected image or images, with all of the changes you made in ACR, into the Edit space of Photoshop Elements. In addition to opening the image in the Edit space, this action also saves the ACR processing instructions to the central cache, so that the next time you open one of these images in ACR it looks just like it did when you clicked the Open Image button. Opening images into the Full Edit space will allow you to access all of the familiar features of the Edit workspace to continue the editing process.

File Naming

Example: Autumn_Leaves01.dng

| Autumn_Leaves | ⌄ | + | 2 Digit Serial Number | ⌄ | + |

| | ⌄ | + | | ⌄ |

Begin Numbering: `01`

File Extension: `.dng` ⌄

Format: Digital Negative

☑ Compressed (lossless) JPEG Preview: `Medium Size` ⌄
☐ Convert to Linear Image
☐ Embed Original Raw File

PERFORMANCE TIP

Adobe has created a universal Raw file format called 'DNG' (Digital Negative) in an attempt to ensure that all Camera Raw files (whichever camera they originate from) will be accessible in the future. The Save option in the Camera Raw dialog box gives you access to convert your camera's Raw file to the Adobe Digital Negative format with no loss of quality. The conversion will ensure that your files are archived in a format that will be understood in the future. Expect to see future models of many digital cameras using this DNG format as standard. One thing is for sure – Raw files are a valuable source of the rich visual data that many of us value, and so the format will be around for many years to come.

Thumbnails and previews of DNG files when not using Photoshop Elements

When using Photoshop Elements Organizer (Windows) or Bridge (Mac) you will probably not be surprised to find that you can see thumbnails and previews of all of your DNG Raw files before you open them in Photoshop Elements. If, however, you are using the Windows or Macintosh operating systems you may not see any thumbnail views or previews for these Raw files. Windows Vista users can download and install a 'DNG Codec' from the Adobe Labs website (http://labs.adobe.com) if they wish to view thumbnails when using the computer operating system to navigate and choose images instead of their Adobe software. Macinstosh users are advised to keep their Preview and iPhoto Applications up to date if they are experiencing any problems viewing thumbnails and previews. Users of Windows XP will need to install the Microsoft RAW Image Thumbnailer and Viewer before they can view Raw images outside of the Adobe Photoshop Elements software.

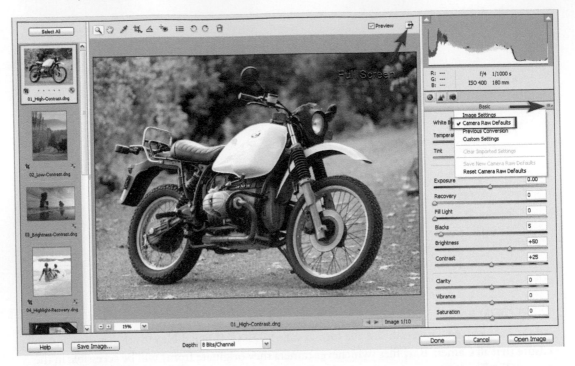

A fast and efficient workspace for editing multiple Raw files

It is possible to open multiple images into the ACR dialog at the same time (just shift-click a range of Raw images in the Organizer workspace or in a folder of images in your Pictures folder and choose Open). If your computer's operating system does not recognize the Raw file format then drag the images on to the Photoshop Elements shortcut. Open all of the Raw images from the supporting website to follow along with this project.

Note > Opening multiple images in ACR is less draining on your computer's working memory than opening the same number of images in the Edit workspace. Your computer just has to deal with the pixels that are on the screen rather than multiple megapixels of the files.

Managing your screen real-estate

Thumbnails of all the open files are displayed on the left side of the dialog – just click one of the thumbnails to display a large preview of the image. This column of thumbnails can be temporarily hidden from view by dragging the central divider to the left to increase the working area in the middle of the dialog. In the top-right corner of the dialog you can see a histogram that relates to the color and tone of the image you are viewing. This histogram is like the one you can access on the LCD screen of most good-quality cameras. This histogram has useful information about the color and tonality of your image. The beauty of the ACR space is that this is by far and away the best place to optimize the histogram to make each and every photograph you edit appear at its absolute best so that the world recognizes you for the wonderful photographer that you are. Click on the tiny icon just to the left of this histogram so that the ACR dialog goes full-screen. Professional photographers spend a lot of time in this dialog so make the most of this feature and give yourself some elbow room!

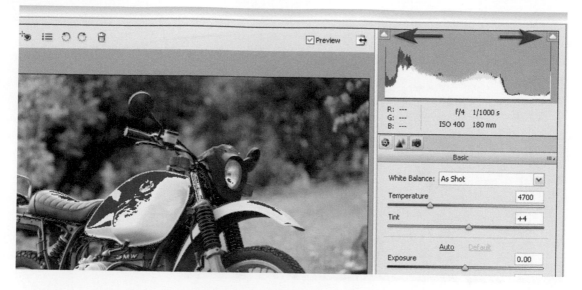

Checking exposure in Adobe Camera Raw

Above the histogram there are two triangles. These are the Shadow and Highlight clipping warning controls. The term 'clipping' is used by Adobe when the pixels in the red, green or blue channels, the three channels that make up an RGB image, are registering either level 0 or level 255 in one or more of the three channels. When there are pixels in the image that are registering level 0 in all three channels then the pixels in the image preview will appear as absolute black and the Shadow clipping warning triangle (the one on the left) will turn white. When there are pixels in the image that are registering level 255 in all three channels then the pixels in the image preview will appear as absolute white. The Highlight clipping warning triangle on the right will again appear white when this happens. When a shadow or highlight in the image is made up of pixels that are all level 0 or 255 then the surfaces will not have any detail. Shadows or highlights that do not have any surface texture or detail are referred to as being 'clipped' and this is usually regarded as a flaw by photographers, whose goal is generally to preserve as much detail as possible. Clipping may occur due to overexposure or underexposure in-camera or due to excessive contrast in the scene that was photographed. It is not uncommon for wedding photographers, for instance, to experience problems of clipping when photographing the bride and groom in sunny locations. They may review their images only to find that neither the bride's white dress nor the groom's dark suit has any detail. I often refer to level 0 and level 255 as the goal posts between which photographers must aim to squeeze all of their tonal information.

Activating the clipping warning in the image preview

If staring at the color of tiny triangles does not give you a lot of feedback about what is actually happening with the shadows and highlights within your image then try clicking the clipping warning triangles. Notice how the shadows or highlights in your image preview that are clipped are replaced with the color blue (for clipped shadows) or red (for clipped highlights). Click on either triangle to leave the warning on so that you can move your mouse cursor away and still retain warnings within the preview image.

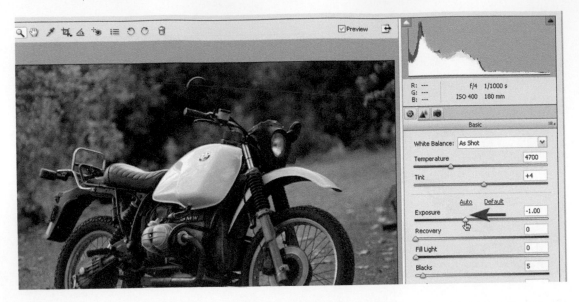

1. Adjusting exposure in Adobe Camera Raw

In the Basic tabbed panel (below the histogram) is an Exposure slider. This slider can be used to control the brightest pixels in the image file. Moving the slider to the left will lower the exposure and quite often pixels in the image that were shown to be clipping can be brought back behind the 255 goal post so that the highlight tones are now filled with tone and texture. Notice in the image above how with a one stop (-1.00) lowering of exposure the fuel tank on the motorcycle is no longer clipped and the clipping warning triangle turns black. The highlights have effectively been restored to this image. This is usually only possible with files that were captured using the Raw file format or processed as a JPEG in-camera using a dynamic range optimizer setting if available. It may not always be possible to save overexposed highlights but Raw shooters may have one or two extra stops of highlight headroom compared to JPEG shooters. The image is now a little dark due to the one stop exposure adjustment but this can be fixed later using the Brightness slider.

Auto and Default

Click on the underlined blue Default option directly above the Exposure slider to return all the adjustments in the Basic tabbed panel back to their default settings or double-click on the slider control to return this single Exposure slider back to its default setting of 0.0. If you click on the Auto setting for the image above you will see that ACR tries to recover some (but not all) of the overexposed highlights using the Recovery slider instead (the one below the Exposure slider). We will look at this alternative approach to recovering highlight detail later.

Set the white point using the Exposure slider

Use the Exposure slider in ACR as a White Point slider. If you are used to using Levels in the main editing space of Photoshop Elements then this slider can be likened to the one under the extreme right-hand side of the histogram. It is used to ensure the brightest pixels in the image are touching, but not pushed beyond, the level 255 goal post.

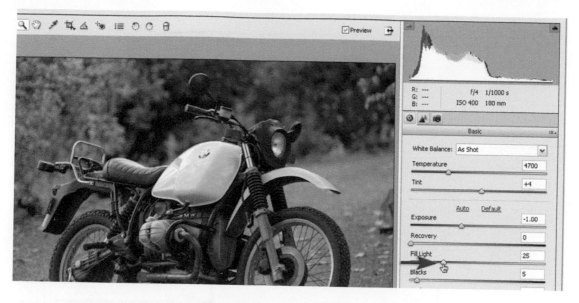

Set the black point using the Blacks and/or Fill Light slider

We can restore the shadow detail in this image using the Fill Light and Blacks sliders (below the Exposure and Recovery sliders). Technically it is the Blacks slider that controls the black point in the image. We could drag this left so that the darkest tones do not clip to black. This approach, however, often leads to blacks with detail but that appear weak and without depth. If you move the Fill Light slider to the right to recover the shadow detail, instead of moving the Blacks slider to the left, the shadows will usually appear to have a lot more depth.

Note > You will notice that no matter how far you move the Fill Light slider to the right you will never be able to make the Shadow clipping warning triangle turn black. The clipping warning will remain blue from the time the slider is moved beyond +20, indicating that the blue channel will remain clipped no matter how far the slider is moved. You will, however, notice that there is no blue clipping warning in the preview image itself. The blue channel is not being clipped because of how dark the shadow tones are but because of how saturated or vibrant some of the leaves are in the background behind the motorcycle.

PERFORMANCE TIP

Excessive adjustment using the Fill Light slider can lighten the shadow but can also reveal the greater amounts of noise that lurk in the shadows. My advice would be to keep the Fill Light value below 35 and keep the camera's ISO setting low to avoid this problem. Keeping the camera's ISO low also keeps the noise in the image file low and the dynamic range of the sensor (the ability to record a range of brightness values) high.

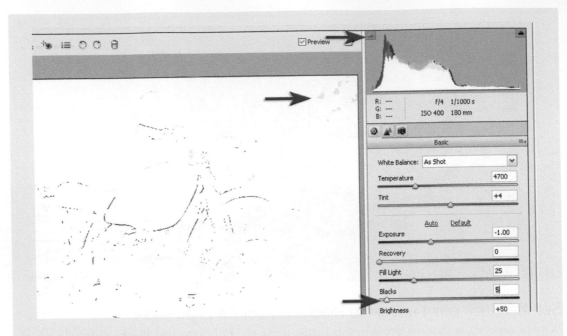

PERFORMANCE TIP

Hold down the Alt key (PC) or Option key (Mac) while clicking on the Blacks or Exposure sliders to give you a 'threshold' view in the preview window in order to obtain a more precise clipping warning. The threshold view will render the image preview entirely black or white except for where there is clipping. Instead of the regular blue and red clipping warnings you are now presented with a broader range of clipping colors to alert you to luminance clipping (all three channels) or whether the clipping is a result of very vibrant or saturated colors clipping. The issue of color saturation and clipping is dealt with later in this project.

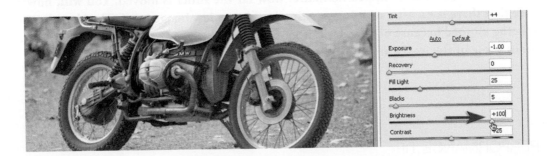

Gamma adjustments

After setting the white and black points using the Exposure and Fill Light sliders you can then dial in your preferred brightness or 'gamma' value for the image. The Brightness and Contrast sliders will usually leave the black and white points where they are and so these adjustments can be considered non-destructive tonal controls, i.e. they are slow to clip tonality after first setting white and black points. If you see any highlight clipping warnings after raising the brightness, return to either the Exposure or Recovery slider to fine-tune the white point.

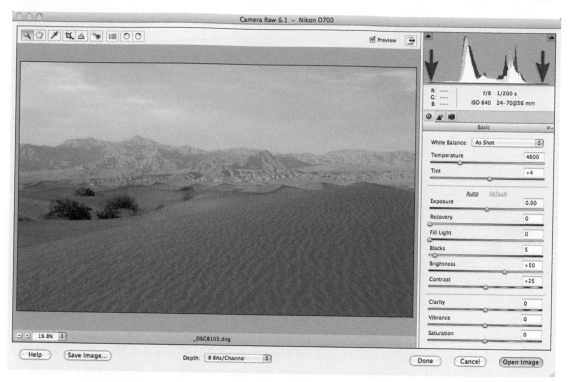

2. Correcting a low-contrast image

Select the Low-Contrast thumbnail from the column on the left. This image has the opposite tonal problems to the previous one. If you see a yellow warning triangle in the image preview window it is telling you that ACR is building a better preview from the data found in the Raw file. This time instead of having to recover shadow and highlight detail we have to expand the subject brightness range (SBR) or contrast. The original contrast was lost due to a combination of using a telephoto lens and the early morning mist.

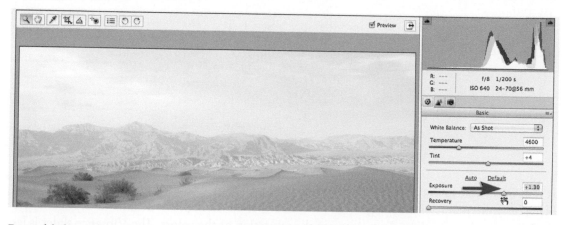

Reestablish a white point by dragging the Exposure slider to a point just before the highlight clipping warning indicates that you have overcooked or clipped the brightest tones in the image (up to 1.5 stops brighter than the original in-camera exposure used to capture the image).

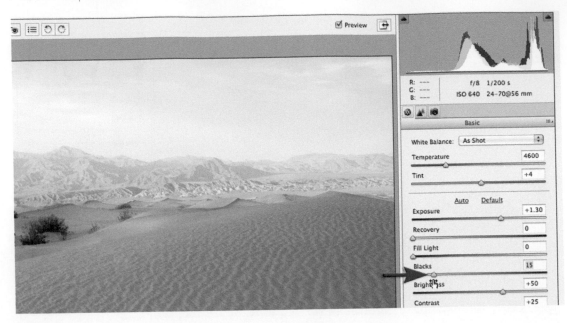

Reestablish a black point by dragging the Blacks slider to a point just before clipping occurs. You have now effectively expanded or stretched the histogram of the file to touch level 0 and level 255. The higher bit depth of the camera's sensor makes this possible without lowering the quality of the outcome (JPEGs are less forgiving).

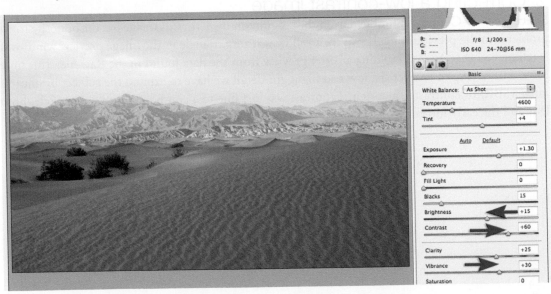

It is now possible to lower the Brightness slider and raise the Contrast slider without upsetting the black or white points of the image. Raise the Clarity slider to improve detail and depth and raise the Vibrance slider to the right to increase the saturation of the colors. The Vibrance slider is less likely to cause saturation clipping compared to using the Saturation slider for this task. Compare the use of the Vibrance slider to the Saturation slider while observing the clipping warnings.

PERFORMANCE TIP

Is saturation clipping a bad thing? In this image I wanted the colors to reflect the strong vibrant autumn colors but saturation clipping seemed inevitable, even when using the Vibrance slider instead of the Saturation slider in order to achieve this effect. If we hold down the Alt key (PC) or Option key (Mac) and then click on the Blacks slider we can see the yellow and magenta colors are clipped. The reality is that when colors clip in one or two channels they will have slightly less texture than if they were processed to have information in all three channels. If, however, we value a vibrant appearance more than texture we must sacrifice texture for color. This is a subtle difference, so many viewers will fail to notice that the clipped colors they are looking at are slightly 'flat' (without a lot of texture) when compared to less vibrant colors that were not clipped. If we are printing to high-end print service providers or using high-quality inkjet printers then it is important to go to Edit > Color Settings in the main Edit space of Photoshop Elements before we open and process images in ACR. Choose Always Optimize for Printing in the Color Settings dialog. This informs ACR that you want to open files in the larger Adobe RGB color gamut rather than the smaller sRGB color gamut that is more suitable for most computer monitors and the cheap-and-cheerful print service providers (consult your own print service provider if you are not sure which yours fits into). If you choose to use the larger Adobe RGB color gamut you will have the advantage of being able to use more vibrant colors that clip less easily, i.e. you can enjoy vibrant colors with good detail and texture.

Note > If you choose the larger Adobe RGB color gamut then you must always remember to convert your images to the smaller sRGB color gamut (Image > Convert Color Profile) when uploading the files to web galleries and sharing the files with people who do not use Photoshop Elements to view their images.

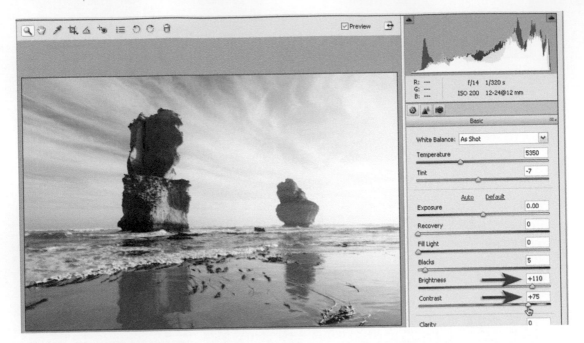

3. Brightness and contrast

The Brightness-Contrast image can be optimized without the need to set a black or white point. The subject brightness range of the subject captured by the camera matches the dynamic range of the image sensor. In order to avoid overexposing the highlights in-camera, the exposure was reduced at the time of capture. This has led to an image that is slightly dark and also lacking in contrast and vibrancy. To correct these shortcomings the Brightness and Contrast sliders can be dragged to the right to bring this image back to life. These adjustments are largely 'subjective', i.e. there is no right or wrong.

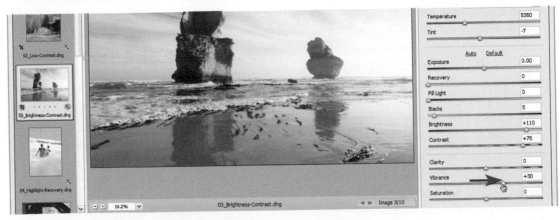

The Vibrance slider in this instance does not cause any saturation clipping when used to achieve the desired effect. If you require a brighter, more saturated outcome than the one shown you will need to raise the recovery slider slightly to ensure you don't lose some of the subtle highlight tones in the sky.

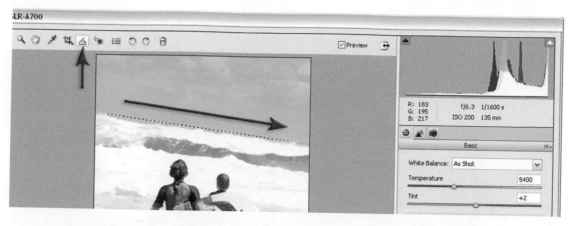

4. Straightening an image

Straightening an image in ACR is very easy. Open Image 04-5_Straighten-Highlight-Recovery, select the Straighten tool at the top of the ACR dialog and then find any horizontal line in the image (such as the horizon line as pictured in the illustration above). If you don't have a horizontal line in an image you are straightening you can select a vertical line so long as it is at, or near, the center of the image (so that you avoid using a vertical that is subject to perspective convergence). Then click and drag along the line while holding the mouse button down. When you let go of the mouse button the image is immediately rendered straight using the minimum amount of cropping.

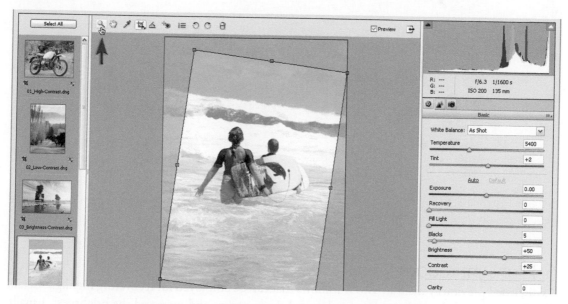

Click on the Zoom or Hand tool to escape from the crop view so that you can see the image straightened in the ACR dialog. The cropped pixels that are hidden from view can be reclaimed at any time by going to the Crop tool and then selecting Clear Crop from the drop-down menu (this action also undoes the straightening effect, putting things back the way they were). You can also press the Enter key to escape from the crop view.

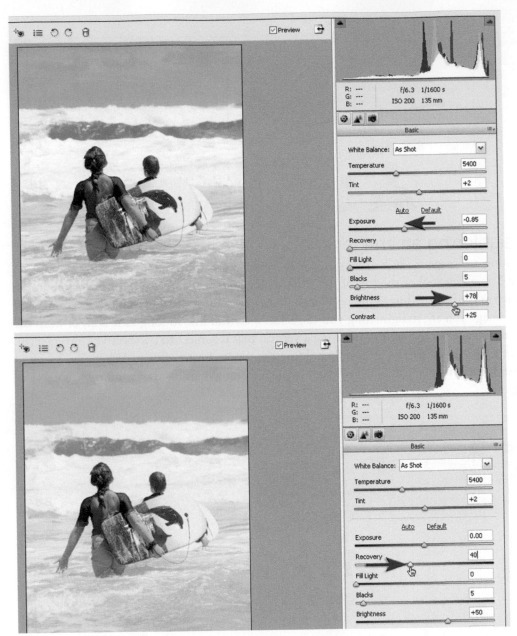

5. Highlight recovery

As discussed previously there are two workflows that can be employed for recovering highlight detail. The first option we looked at, where we lowered the exposure and increased the brightness, usually gives superior results to the single Recovery slider option. As we can observe in the examples above, the first option gives slightly better midtone contrast with slightly improved highlight detail. This workflow, however, is usually only superior when working with images that have the detail from the dynamic range headroom that Raw files possess. The Recovery slider really comes into its own when one or more channels are truly clipped, as would be the case with overexposed JPEGs.

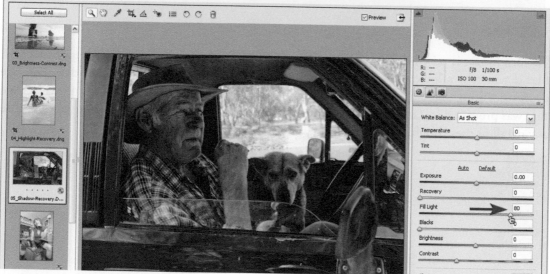

6. Shadow recovery

Great care needs to be taken when using the Fill Light slider to rescue dark shadow tones. In Image 06_Shadow-Recovery an extreme adjustment is being made to rescue the shadow tones that have been accidentally underexposed due to the bright tones in the center of the viewfinder. Notice how the shadows are slow to clip in such an underexposed file. The shadow tones are moved away from the left hand wall of the histogram quite easily with the Fill Light slider. With such a heavy application of the Fill Light slider you may find the color saturation becomes excessive so this will need to be addressed using the Saturation or Vibrance sliders.

Note > Be careful with raising the Fill Light value too high, especially with photos taken with a high ISO setting. Fill Light will also brighten noise in the photo and make it more apparent. Photos taken at a lower ISO will be more forgiving to the Fill Light slider.

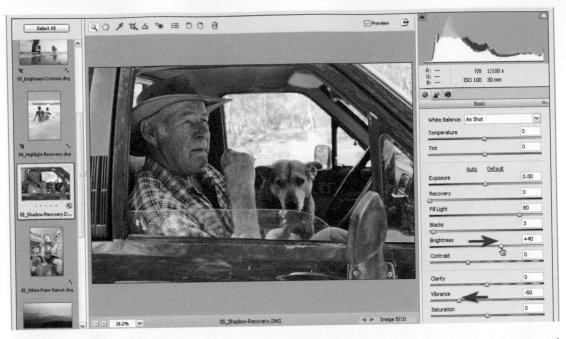

The brightness is raised and the vibrancy reduced to complete the editing of this underexposed file. If you take a look at the Highlight clipping warning there is an indication that there are overexposed highlights in the image. This DNG file, however, was converted from a JPEG file that was processed in-camera and would therefore require the recovery slider to be used to restore any detail in these brighter areas.

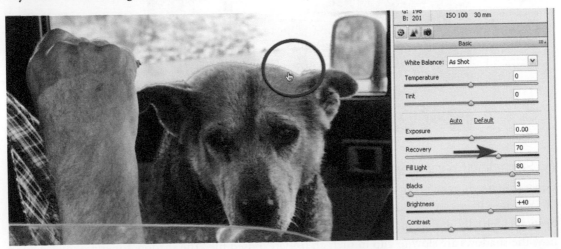

The problem with raising the Recovery slider and Fill Light sliders to high settings in the same image file is that high-contrast edges can acquire edge artifacts. In the image above a dark outline appears around the high-contrast edges in the image. A more pleasing result can be achieved in this instance if the file is opened in the main editing space and the Shadows/Highlights adjustment feature is used instead (go to Enhance > Adjust Lighting > Shadows/Highlights).

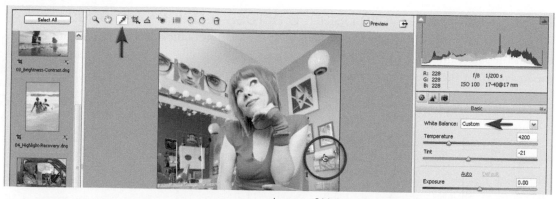

Image of Melissa Zappa courtesy of Victoria Verdon-Roe

7. Gamut control and white balance

In Image 07_Gamut much of the clipping warning you see when you first open the image is due to colors that are out-of-gamut rather than any luminance clipping. Many of the colors are simply too saturated to be contained by even the larger Adobe RGB gamut. It is, however, possible to put all of these colors back into the gamut with a little bit of care and attention. The first step is to ensure that these warm orange and yellow tones are no warmer than they really need to be (due to a slightly inaccurate Auto White Balance setting in-camera). Select the White Balance tool at the top of the ACR dialog and then click on the kitchen roll paper hanging on the wall to the right of the image.

Note > If you have not changed your Color Settings in the main Edit space of Photoshop Elements (Edit > Color Settings) to Always Optimize for Print then you will not be able to pull the colors back into the smaller sRGB color space.

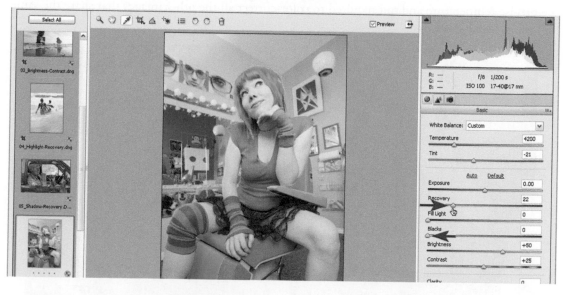

The Recovery slider in this instance is useful for pulling the out-of-gamut colors at the 255 end of the histogram back into gamut, while moving the Blacks slider to 0 will take care of the out-of-gamut colors at the level 0 end of the histogram.

8. Correcting the white balance across a batch of images

As we have seen with editing the previous image, it is sometimes quicker to use the White Balance tool in the ACR interface to color-correct an image by simply clicking on a neutral tone within the image to set the correct color temperature and tint.

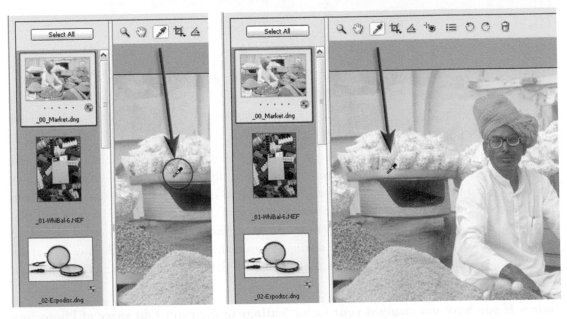

If the subject you wish to capture does not have an obvious neutral tone then you can introduce a neutral tone as a reference point in the first image of the shoot. This will enable you to measure the precise temperature and tint required to color-correct all the other images that share the same lighting conditions.

In this image a white balance card (a 'WhiBal' is used in the image above) has been introduced into the image; the White Balance tool is then used to set accurate temperature and tint settings.

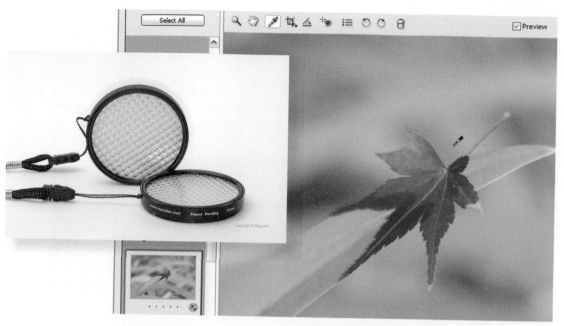

In some scenes there may be no neutral tones to click on and no opportunity to include a white balance reference card in the scene. In these instances it is important to either create a custom white balance setting in the camera at the time of capture or capture a reference image using a product such as the 'Expodisc'. The Expodisc is placed in front of the lens and an image captured by pointing the camera back towards the light source (with the camera set to manual focus). The resulting image provides the photographer with a reference image that can be used to assign the correct white balance to all of the images captured in those lighting conditions.

When you want to assign the correct white balance across a group of images, select multiple Raw files in the Organizer space (PC) or Bridge (Mac) and then open them in the ACR interface.

Click on the reference image thumbnail on the left-hand side of the ACR interface. Then hold down the Shift key and click on the last thumbnail in the group of images that share the same lighting conditions. Select the White Balance tool and click on the main reference image preview to assign the correct white balance to all of the images.

These before and after images of autumn leaves clearly demonstrate how the Auto White Balance setting in the camera has misjudged the correct white balance.

Note > The Expodisc can also be used to create custom white balance settings in the camera, to take accurate incident light meter readings and also to help locate any dust on the camera's sensor (go to www.expodisc.com for more details about this useful product).

PERFORMANCE TIP

As long as the photographer takes frequent reference images as the lighting conditions change (e.g. cloudy, sunny, time of day, etc.), color accuracy is assured with just a few clicks. Remember this color accuracy can only be fully appreciated if both computer monitor and printer are calibrated to display accurate color.

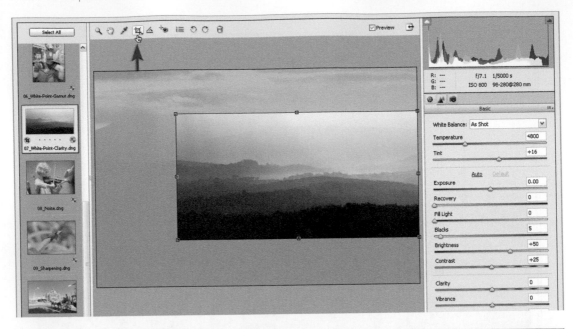

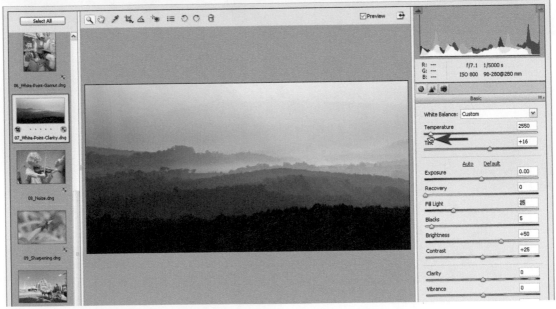

9. Creative use of white balance to tone an image

In the illustration above the Crop tool has been used to crop into the most interesting aspect of this landscape. Even with this more dramatic crop the original white balance of the camera does not capture the mood of the cold winter morning in the valley. Instead of clicking on a neutral tone within the image with the White Balance tool (to create a neutral white balance) the Temperature slider has been lowered to something just above freezing by dragging it to the left! This had induced some extensive saturation clipping but now expresses the mood I am after.

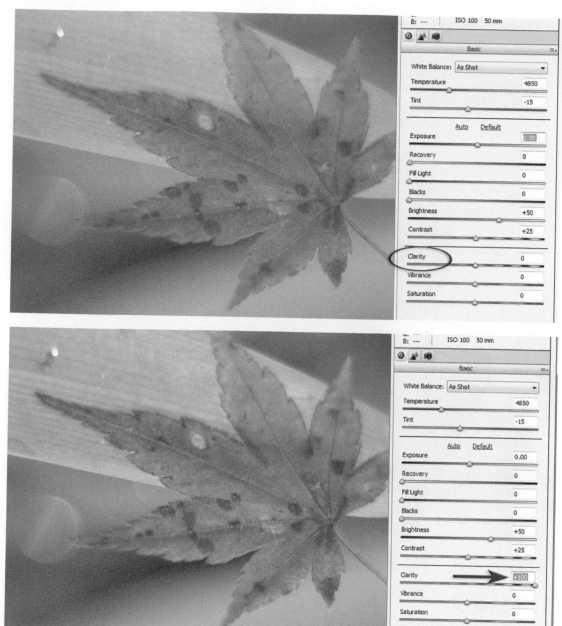

10. Clarity

The Clarity slider can be used to effectively increase localized contrast and give images more apparent depth (and sometimes make them a little sharper). Notice how contrast is raised both in the areas of fine detail and the broader areas of continuous tone. Unlike the Recovery and Fill Light sliders, which have to be used in moderation, this slider is slow to introduce unpleasant artifacts – especially in images where the light quality was soft and even.

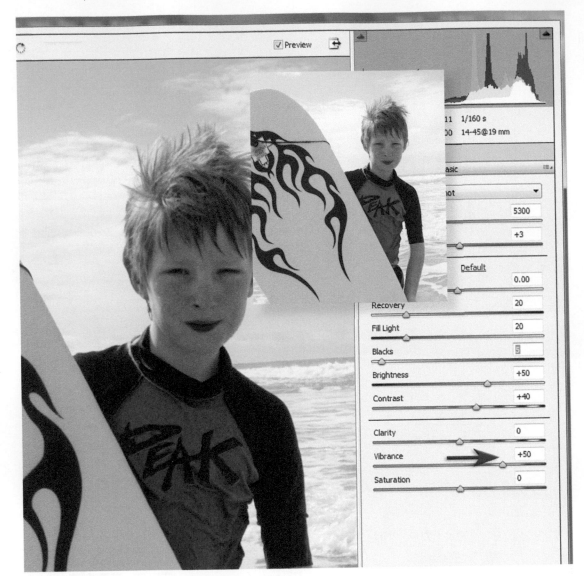

11. Vibrance

Increasing saturation in ACR can lead to clipping in the color channels. Clipping saturated colors can cause a loss of fine detail and texture. The Vibrance slider applies a non-linear increase in saturation (primarily targeting pixels of lower saturation rather than colors that are already vibrant). The adjustment feature has also been designed to protect skin tones from becoming oversaturated and unnatural. The Vibrance adjustment feature should lead to fewer problems when compared to the Saturation control and should be used for most situations where increased color saturation is required.

Note > Choosing Adobe RGB in the Color Settings dialog box in the main editing space (Edit > Color Settings) will provide a working space with a larger color gamut than sRGB. This will allow saturation or vibrance to be increased to a greater degree before clipping occurs.

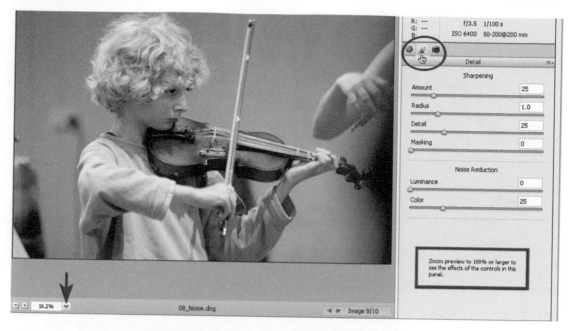

12. Detail tab (sharpening and noise reduction)

Zoom to 100% and click on the Detail tab (next to the Basic tab) to access the Sharpening and Noise Reduction controls. The Sharpening controls can be left at their default settings if you intend to implement the advanced sharpening techniques (see Project 8) or use the techniques outlined on page 32 (if you wish to apply sharpening settings to a batch of images). The Luminance Smoothing and Color Noise Reduction sliders are designed to tackle the camera noise that occurs when the image sensors' ISO is raised.

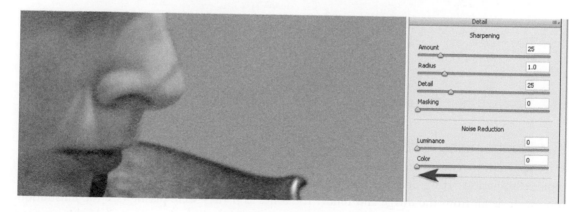

In the image above, the camera's ISO was set to 6400 (a Nikon D700 DSLR). Both luminance and color noise are evident when the image is viewed at 100% and the Color Noise slider is set to 0. When cameras are set to 100 or 200 ISO it may be possible to leave the Luminance slider at 0 as noise will be low or non-existent. Most files (even the ones captured at low ISO settings) benefit from a small amount of color noise reduction. Be careful not to apply too much, though, as this will steal color from the finer details within the image.

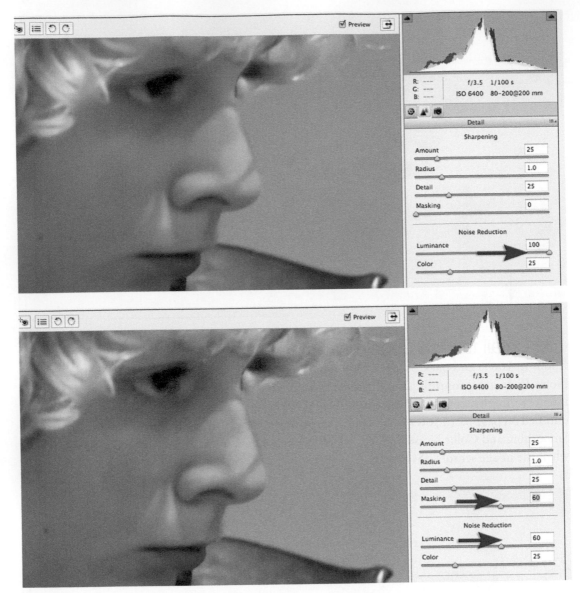

Luminance noise reduction

It is important to remember that the Noise Reduction controls are called 'noise reduction' and not 'noise elimination'. If we drag the Luminance Noise slider too far to the right we will take away too much detail from the image and render the tones as if they were plastic (see the illustration at the top of this page). It is also important to remember that the noise appears a lot bigger now that we are looking at the image at 100% (Actual Pixels) compared to how we will view the image in a screen presentation or a full page print. I am happy to just use a moderate amount of noise reduction (perhaps no more than 60) on my images captured at ISO 6400 in the full knowledge that the images will look reasonably detailed and smooth at 'normal' viewing sizes. So that we don't sharpen the areas of smooth tone, where the noise will be most visible, it is also advisable to drag the Masking slider (directly above the Luminance slider) to a value of around 60.

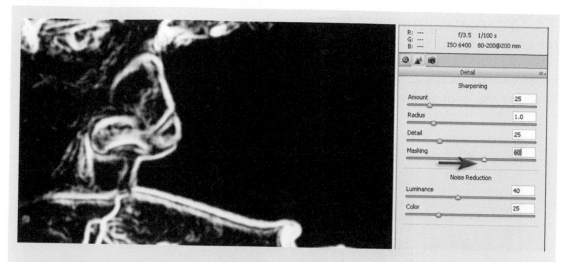

PERFORMANCE TIP

Hold down the Alt key (PC) or Option key (Mac) to see a Threshold view of the masking process. Any areas of the image that appear black will be shielded from the sharpening process.

13. Sharpening multiple files

Just as a white balance setting can be applied across multiple images open in ACR, the same batch processing can be achieved when sharpening images. Although the sharpening controls have vastly improved in the ACR interface, it is still recommended that you sharpen in the main editing space to achieve maximum performance when sharpening (see Project 8 – 'Sharpening').

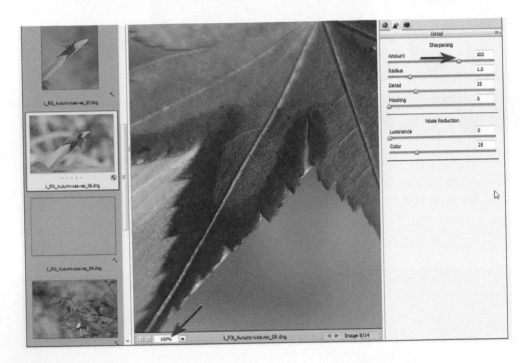

Set the magnification to 100% before sharpening any image in ACR as the results are not visible at smaller magnifications. Start by increasing the Amount slider until the edges that have the most contrast are suitably sharp. Amounts up to 100% are considered normal. If you hold down the Alt/Option key and click and drag the Amount slider the preview is displayed in black and white, which makes it easier to see the effects of the Amount slider. Generally it is recommended to leave the Radius slider at its default setting of 1.0.

Hold down the Alt/Option key and drag the Detail slider to the left or right to observe the amount of detail that will be targeted for sharpening. Drag to the right to increase detail in the areas of continuous tone and to the left to decrease apparent detail. Let go of the Alt/Option key to observe the effect on the image.

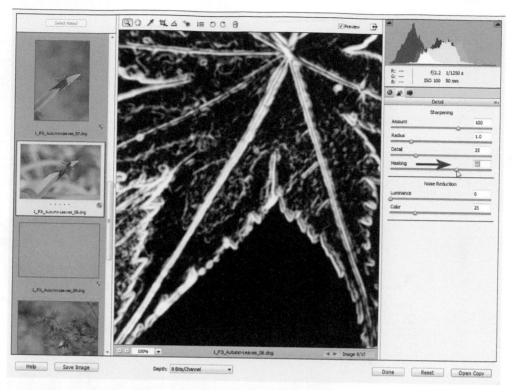

To eliminate the sharpening process from areas of continuous tone we can drag the Masking slider to the right. Hold down the Alt/Option key as you drag this slider to observe the areas of the image that will not be sharpened (as indicated by the black mask).

To apply these settings to the other images in the shoot simply choose the Select All option above the thumbnails on the left side of the ACR interface. The numbers for each slider will be blank if the settings are not the same for all of the selected images. Click on each slider in turn to sync the sharpening settings for all images. Click on Done to apply all of these changes and close the ACR dialog box. Select Save to process the files using the current Raw settings or select one or more images to open in the main editing space of Elements.

Note > Sharpening and other corrections applied over a batch of images may not always be desirable for every image. Check each image in turn to see if specific adjustments are required.

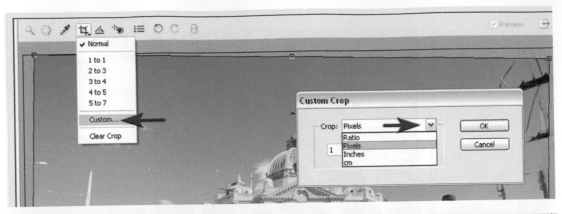

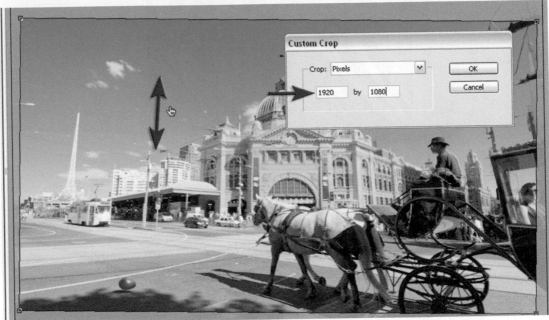

14. Cropping

Cropping an image to a specific output size

In Step 4 ('Straightening an image') we saw how images can be cropped automatically in ACR using the Straighten tool. It is also possible to crop to a particular shape or 'aspect ratio' using one of the presets in the crop drop-down menu. If you select Custom you can also crop to a particular size as well as a particular shape. Select Custom in the Crop menu and then choose pixels, inches or cm from the Crop drop-down menu in the Custom Crop dialog. In the illustration above I have selected pixels and then entered 1920 by 1080 in the Width and Height fields (the dimensions of a wide-screen full-HD TV). Select OK and then click and drag the cropping marquee over the image to establish a cropping rectangle of the ratio of the two Pixel fields. You can then move the crop bounding box inside the image area to fine-tune the design. When you click on the Hand or Zoom tool the rest of the pixels will be hidden from view. You can also press the Enter key to execute the crop, while pressing the Esc key backs out of the crop altogether.

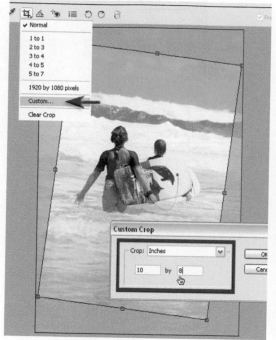

Cropping an image for print

If you return to the Highlight-Recovery image from Step 4 and click on the Crop tool at the top of the ACR dialog you will see the pixels that were previously hidden from view. If you now select Custom from the crop Drop-down menu and choose inches from the Custom Crop dialog, you will be set to crop the image for a print output size rather than for the screen. I entered in 10 by 8 in the Width and Height fields to create a typical print size and then clicked and dragged inside the crop bounding box to perfect the composition. Note how the horizon line stays parallel to the top edge of the bounding box. The image can be rotated if required by moving your mouse cursor to a position just outside one of the corner handles of the crop bounding box and then clicking and dragging to rotate. Click on the Hand or Zoom tool in the ACR dialog to once again hide from view the pixels that lie outside the bounding box.

15. Processing files that have been optimized

If you click the Done button at the base of the ACR dialog, all of the changes you have been making to these files are saved. The Raw files cannot, however, be printed or displayed in web galleries or screen presentations unless the files are processed as TIFF, Photoshop or JPEG files. This process can be handled by going to the main Edit space in Photoshop Elements and then going to File > Process Multiple Files. In the Process Multiple Files dialog you can browse to your folder of Raw files and then process the files to any format of your choosing. The original Raw files will remain unchanged.

Note > Remember that the processed files will carry the profile as directed by the Color Settings dialog (Edit > Color Settings) at the time you process the files – either sRGB or Adobe RGB.

Project 2

Basic Retouching

Sometimes it is not enough just to optimize an image in Adobe Camera Raw (ACR). To achieve maximum performance from our editing software we occasionally need to fine tune the optimization process by opening the image in the main editing space of Photoshop Elements and finishing the job using some localized, rather than global, editing techniques.

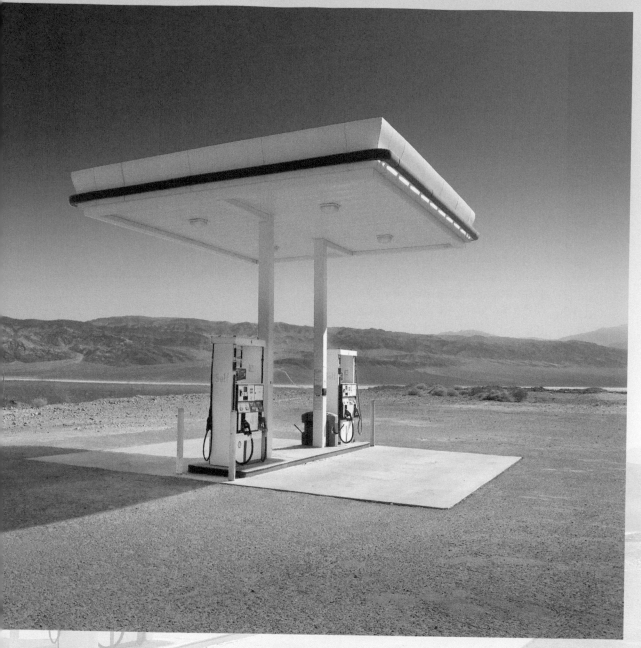

Gas Station, Nevada

This tutorial guides you through the process of editing non-destructively using a series of adjustment layers, image layers and layer masks. By adopting a non-destructive workflow we can maintain maximum quality and ensure that for every adjustment of color or tone we have a controlling layer that can be re-adjusted or removed at any time.

Color settings

In the full version of Photoshop users have the choice to open an image from Adobe Camera Raw into the Edit space using either the larger Adobe RGB profile or smaller sRGB profile. Photoshop Elements users do not have the choice in Adobe Camera Raw to choose a profile but they can ensure that images are opened in the larger Adobe RGB space by going to Edit > Color Settings and choosing Always Optimize for Printing prior to opening Raw images. If after editing the image in the larger color space you decide to post the image to the web (using the smaller color profile) you can always change the setting from Adobe RGB to sRGB by going to Image > Convert Color Profile and choosing sRGB.

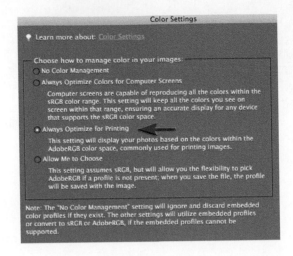

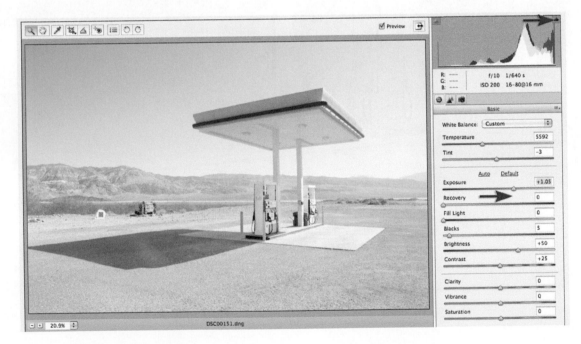

1. Open the project image into Adobe Camera Raw (ACR). Sometimes it is worth seeing if ACR can optimize an image by simply clicking on the Auto button (just above the Exposure slider) but the result of taking this course of action for this image would just result in a muddy mess. To optimize the white point for this image drag the exposure slider to the right until you see the black 'Highlight clipping warning' triangle above the right side of the histogram turn white or another color. Move the slider back slightly until the triangle turns black again.

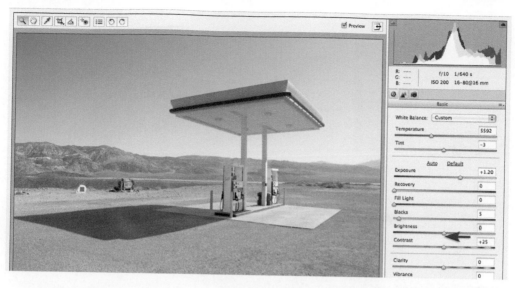

2. Lower the Brightness slider to 0 to re-establish the 'gamma' or midtone brightness. The result will be improved contrast values throughout the file. After lowering the Brightness slider you may need to return to the Exposure slider to fine-tune the white point adjustment.

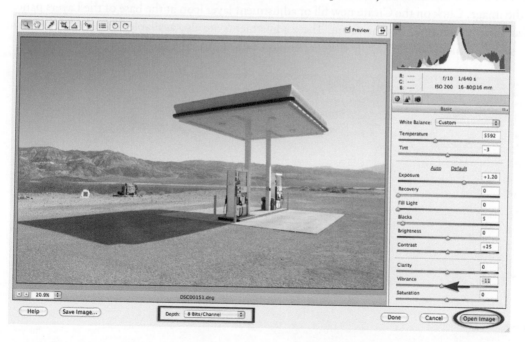

3. The tall blue line on the left side of the histogram and the illuminated 'Shadow clipping warning triangle' indicates saturation clipping. The yellow colors are too vibrant for the color gamut of Adobe RGB. These colors can be brought back into gamut by lowering the Vibrance slider to –11. Set the Depth to 8 Bits/Channel and then select Open Image to open the image into the main Edit space of Photoshop Elements.

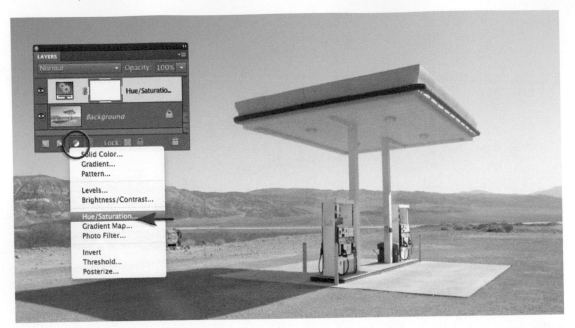

4. In the next three steps we will modify the luminance values of the blue sky and the yellow colors in the image. Click on the Create new fill or adjustment layer icon at the base of the Layers panel and select Hue/Saturation from the menu. These adjustments are also available from the Enhance menu but selecting them here will apply the changes to a non-destructive adjustment layer.

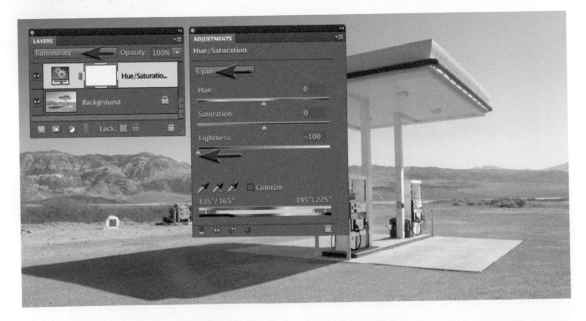

5. Set the mode of the layer to Luminosity and select Cyans from the menu in the Hue/Saturation dialog. Drag the Lightness slider to −100. Now select 'Blues' from the menu and again lower the Lightness slider to −100.

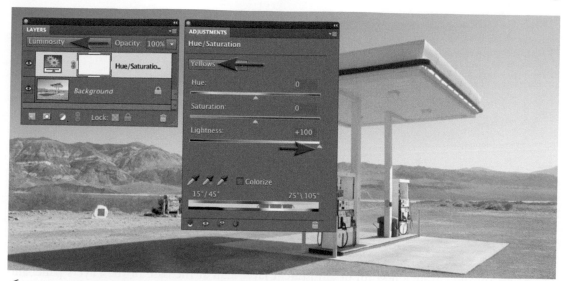

6. Select the Yellows from the menu and now raise the Lightness slider to +100. The Luminosity mode applied to the adjustment layer in the last step ensures that when the Lightness slider is moved, the saturation values of the colors being adjusted remain constant. This is as far as we can adjust the Luminance values using the Lightness slider in the Hue/Saturation dialog. If we need tones to be darker or lighter we will have to use an alternative adjustment feature and mask the other colors to protect them from the adjustment.

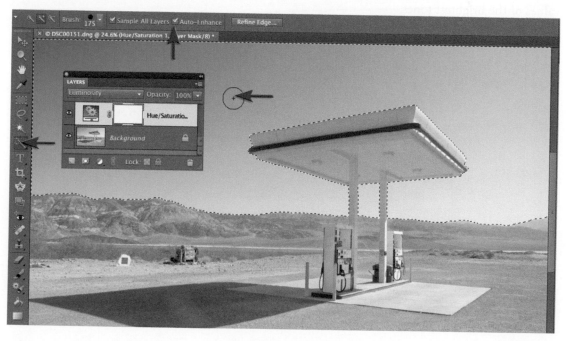

7. To prepare the mask click on the Quick Selection tool in the Tools panel and check the Auto-Enhance option in the Options bar. Click and drag the tool over the sky to make a selection of this area of the image.

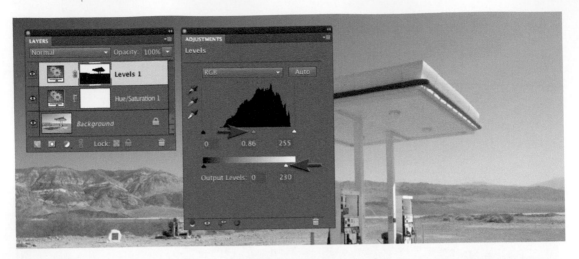

8. Click on the Create a new fill or adjustment layer icon at the base of the Layers panel and this time select a Levels adjustment layer. Move the slider directly underneath the histogram to the right to darken the sky even further. As you darken the image the saturation values of the sky will also climb. Drag the highlight Output Levels slider to the left to reduce the luminance of the highlights on the horizon line and protect the saturation levels of the darkened sky. Switching the mode of the adjustment layer to Luminosity would be an alternative way of modifying the luminosity without raising the saturation. This option, however, would retain the luminance values of the brightest tones.

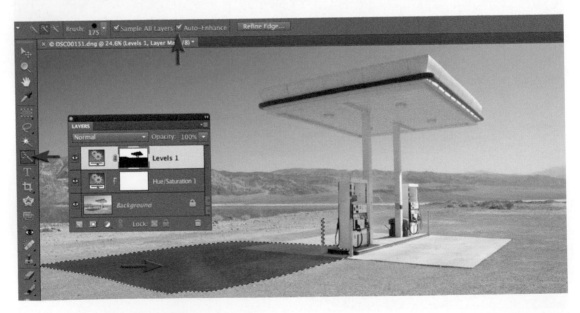

9. With the Quick Selection tool now click and drag on the shadow to make a selection of this area of the image. If you accidentally select any areas that are not the shadow hold down the Alt key (PC) or Option key (Mac) and drag over any area that you want to remove from the selection.

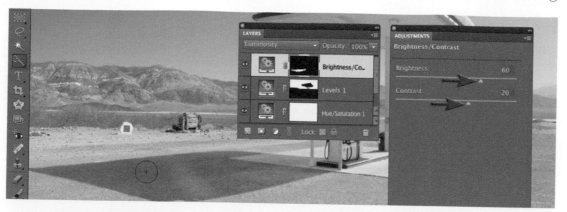

10. Click on the Create a new fill or adjustment layer icon at the base of the Layers panel and this time select a Brightness/Contrast adjustment layer. Although a very simple adjustment feature it can lighten the shadows and increase the localized contrast in this area quite effectively. A long time ago the Brightness/Contrast adjustment in Photoshop had a destructive tendency (it would clip highlight and shadow detail), but these days the behavior is as it should be (progressive rather than linear).

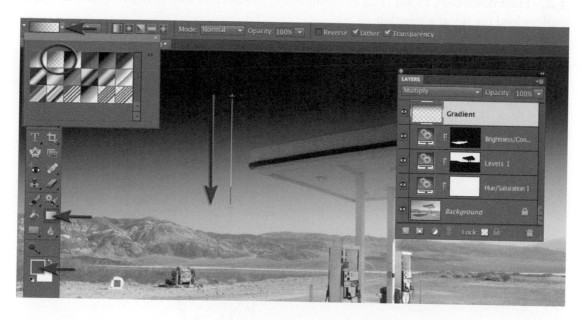

11. Click on the Create a new layer icon at the base of the Layers panel to create an empty new layer. Set the mode to Multiply and then double-click the name of the layer and rename it Gradient. Click on the Gradient tool in the Tools panel and then hold down the Alt key (PC) or Option key (Mac) and click on a bright blue color in the sky to sample it (the color will appear in the foreground color swatch in the Tools panel). Select the Foreground to Transparent gradient from the Gradient picker and the Linear gradient in the Options bar. Click and drag a gradient from the top of the image preview to a position just above the distant hills. The Gradient will clip the top of the gas station but this will be fixed in the next two steps.

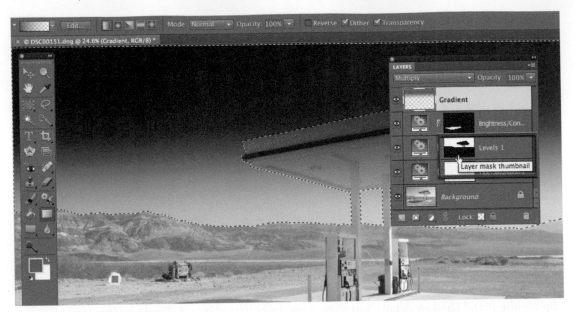

12. Hold down the Ctrl key (PC) or Command key (Mac) and then click on the Levels 1 layer mask to load the sky as a selection.

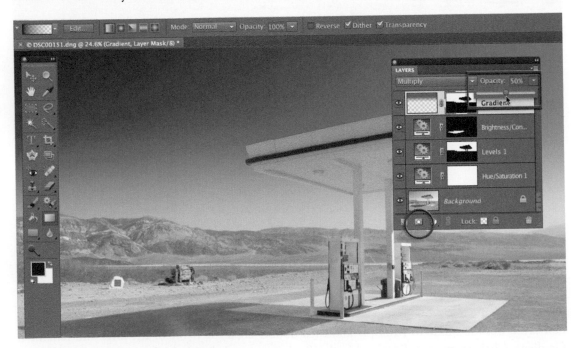

13. With the Gradient layer selected, click on the Add layer mask icon in the Layers panel. The selected area and the masked areas are opposite, so the mask is effectively duplicated on the new layer. The luminance of the sky is now likely to be too dark (after the three luminance treatments) so you will probably need to lower the opacity of the layer to around 50%.

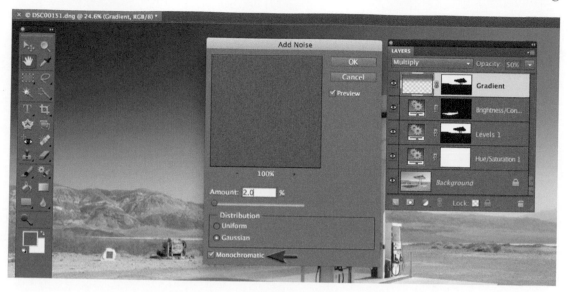

14. Gradients applied to smooth continuous tones can cause banding (visible steps of tone) in the resulting image. The banding, if present, can be reduced by applying noise to the gradient layer. Make sure the image is selected rather than the mask (click on it to select it) and then go to Filter > Noise > Add Noise. Add 2% Noise and check the Monochromatic option.

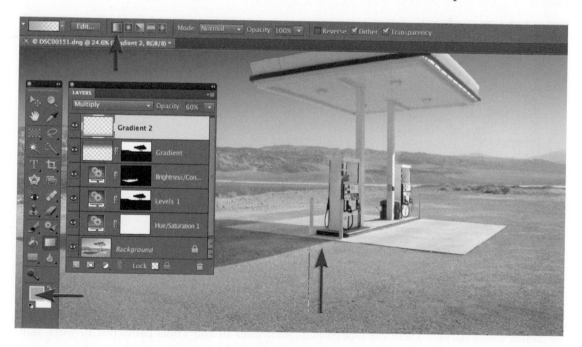

15. Add an additional gradient to the bottom of the image (create a new layer, set the mode to multiply, sample the color and drag a gradient from the bottom of the image). Pressing the keyboard shortcut Ctrl + F (PC) or Command + F (Mac) will apply the last filter used.

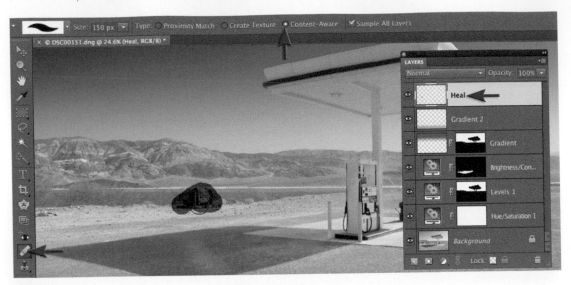

16. The best way to remove small distracting details (or not so small as in the case of this image) is to add a new empty layer and then select the Spot Healing Brush tool. Select the new Content - Aware and Sample All layers options in the Options bar then brush over the things you wish to remove. The Sample All Layers option is critical as there are no pixels in the empty layer to be cloned.

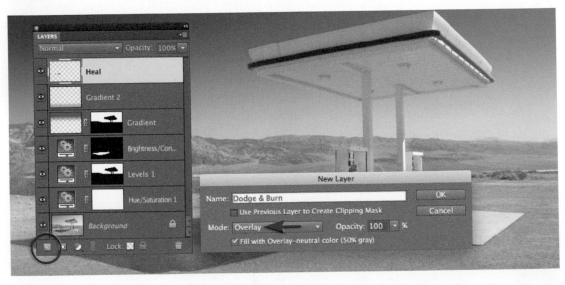

17. Another way of controlling luminance values non-destructively is to 'Dodge' tones lighter or 'Burn' tones darker. There are Dodge and Burn tools in the Tools panel but to work non-destructivley we need to create a Dodge & Burn layer. Hold down the Alt/Option key and then click on the Create a new layer icon to open a New Layer dialog. Name the layer Dodge & Burn and set the mode to Overlay and check the Fill with Overlay neutral color (50% gray) option. Select OK to create a new layer with these settings.

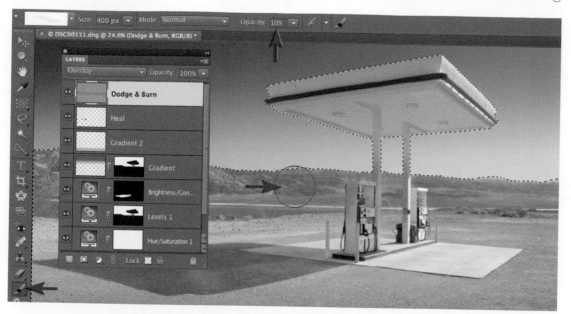

18. Select the Brush Tool from the Tools panel and set the brush hardness to 0% by clicking on the brush in the Options bar to access the brush settings. Set the Foreground and background colors to their default settings and set the Opacity to 10% in the Options bar. Paint with black to darken the underlying tones and with white to lighten the underlying tones. It is possible to paint free hand or make a selection to restrict you painting to clearly define areas (You can only modify selected pixels).

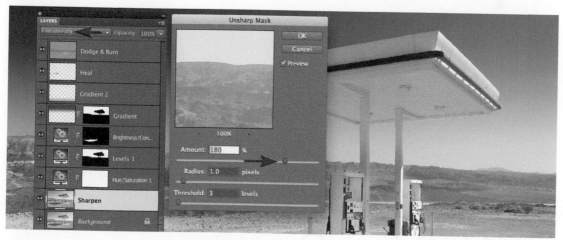

19. Sharpen the image to complete the project. Duplicate the background layer and set the mode to Luminosity (to maintain color accuracy when the edges are sharpened). Go to Enhance > Unsharp Mask and in the Unsharp Mask dialog set the Amount slider to 180 and the Radius to 1.0. Raise the Threshold slider to 3 to protect the smoother tones from the sharpening process. Select OK to apply the sharpening. Adjust the opacity of the sharpen layer to reduce the amount of sharpening. The tonality of this project can continue to be adjusted after the sharpening process as all the layers above the sharpening layer are interactive.

Project 3

Working Spaces

For Photographers shooting in the Raw format we can now optimize and enhance images either in Adobe Camera Raw (ACR) or in the main editing space of Photoshop. Increased flexibility and options brings increased confusion as to where is the best place to edit. Am I in the right space for the right job? What if I change my mind? Decisions, decisions.

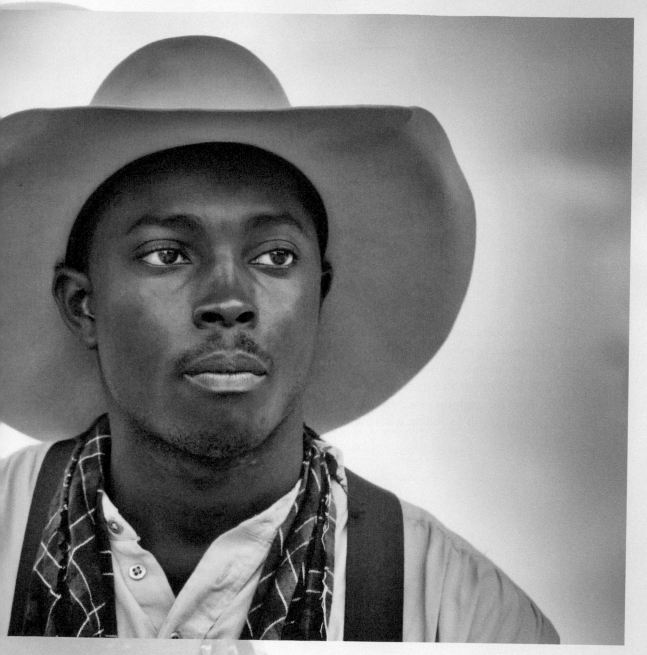

Cowboy - Fort Worth, Texas

This tutorial provides insights into how we can edit a single file in both spaces. The workflow outlined will give you the flexibility to return to ACR to tweak some of those initial settings – an additional step for those photographers who can never make up their mind.

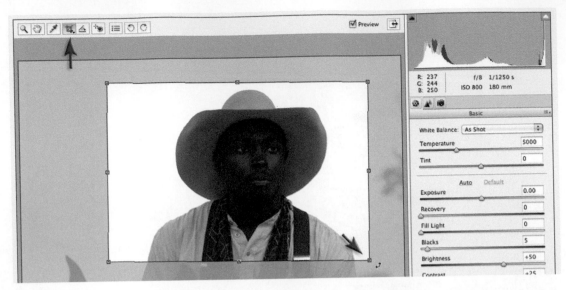

1. Open the project image into Adobe Camera Raw (ACR). Select the Crop Tool and create a tighter composition by dragging the tool over the head and shoulders of the cowboy. Move your cursor to a position just outside one of the corner handles to rotate the crop marquee if required. Select the Hand Tool or Zoom tool to apply this crop. It is important to remember that pixels are not discarded in the cropping process in ACR – just hidden from view. This is an advantage to using ACR rather than the main editing space for this task.

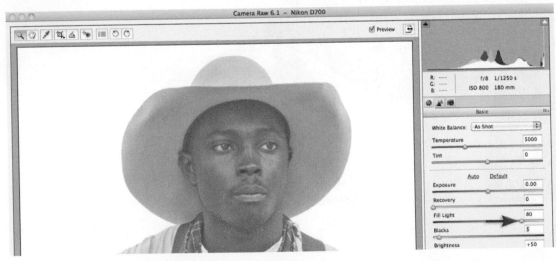

2. No fill flash reached the subject in any usable strength and the exposure compensation used in-camera was insufficient to lighten the dark shadows. In Adobe Camera Raw we can use the Fill Light slider to restore usable detail in these tones. In the main editing space we could use the Shadows/Highlights adjustment feature. The advantage to restoring these tones in ACR, however, is that we are working at the native bit depth of the sensor. Alternatively we could open the file from ACR as a 16 Bits Channel file but that would then prevent us working with layers in Photoshop Elements.

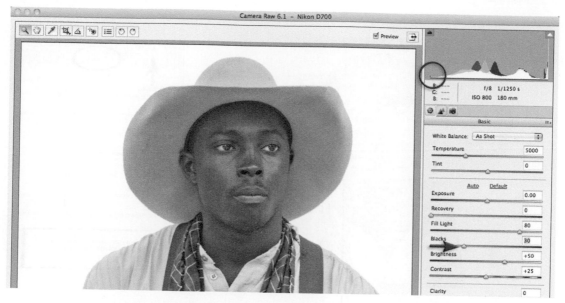

3. If we drag the Fill Slider to a value of +80 in ACR we will no longer have a black point in this image so we need to raise the value of the blacks until the toe of the histogram touches the left hand side again.

Alternative approach > Raise the Exposure slider to +1.5 and the brightness slider to +80. The outcome is similar but not the same. The shirt and hat will be brighter as the lightening effects will be applied to all tones and not just the shadows. If using the Exposure slider be sure to switch on the clipping warning (click the triangle above the top right hand side of the histogram) to ensure you don't lose any detail in the brightest tones of your subject.

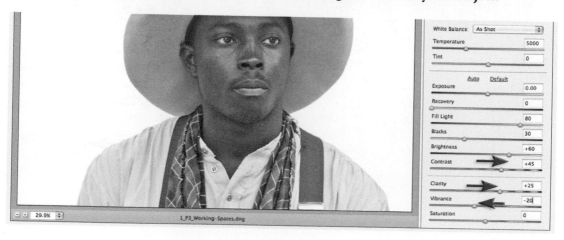

4. Localized contrast in the shadows can be improved by raising the Contrast slider to a value of +45 and the Clarity slider to a value of +25. Lower the Vibrance slider (-20 in this instance) to reduce excessive saturation that has been created by this contrast adjustment. Raise the Brightness slider to +60.

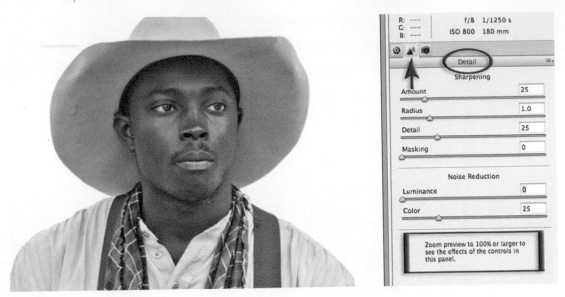

5. If we lighten the shadow tones we will also increase the amount of visible noise within the image. We can reduce this noise by going to the Detail tab in ACR. At the base of this panel you will see the note reminding you to zoom in to 100% or Actual Pixels.

Note > Reducing Noise in ACR, rather than in the main editing space, is the most effective and fastest place. The only downside to reducing noise in ACR is that the effect is global, i.e. we cannot restrict the noise reduction to localized areas of the image.

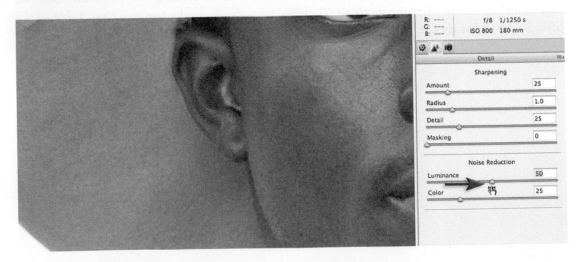

6. Zoom in using the keyboard shortcut Ctrl + Alt + 0 (PC) or Command + Option + 0 (Mac). Raise the Luminance slider to +50. If you raise this slider too far you may remove detail that is important to the sharpness of this image. The Color slider in the Noise Reduction controls can be left at +25 as most of the excessive noise in this file is luminance noise, a result of raising the ISO in-camera and lightening the shadows in ACR.

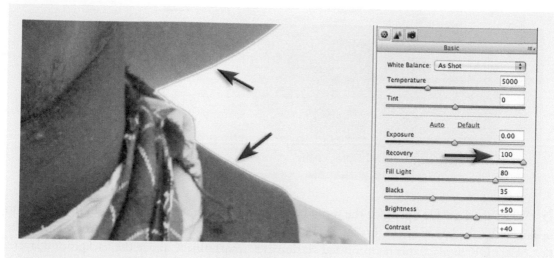

PERFORMANCE TIP

It is possible to recover the highlights that have been clipped in this image in ACR – but at a cost. The over-exposure in the sky can be corrected by raising the Recovery slider, but this causes edge artifacts around your subject due to our work with the Fill Light slider. Raising the Recovery slider will also lower the localized contrast in the rest of the subject, which will make the cowboy appear dull. To avoid these problems we must use a technique that requires using the main editing space of Photoshop. Set the Recovery slider back to zero and then click on the Open Image button.

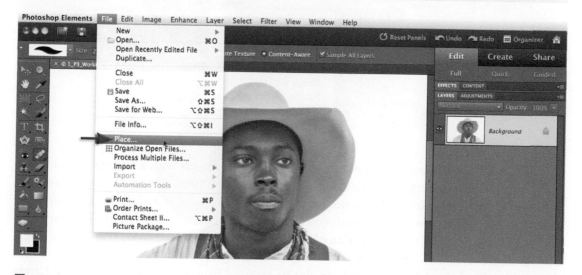

7. When the file opens in the main editing space of Photoshop go to File > Place and then browse to the project Raw file so that we can open it a second time. Zoom out so that you can see all of your image in the image window. Using the Place command instead of the Open command will ensure that the Raw file can be re-optimized for the highlights and placed as a 'Smart Object' above the background layer instead of it opening as a new document.

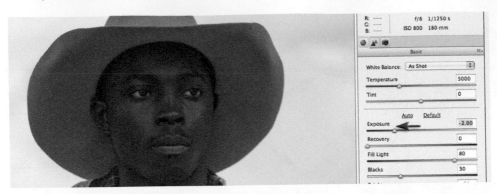

8. When the Raw file opens for the second time it will remember all of the settings you used to optimize the shadow tones of this image. Lower the exposure slider by -2.00 stops to darken the sky. Select OK to place this re-optimized version as a 'smart object' above the background layer.

9. The image that has now been optimized for the sky will appear with a large cross indicating that it can be scaled if required. This layer is called a 'Smart Object' (a special sort of layer that can be edited non-destructively). We need this layer to be the same size as the background layer so we just need to click on the Commit (check mark) icon in the bottom right-hand corner of the image window or hit the Return/Enter key. Right-click on this layer (Mac users with a single button mouse need to Ctrl + Click on the layer) to bring up the context sensitive menu and choose 'Simplify layer' (this command can also be accessed from the fly-out menu in the Layers panel. This will render the smart object layer as a regular layer. Smart Objects in the full version of Photoshop allow the user to double click the layer and reopen the Raw file embedded in the layer into the ACR window. Elements users do not have this luxury but I will be offering a workaround for Elements users later in this tutorial.

10. Switch off the visibility of the top layer. Click on the background layer in the Layers panel to make this the active layer. Select the Quick Selection Tool in the Tools panel and then click and drag over the sky to make a selection.

11. Select the top layer in the Layers panel and switch the visibility of this layer back on. Click on the Add layer mask icon at the base of the Layers panel. The layer mask will now effectively mask the dark cowboy on the top layer to reveal the lighter cowboy on the background layer. The extreme exposure variation between the two layers will, however, create an unsightly hard edge around the subject. By softening the layer mask in the next step we will create a more gradual transition between the two exposures.

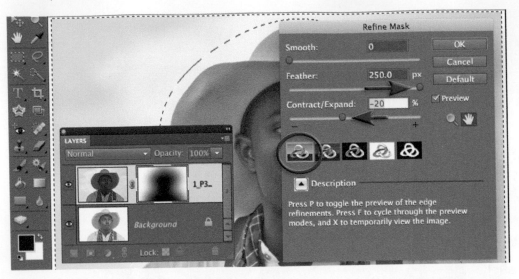

12. We could apply a Gaussian Blur filter to the layer mask to soften the edge of the mask but the Refine Edge feature gives the option of expanding or contracting the mask as well. Click on the layer mask thumbnail to make this the active component of the layer and then go to Select > Refine Edge. Move the Feather slider to its highest setting of 250 px and move the Contract/Expand slider to the left to a value of -20. Select OK to apply the adjustment to the layer mask.

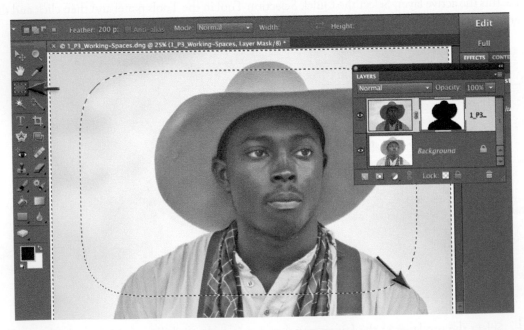

13. Adding a vignette to this image will serve to darken the sky even further. Vignettes cannot be added in the Photoshop Elements version of ACR so this must be done in the main editing space. Select the Rectangular Marquee Tool and enter in a Feather value of 200 px in the Options bar. Select the central portion of the image (the resulting selection will have rounded corners). Go to Select > Inverse so that the edges of the image are now selected.

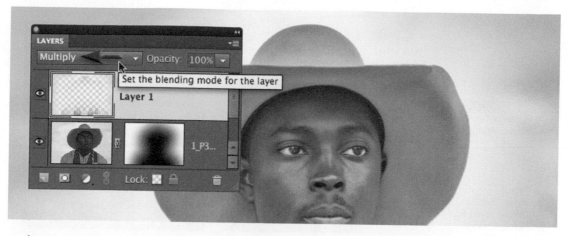

14. Go to Edit > Copy Merged and then again from the Edit menu choose Paste. This action will paste the visible pixels in the selected area (as opposed to the pixels on the active layer) to a new layer. Changing the blend mode of this new layer to Multiply in the Layers panel will darken the edges of the image.

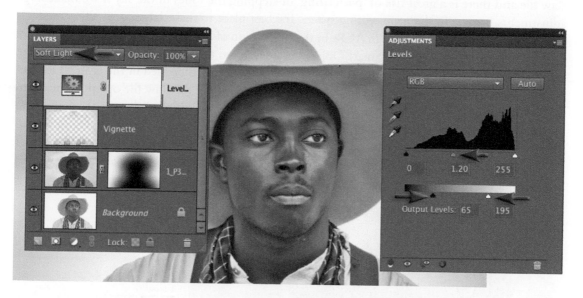

15. To increase contrast in just the midtones of the image (leaving the darkest shadow tones and brightest highlights unaffected) we can add another Levels adjustment layer. Set the mode of this adjustment layer to Soft Light (one of the contrast blend modes). Moving the Output Levels sliders to 65 and 195 will protect the shadows and highlights from contrast that results from the Soft Light blend mode. Move the central gamma slider to control the final brightness of the image.

Note > If the Saturation climbs too high (a result of the increase in contrast) add a Hue/Saturation adjustment layer and drag the Saturation slider to the left slightly.

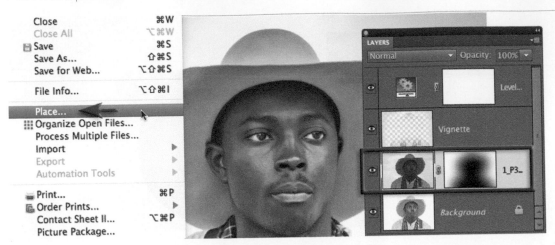

16. Now that the project is nearly complete, I am not happy with the brightness of the sky. I feel it still needs to be darker. I could make the sky layer darker just by applying a Brightness/Contrast adjustment directly to the layer, but this composite file is at a lower bit depth than the original Raw file and there is a great risk of 'posterizing' or stepping the tones in the sky if we make large adjustments to tone in the main editing space. The best place to make large tonal adjustments is not in the main editing space but in ACR. In the full version of Photoshop, Smart Objects (the sky layer in this project used to be a Smart Object before we used the command 'Simplify Layer') are very useful when they are created from Raw files (the Raw file is embedded in the layer). Double-clicking a smart object in the full version of Photoshop results in the Raw file opening back into Adobe Camera Raw. This allows users to re-adjust any of the initial settings so that they are re-optimized for the composite file in the main editing space. This feature has, sadly, been turned off for Elements users. We can, however, still adopt this type of workflow in Elements with just a few inconveniences. Click on the sky layer to select it and then go to File > Place and browse to the original Raw file.

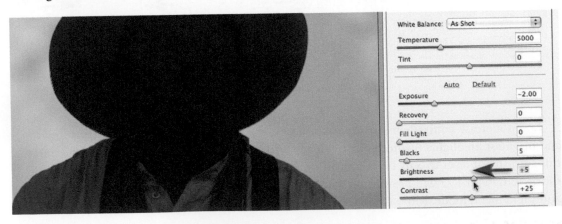

17. When the Raw file opens into ACR the settings will be the same as when you adjusted them for the sky. We are now free to make the sky even darker by lowering the Brightness slider to a value of +5. Select OK to place this file a second time in the composite file.

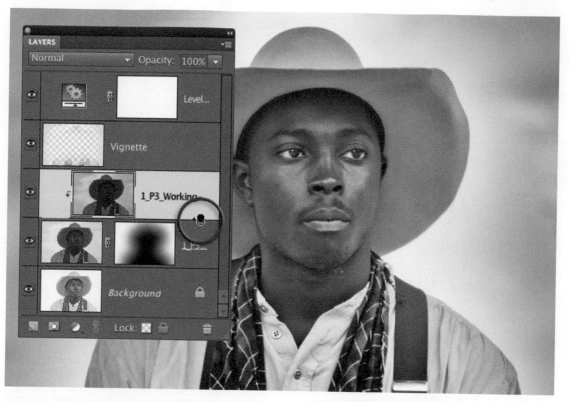

18. Treat this smart object just as we did in Step 9, i.e. click on the Commit icon in the bottom right-hand corner of the image window or hit the Return/Enter key. Right-click on this layer (Mac users with a single button mouse need to Ctrl + Click on the layer) to bring up the context sensitive menu and choose 'Simplify layer'. The sky will now be darkened using the new Brightness settings we applied in the Adobe Camera Raw interface. The mask from the original sky layer has to be transferred to the new layer. Hold down the Alt/Option key and click on the dividing line between the two sky layers to create a clipping mask (this new layer will now use the layer mask on the underlying layer). Alternatively you could hold down the Ctrl key (PC) or Command key (Mac) and click on the layer mask then select the new layer and click on the Add layer mask icon. If you take this alternative approach you could delete the old sky layer by dragging it to the trashcan in the Layers panel. Although not as streamlined as the Full version of Photoshop, this workflow does demonstrate that we can still harness the power of the Adobe Camera Raw interface in a multi-layered file in Photoshop Elements using the Place command.

This tutorial shows us the importance of adopting a workflow that allows us to use the strengths of both the Adobe Camera Raw and the main editing spaces inside of Photoshop Elements.

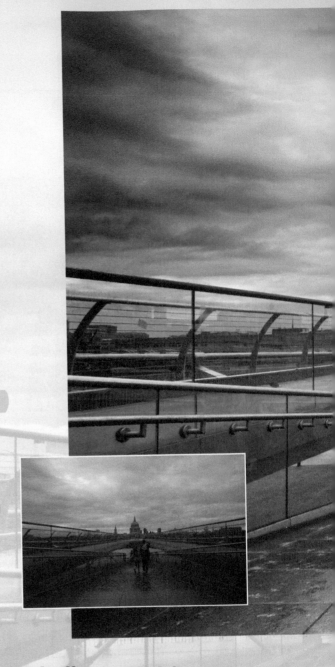

Project 4

Gradients & Vignettes

One of the top ten most powerful editing tools for Photoshop users, that has been around since the dawn of Photoshop time, is the mighty Gradient Tool. This project shows you how you can breathe drama into seemingly lifeless images using some super special tips and techniques, designed to extract the maximum performance from your images.

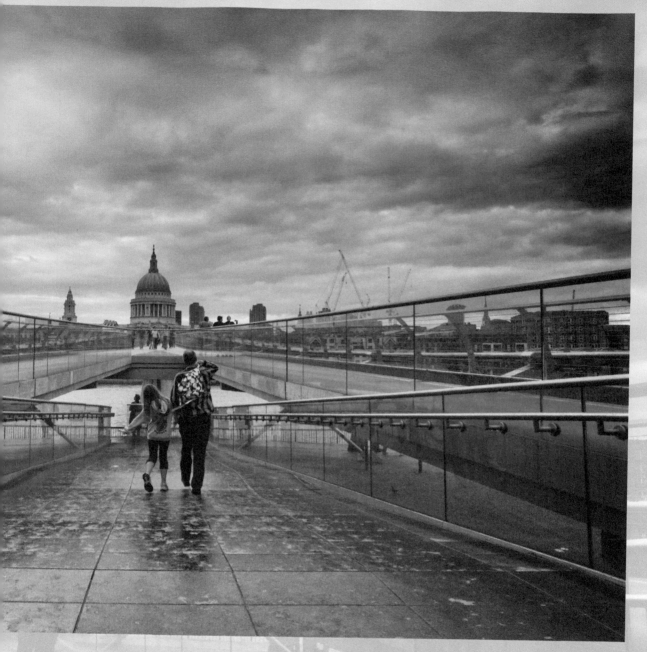

St. Paul's Cathedral from Millennium Bridge, London

This project explores how we can use a gradient in an Adjustment Layer mask to merge the same Raw file processed in two different ways. The project will also utilize a colored gradient applied to two new layers that, in turn, have been set to two different blend modes. The idea is to extract every ounce of life from this underexposed image captured on a gray and wet day in London (nothing new here).

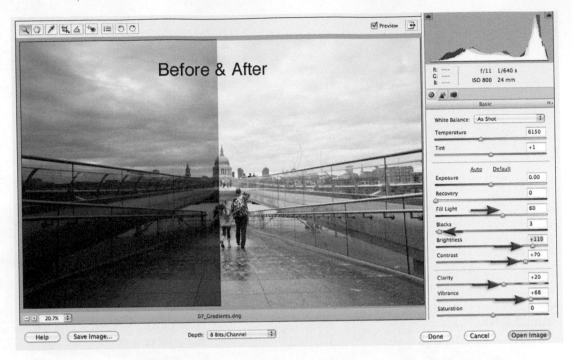

1. Open the Raw file in Adobe Camera Raw (ACR) and then optimize the image for the foreground content. Raise the Fill Light slider to +60, the Brightness slider to +110, the Contrast slider to +70, the Clarity slider to +20 and the Vibrance slider to +68. Lower the Blacks slider to +3.

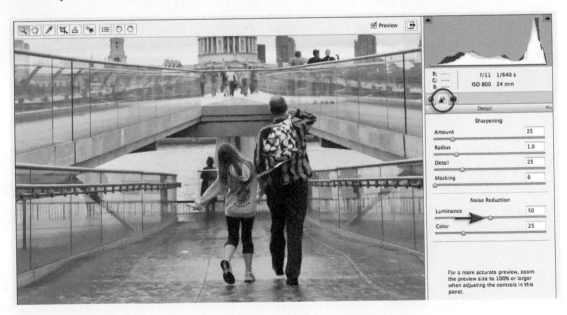

2. Select the Detail tab and raise the Luminance slider in the Noise Reduction section to +50. This will ensure the image is free from excessive noise. Then hit the Open Image button to open this file into the main editing space of Photoshop (got to love ACR for fast editing!).

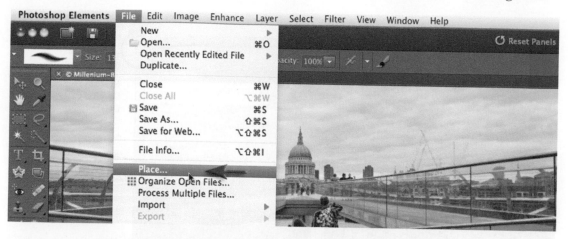

3. When the Image has opened go to File > Place and then browse to the location of the same Raw file you opened in Step 1. Using the Place command instead of the Open command will ensure the Raw file is opened and then placed as a layer above the background layer in your working file.

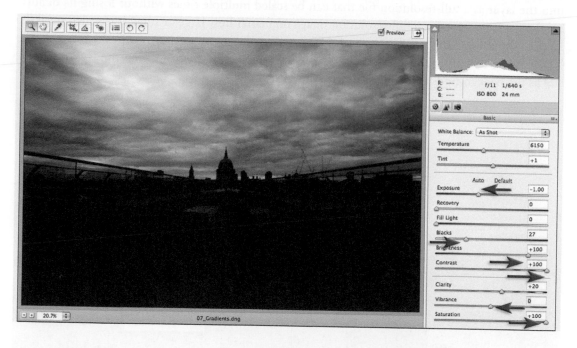

4. When the Raw file opens for the second time you will see all of the settings you used to optimize the image for the foreground. To clear all of these settings click the blue word 'Default'. This will clear all of the settings except for the Clarity, Vibrance and Saturation sliders. Optimize the image for the sky by raising the Blacks slider to +27 and the Brightness and Contrast sliders to +100. Leave the Clarity slider set to +20, but reset the Vibrance slider to 0 by double-clicking the slider and then raise the Saturation slider to +100. Now select the OK button to place this optimized version of the Raw file as a layer above the background layer.

5. The image has been placed as a Smart Object, i.e. not a regular layer. The image is embedded into the layer as a full-resolution file that can be scaled multiple times without losing its quality, i.e. the file is preserved as a full-resolution image no matter how large or small it is scaled until the layer is 'simplified' (this can be very useful for creating photomontages or composite images). The large cross on the image is an invitation to scale this image. We need to keep the layer the same size as the background layer so just hit the commit icon.

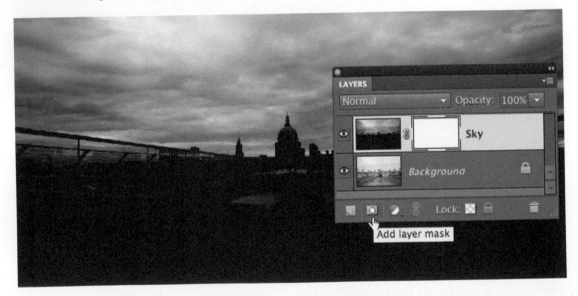

6. We can now start to merge the best of the two exposures using a layer mask to hide the dark foreground information on this top layer. Click on the Add layer mask at the base of the Layers panel. Double-click on the name of this top layer and rename it 'Sky'.

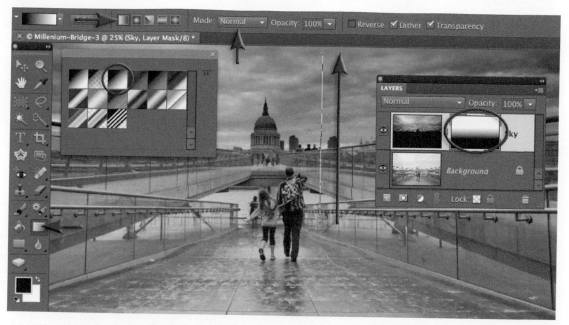

7. Press the G key on your keyboard to select the Gradient Tool. In the Options bar click on the little triangle next to the Gradient ramp to open the gradient picker. Select the third gradient (Black, White gradient). Select the Linear Gradient option to the right of the Edit button and make sure the Mode is set to Normal and the Opacity is set to 100%. Click on the layer mask of the Levels 1 adjustment layer to make this the active component of the layer and then click and drag a gradient from the base of the people's feet to a position just above the top of the spire on St. Paul's cathedral. If the top of the cathedral still appears a little dark after dragging this gradient, drag a second one slightly higher in the sky. If you hold down the Shift key as you drag a gradient it will constrain it so that it is perfectly vertical.

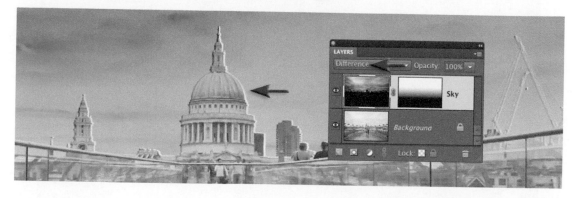

8. To check that we have perfect alignment between these two layers set the mode of the top layer to Difference. Zoom in so that you can see the edge detail along the skyline. If there are white lines visible around the edges select the Move tool from the Tools panel and then use the keyboard arrow keys to nudge the two layers into alignment. Set the mode of the layer back to Normal when you have finished.

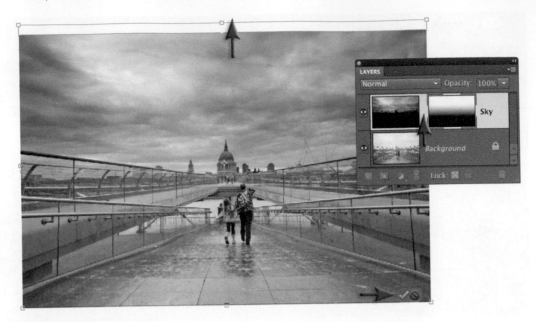

9. The transition between the two layers can be controlled using the Free transform command. Click on the link between the image thumbnail and the layer mask so that we can modify the gradient in the mask without affecting the image on this layer. Go to Image > Transform > Free transform. Drag the top handle of the Transform bounding box up to raise the gradient and brighten the skyline area if required. Commit the transformation by clicking on the check mark.

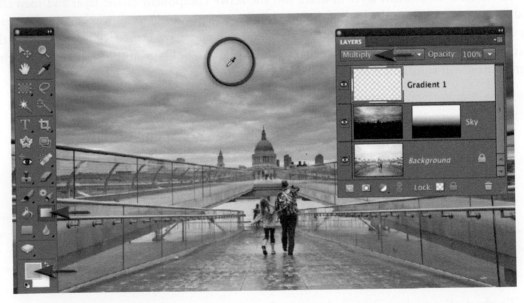

10. We will now increase the drama in the sky be adding a colored gradient. Click on the Create a new layer icon to add an empty new layer. Set the mode to Multiply (one of the darkening blend modes) in the Layers panel. With the Gradient Tool still selected hold down the Alt key (PC) or Option key (Mac) and click on the orange color in the sky to load this as the foreground color.

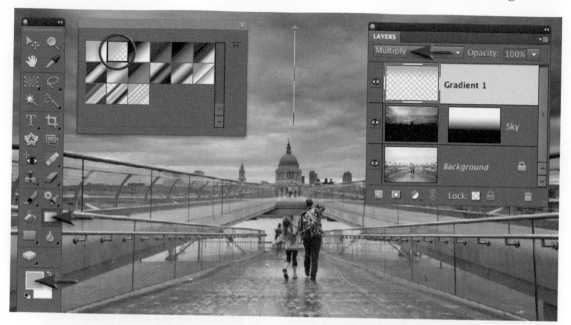

11. Select the second gradient (the Foreground to Transparent gradient) in the gradient picker. While holding down the Shift key, drag a gradient from the top of the image window to a position just above the spire on St. Paul's cathedral. This will enhance the warm colors that are already an important aspect in this dramatic sky.

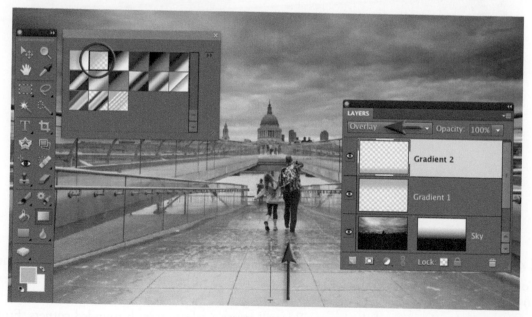

12. Add another new layer (click on the Create a new layer icon in the Layers panel) and set the mode to Overlay (one of the contrast blend modes). While holding down the Shift key drag a gradient from the base of the image window to a position just higher than the feet of the people in the center of the image. This will mirror the warm colors that are in the sky in the wet paving.

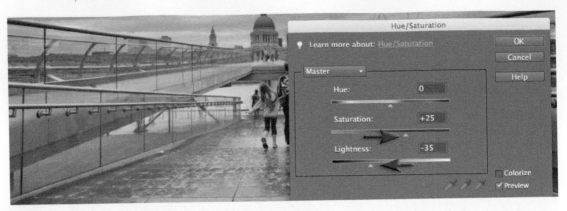

13. To modify how this gradient interacts with the underlying color go to Enhance > Adjust Color > Adjust Hue/Saturation. Drag the Lightness slider to the left and the Saturation slider to the right to increase the drama of this gradient.

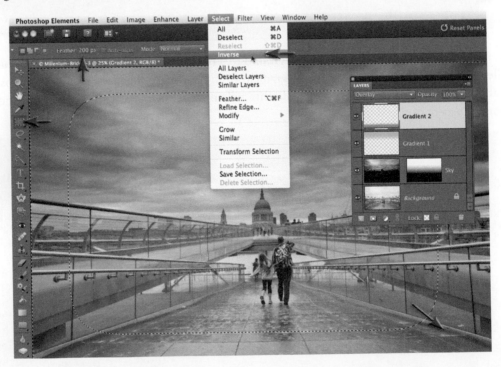

14. We will complete the project by adding a contrast vignette. Select the Rectangular Marquee Tool from the Tools panel and set a Feather value of 250 px in the Options bar. Click and drag 10% in from the top left-hand corner of the image to a position just short of 10% from the bottom right-hand corner of the image. This will create a selection with rounded corners. From the Select menu choose 'Inverse'. We will now copy the visible pixels (rather than the pixels on a single layer) by going to Edit > Copy Merged. Again from the Edit menu choose Paste. This will paste the pixels from the clipboard onto a new layer. There will be no visible change in the image window at this point until we change the blend mode of the layer.

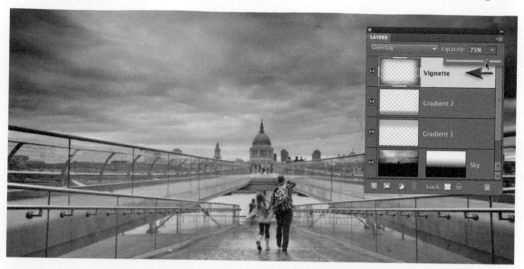

15. It is common to use either the Multiply or Screen blend modes when creating a vignette in this manner (to darken or lighten the edges of the image), but with this project we will use the Overlay blend mode instead to increase contrast and color saturation at the edges of the image. If you find the color is a little excessive, you have the choice to either lower the opacity of the layer or change the blend mode to Soft Light.

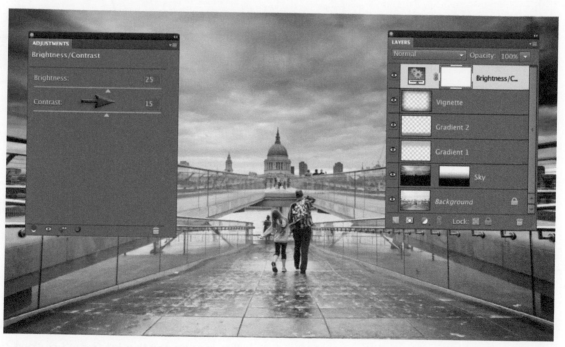

16. To complete the project we will give the tonality a little bit of a lift courtesy of a Brightness/Contrast adjustment layer. Raise the Brightness to a value of +25 and the Contrast to a value of +15. Hold down the Alt key (PC) or Option key (Mac) and click on the visibility icon (the eye) on the background layer so that you can see just how far we have come.

Project 5

Preparing for Print

Setting the levels in a digital image is only the first step to achieving optimized images. It is also necessary to optimize the image for the intended output device. To achieve optimum tonal quality in your digital images it is important to target both the highlight and shadow tones within each image. When using Photoshop Elements, the Eyedropper tool is a key to unlocking the quality that lies dormant in any one of your images which has been correctly exposed.

What you see is not always what you get – target your levels to your output device for predictable results

To achieve maximum quality, set the target levels in images that are in 16 Bits/Channel mode (accessed through the Camera Raw format or via 48-bit output scans from film). If you are optimizing your files in 8 Bits/Channel mode (via JPEG files) be sure to use an adjustment layer rather than an adjustment from the Enhance menu.

Ansel Adams was responsible for creating the famous/infamous 'Zone System' in order to precisely control the tonal range of each of his masterpieces. If you look carefully at one of his beautiful landscape photographs you will notice that only the light source (or its reflection – something termed a 'specular highlight') appears as paper white. All the rest of the bright highlights reveal tone or texture. Likewise, the shadows may appear very dark, but they are not devoid of detail. Ansel was careful only to render holes as black (the absence of a surface). Any surface, even those in shadow, would render glorious amounts of subtle detail.

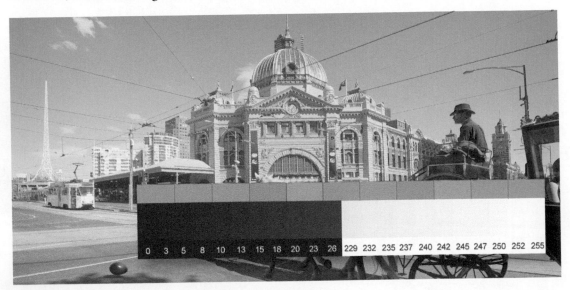

Even though you may have set a black and a white point in Adobe Camera Raw (ACR), there is no guarantee that your shadow or highlight tones will be visible in the final print. To make sure the highlight detail does not 'blow out' (become white) and the shadow detail is not lost in a sea of black ink, it is possible to target the highlights and shadows in your image to the brightest and darkest tones that the printer can reproduce. The default settings of the eyedroppers to be found in the Levels dialog are 0 (black) and 255 (white). These settings are only useful for targeting the white overexposed areas or black underexposed areas; they can, however, be recalibrated to something much more useful, i.e. tones with detail. A typical photo quality inkjet printer printing on premium-grade photo paper will usually render detail between the levels 18 and 250. Precise values can be gained by printing a 'step wedge' of specific tones to evaluate the darkest tone that is not black and the brightest tone that is not paper white.

PERFORMANCE TIP

The precise target values for images destined for the commercial printing industry are dependent on the inks, papers and processes in use. Images are sometimes optimized for press by skilled operatives during the conversion to CMYK and sometimes they are not. If in doubt you should check with the publication to get an idea of what you are expected to do and what you should be aiming for if the responsibility is yours.

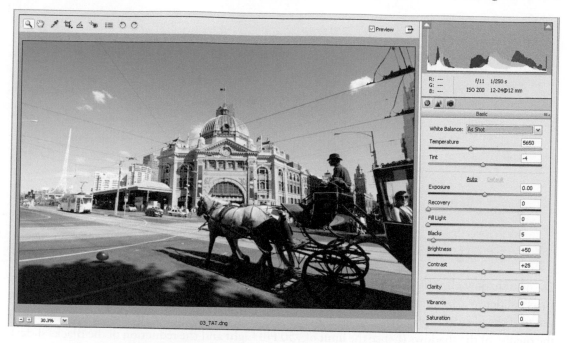

1. Before we can set appropriate Shadow and Highlight values for the printer we must first optimize our file in ACR. The high-contrast project image shows that both the Shadow and Highlight values are 'clipped'. The darkest shadows are absolute black (level 0) and the brightest highlights are absolute white (level 255). Our first aim is to recover more appropriate black and white points and thereby attempt to recover lost detail in the shadows and highlights.

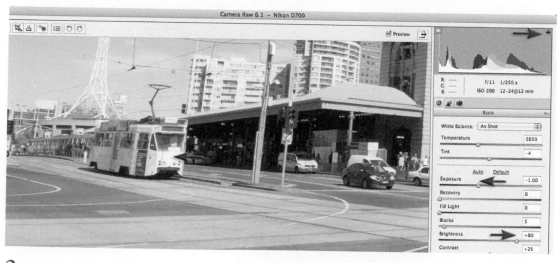

2. Click on the highlight clipping warning above the right-hand side of the histogram to locate the clipped highlights. Note how some of the clipping is due to saturated colors rather than overly bright highlights. Zoom in to 100% and focus your attention on the front of the tram (the brightest highlight in the image). Drag the Exposure slider to the left until the clipping has disappeared (approximately -1 stop) and then raise the Brightness slider to +80.

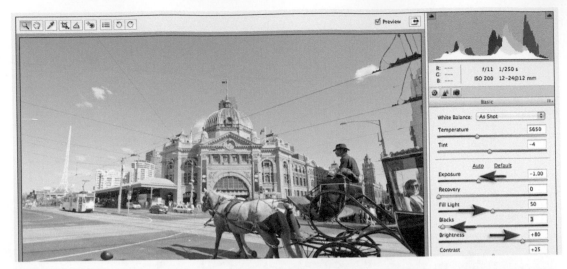

3. The shadow clipping can be removed by raising the Fill Light slider to +50 and lowering the Blacks slider to +3. Normally I would try to recover any shadow clipping using only the Fill Light slider (if the file was captured at low ISO) but raising the Fill Light slider too high can compromise the quality of the shadows (hence the limit of +50 Fill Light and the reduction of the Blacks slider).

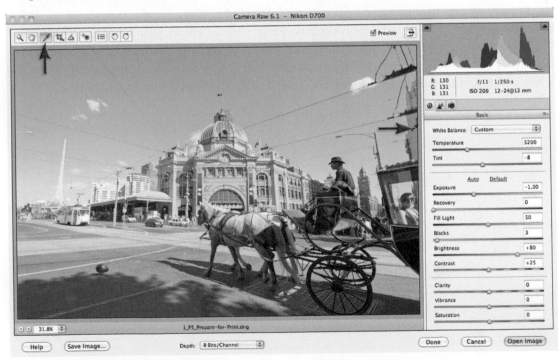

4. The Auto White Balance setting in-camera has rendered this file a little too warm. Assign a new white balance by selecting the White Balance tool at the top of the ACR dialog. Click to activate the tool and then click on something that should have a neutral tone in the image preview. I have selected the side of the building on the extreme right-hand side of the image (close to equal RGB values).

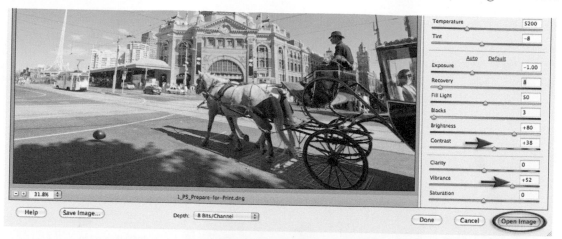

5. The Contrast and Vibrance sliders have both been raised to give the image a summer feeling. If you notice the highlight clipping triangle above the histogram turns red you may need to fine-tune the Exposure slider. If there is luminance clipping (a loss of detail in all three channels) the highlight clipping warning triangle will turn white indicating a more serious problem. Now that the image has been optimized in ACR we can choose Open Image in the bottom right-hand corner of the dialog so that we can complete the editing process in the main Edit space of Photoshop Elements.

Note > Prior to opening this file in Adobe Camera Raw I have set the Color Settings in the Edit workspace to Always Optimize for Print so that I can preview the colors in the larger Adobe RGB gamut.

6. We will adjust the converging verticals of the image after first duplicating the layer. Either drag the background layer to the Create a new layer icon in the Layers panel or use the keyboard shortcut Ctrl + J (PC) or Command + J (Mac). Go to Filter Correct Camera Distortion to start the process of correcting the converging verticals.

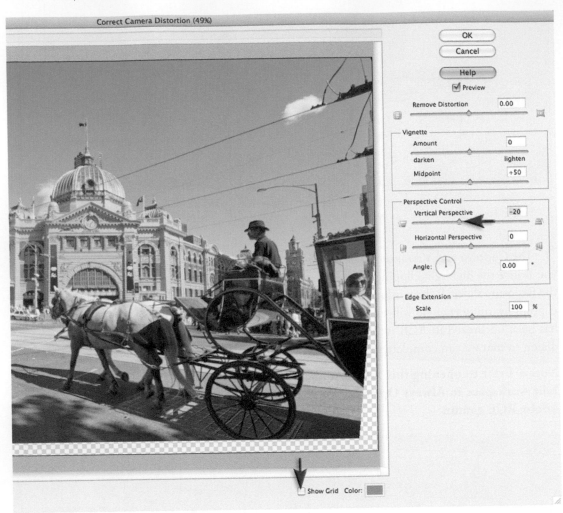

7. When a camera is tilted up or down with a short focal length lens (wide angle) the verticals within the image can lean excessively inwards or outwards (converging verticals). Professional architectural photographers use cameras with movements or special lenses to remove this excessive distortion. Use the Correct Camera Distortion filter to correct perspective. The process of correcting the verticals in an image is often referred to as 'keystoning'. The top slider in this dialog corrects either barrel distortion or pincushion distortion, which sometimes result when using the extreme focal lengths of the zoom lens. Both result in curved straight lines which are usually most noticeable with the curvature of a horizon line when using a short focal length (wide angle) lens. In this image we just need to move the Vertical Perspective slider to a value of -20 so that the buildings are not leaning inwards so much. You will notice that the image gets smaller at the bottom of the dialog and transparency appears around the image. Uncheck the Show Grid option to get a clearer preview.

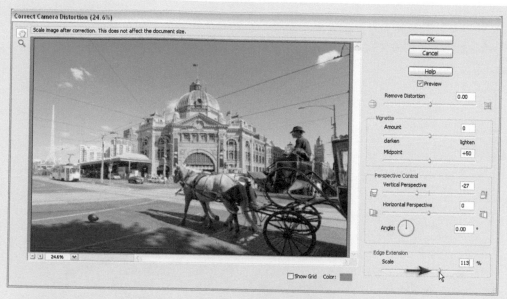

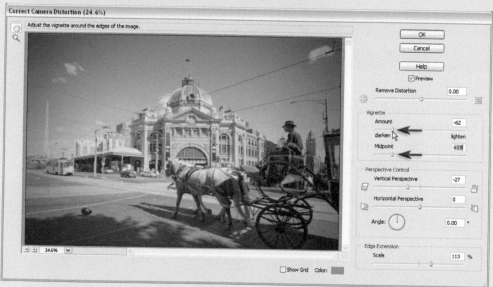

PERFORMANCE TIP

It is possible to remove transparency in the Correct Camera Distortion dialog by increasing the scale of the image. This will, however, result in 'bicubic interpolation', i.e. Photoshop Elements will add new pixels to grow the image. A small amount of scaling will probably go unnoticed but it is actually kinder to the file to first select OK and then crop the transparency away using the Crop tool in the main Edit space. This may, however, not be an option if you first cropped the image to your output size in ACR. It is also possible to either correct lens vignetting (images where the corners appear darker or lighter than the rest of the image) or add creative vignettes for effect in the Correct Camera Distortion dialog. There is a more effective way of darkening the corners of an image for effect that is outlined in the following steps.

8. Select the Crop tool in the Tools panel and then click and drag over the image to select the area to be cropped. While still holding down the mouse button, press and hold the spacebar as well in order to float the crop bounding box so that you can move it into position. Press the Return/Enter key to commit the crop.

9. Open the Layers flyout menu and choose Flatten Image. If the visibility of the other layers is still turned off you will see a warning dialog that asks you if you want to 'Discard hidden layers'. Select Yes and the other layers will be removed from the file.

10. Before we start to locate and adjust the shadow and highlight tones within this image we should optimize the performance of the Eyedropper tool in the tools panel and the second readout values in the Info panel. Select the Eyedropper tool in the Tools panel and in the Options bar set the Sample Size to a 5 by 5 average. This will give us a much more representative sample of the area we are monitoring than a single pixel from that area. From the Window menu choose Info to open the Info panel. Click on the second mini eyedropper in the Info panel to access the sample options. Choose HSB so that we can monitor the brightness of the shadows and highlights rather than the RGB levels.

11. In this step we will locate the darkest area of the image that has shadow detail. Select Levels from the Create a new fill or adjustment layer drop-down menu. Double-click on the Set Black Point eyedropper in the Levels dialog to open the Select target shadow color dialog. Enter a value of 8% into the 'B' field (the actual value depends on the shadow performance of your printer). Select OK and then Yes when you see the 'Save the new target colors as defaults?' dialog.

12. With the Black eyedropper still selected, hold down the Alt/Option key and drag the shadow slider to the right slightly. The image will now appear in threshold view. Only the shadows that are clipping will be visible against a white background. Locate an area of black rather than a color and zoom in on this region until you are at 100%, or Actual Pixels (Ctrl/Command + Spacebar will access the Zoom tool). Hold down the Alt/Option key and move your cursor into the image preview and click on this region (you will be able to see the Threshold view when you move into the image preview).

13. Clicking on this darkest area of the image will render your shadow detail lighter so that it will not appear as absolute black in the final print. If you observe the readout in the Info panel you will see before and after sets of numbers. As you move your mouse cursor over the darkest shadow again you will notice that the darkest tones now read the 7 or 8% Brightness value that you assigned to them.

14. In this step we will locate the lightest area of the image in which we want to see highlight detail in the print. Double-click the Set White Point eyedropper to display the Select target highlight color dialog. This time enter a value of 98 in the Brightness field and select OK. Choose Yes when the info dialog appears asking you if you want to 'Save the new target colors as defaults?'.

Note > Most printers are much better at handling bright highlight detail than they are at rendering good shadow detail.

15. Hold down the Alt/Option key and drag the white Input slider (underneath the histogram) in the Levels dialog to the left so that you can see the highlights clipping in the Threshold view. You will notice that the front of the tram is the brightest part of this image. Zoom in to 100% (Actual Pixels) to take a closer look at this area of the image.

16. Hold down the Alt/Option key, move your mouse cursor into the image preview and click on this clipped tone. When you click you will see the clipping disappear. The highlight tones will be made a little less bright so that they conform to the values you set in the Color Picker.

17. If you notice that a color cast has been introduced by setting new Shadow and Highlight values, select the Set Gray Point eyedropper (between the Black and White eyedroppers) and then click on the building you first clicked on in ACR to reestablish the correct white balance. The neutral tone selected to be the 'Gray Point' can be a dark or light tone within the image.

Note > If you look at the individual Red, Green and Blue channels in the Levels dialog, you will be able to see how the shadows and highlights have been optimized for the printer targets. The Output values have been increased to encourage either more or less ink to be applied to highlights or shadows so that they are information-rich in print and not clipped by excessive contrast.

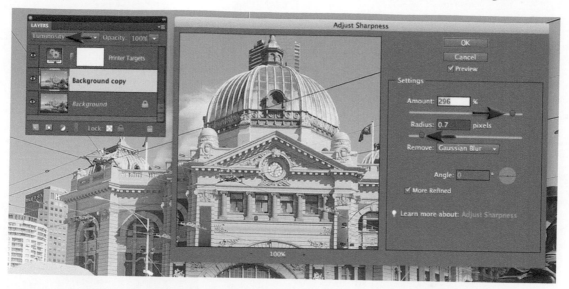

18. Before printing any file it is advisable to sharpen a duplicate of the background layer. Printed images always look a little softer than the screen files they were printed from. This type of sharpening is called Output sharpening. Set the mode of this duplicate layer to Luminosity in the Layers panel. From the Enhance menu choose Adjust Sharpness. I typically use a high Amount (between 100 and 300%) and a low Radius setting (between 0.5 and 1.0 pixel) for print images.

Note > Sharpening on a separate layer gives the flexibility to adjust the opacity of the Sharpening layer and thereby adjust the sharpening of the file to suit the printer and paper we are printing to, i.e. there will be no need to go back to an unsharpened file and repeat the sharpening process.

Project 6

Curves

One of the most important image adjustment features in a professional photographer's workflow is Curves (a sort of Levels command on steroids). Adobe, in their wisdom, decided to include this feature in Photoshop Elements 5.0. Color Curves now makes a welcome appearance in the Enhance menu but it is still not available as an adjustment layer. This project shows you several ways to control contrast using adjustment layers to increase your post-production editing power to maximum performance.

Create dramatic images by building in some non-destructive contrast

The revised Brightness/Contrast adjustment feature

If you have been image editing for some time you will know that 'Levels' has always been a superior option for enhancing the brightness and contrast of your image to the Brightness/Contrast feature. Adjusting the brightness or contrast of an image using the Brightness/Contrast adjustment used to be very destructive. For example if you wanted to make the shadows brighter and elected to use the Brightness/Contrast control, all of the pixels in the image were made brighter (not just the shadows), causing the pixels that were already bright to fall off the end of the histogram and lose their detail or become white (level 255). The Brightness/Contrast adjustment feature was fully revised with version 7 so that its behavior now falls in line with the non-destructive nature of the Brightness and Contrast sliders in Adobe Camera Raw (ACR).

Using the Brightness slider is now like moving the center (Gamma) slider in the Levels adjustment feature, i.e. the image is made brighter whilst preserving the black and white points within the image. The Contrast slider, on the other hand, makes the shadows darker and the highlights brighter but not at the expense of the black and white points of the image. The only problem with the Brightness/Contrast adjustment feature is that it cannot focus its attention on a limited range of tones, e.g. make the shadows darker or lighter but leave the midtones and highlights as they are.

The Curves adjustment feature as seen in the full version of Photoshop

The Curves adjustment feature allows the user to target tones within the image and move them independently, e.g. the user can decide to make only the darker tones lighter whilst preserving the value of both the midtones and the highlights. It is also possible to move the shadows in one direction and the highlights in another. In this way the midtone contrast of the image can be increased with a great deal more control than the new Brightness/Contrast adjustment feature.

Resolving the problem

Now there are three ways to enable you to harness the power of Curves in Adobe Photoshop
Elements 9.

Method 1 – Color Curves

Adjust Color Curves is a user-friendly version of the Curves adjustment feature found in the full
version of Photoshop and can be accessed from the Enhance menu (Enhance > Adjust Color >
Adjust Color Curves). The user should first set the levels of the image file by using the techniques
outlined in Projects 1 and 2. Unfortunately, Adjust Color Curves is not available as an adjustment
layer so it would be advisable to first duplicate the background layer and then apply the changes to
this duplicate layer. Select the Default style and then move the sliders to fine-tune the tonality of
your image or choose one of style options. It may be necessary to add a Hue/Saturation adjustment
layer to modify any changes in the color saturation that may have occurred as a result of the Color
Curves adjustment.

Accessing curves as an adjustment layer

The second way of using curves, this time as an adjustment layer, is a bit cheeky and is possible if you have access to a multilayered file created in the full version of Photoshop (the file below is included in the resources for this project that can be downloaded from the supporting website).

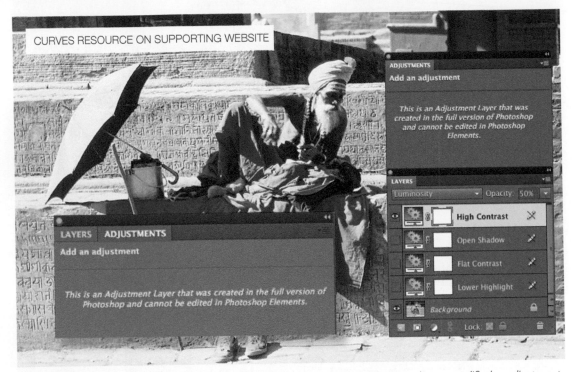

A Photoshop file opened in Elements will allow the user limited functionality to modify the adjustments

Method 2 – Grand theft

One of the great mysteries of life is that although you can't create a Curves adjustment layer in Photoshop Elements you can open an image that already has one. Photoshop Elements allows you to see the effects of the Curves adjustment layer (that was created in the full version of Photoshop), to switch it off and on, and to lower the opacity of the Curves adjustment layer (enabling you to lower the effect of the adjustment layer gradually). You can also drag this Curves adjustment layer into any other image file that is open in Elements (just click on the adjustment layer thumbnail in the Layers panel and drag it into another image window). Theoretically this means that, if you had a single file that was created in Photoshop with a wide range of Curves adjustment layers to suit your everyday image-editing tasks, you could use this as a 'Curves resource' – just drag, drop and adjust the opacity to suit the needs of each image you are editing. The sort of adjustment layers that would be particularly useful would be those that enabled the Photoshop Elements user to increase and decrease image contrast, raise or lower shadow brightness independently, and raise or lower highlight brightness independently. If the adjustment layers contained generous adjustments they could be simply tailored to suit each new image-editing task by just lowering or increasing the layer opacity. The adjustment layers are resolution-independent, which is another way of saying that they will fit any image, big or small – naughty but very nice!

Method 3 – Gradients

The third version is for users of Photoshop Elements who want a little more control, have a guilty conscience or prefer to explore the advanced features of the package they have purchased rather than the one they have not. This method allows you to access the ultimate tonal control that Curves has to offer using a different adjustment feature not really designed for the job but which, when push comes to shove, can be adapted to fit the needs of the cash-strapped image editor seeking quality and control.

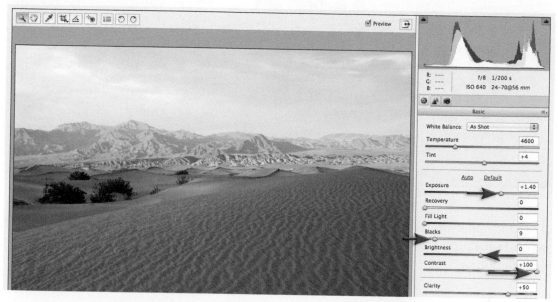

1. The image used in this project is the one used in Project 1 to demonstrate how we can correct a low contrast image in Adobe Camera Raw. The maximum amount of contrast has been applied. Although the image is vastly improved from the unprocessed version the contrast in the foreground sand dune is still relatively low when compared to the contrast of the distant dunes. Open the image into the main Edit space of Photoshop Elements after applying these settings.

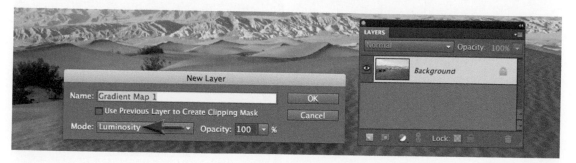

2. Set the Foreground and Background colors to the Default setting in the Tools panel (press the letter D on the keyboard). Hold down the Alt/Option key while selecting the Gradient Map adjustment layer from the Create Adjustment Layer menu in the Layers panel. This will open the New Layer dialog box. Select Luminosity from the Mode menu and click OK.

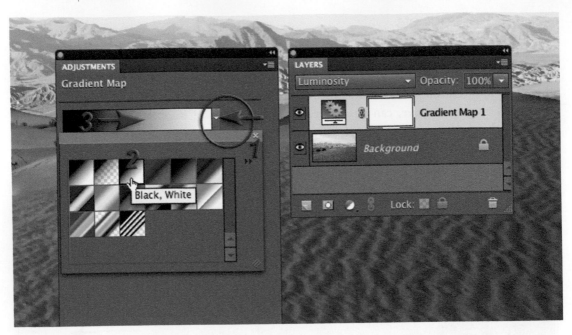

3. In the Adjustments panel click to open the drop-down menu and then select the third gradient swatch in the presets menu (Black, White). Click on the gradient above the presets to open the Gradient Editor.

4. Move the cursor to just below the gray ramp and click to add a 'stop' slightly left of center. Type in 25% as the location and click on the color swatch to open the Color Picker.

5. Choose a Brightness value of 25% and click OK (ensure a value of 0 is entered in the other two fields of the HSB radio buttons). Add another stop right of center (at a location of approximately 75%) and again click on the color swatch to open the Color Picker. This time choose a Brightness value of 75% and again click OK.

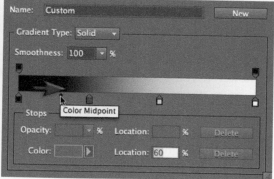

6. The Black/White gradient map in Luminosity mode will leave the existing tonal values of your image the same as before. The magic starts when you start to drag the stops you created to new positions on the gray ramp. Moving the two sliders further apart will lower the contrast whilst dragging them closer together will increase it. A 'color midpoint' also appears between the two stops that you are adjusting to allow you to fine-tune your adjustment. In this project we will concentrate our attention of the foreground sand dune (do not worry if the sky and distant sand dunes becomes too bright at this stage). Drag the shadow slider to a position of 30% and the highlight slider to a position of 50% to increase the contrast. Move the color midpoint to fine-tune the shadow contrast. Be amazed – you are exercising absolute control over the brightness values of your image! This technique allows all of the versatility of a Curves adjustment layer when editing the luminosity of your image.

The Gradient Map adjustment layer set to Luminosity mode acts like a 'hot-wired' Levels adjustment layer. Its advantage is that you can set as many stops or sliders as you like, giving you total control. Any localized areas that require further attention can simply be masked on the adjacent layer mask and tackled separately on a second Gradient Map layer.

Note > If you have a selection active when you choose the Gradient Map adjustment layer, it automatically translates the selection into a layer mask, restricting any adjustments to the selected area.

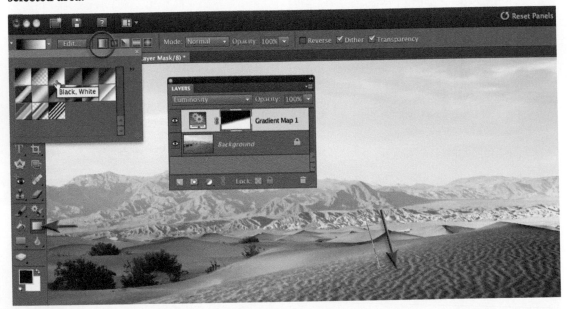

7. If you are looking to achieve a simple global contrast adjustment the project is complete. If, however, you want to enhance the image further using more gradients, try the following techniques. Select the Gradient Map adjustment layer and choose the Gradient tool from the Tools panel (or type the letter G on the keyboard). Choose the Black/White and Linear options and then drag a gradient from just below the distant sand dunes to a position just above the sand dune in the foreground. This will shield the sky and distant dunes from the contrast adjustment applied by the Gradient Map adjustment layer.

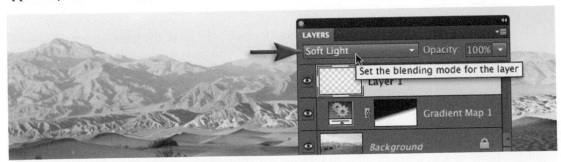

8. We will now balance the tonality in the image by darkening the sky. Click on the Create a New Layer icon in the Layers panel and set the blending mode of this new layer to Soft Light.

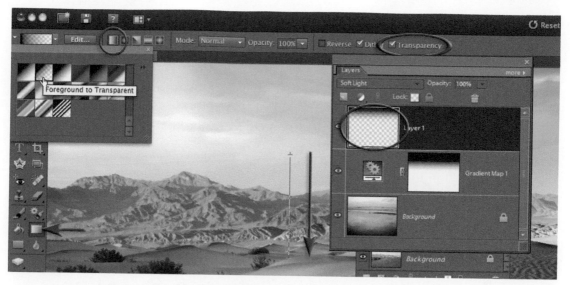

9. Ensure that black is the foreground default color (type the letter D on the keyboard) and then choose the Foreground to Transparent gradient. Drag a gradient from the top of the image to a position just below the distant dunes. Holding down the Shift key as you drag a gradient will 'constrain' the gradient to ensure that it is absolutely straight. Try changing the blend mode of this gradient layer to Overlay and Multiply to see the variations of tonality that can be achieved.

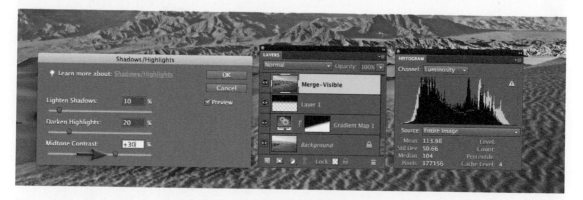

10. Yet another way of targeting tones for adjustment is using the Shadows/Highlights adjustment feature. This very useful adjustment feature is not available as an adjustment layer so you will need to create a 'composite' layer of the work carried out so far before you can apply it, by using the Merge Visible technique. Select the top layer in the Layers panel and then hold down the Shift + Alt + Ctrl keys (PC) or Shift + Option + Command keys (Mac) whilst you type the letter E on the keyboard. The new layer should appear on top of the layers stack. Double-click the name of the layer to rename it 'Stamp Visible'. Now choose Shadows/Highlights from the Enhance > Adjust Lighting submenu. Set the Lighten Shadows and Darken Highlights sliders to 0 and raise the Midtone Contrast to +30. You can watch the effects of raising this slider by clicking on the Preview box and by viewing the histogram in the Histogram panel.

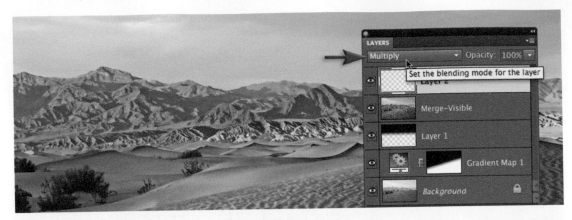

11. Create another new layer and this time set the blend mode to Multiply. As with the previous gradient you can experiment with alternative blend modes after you have finished creating this second gradient.

Note > You can also set the blend mode for a new layer in the New Layer dialog box.

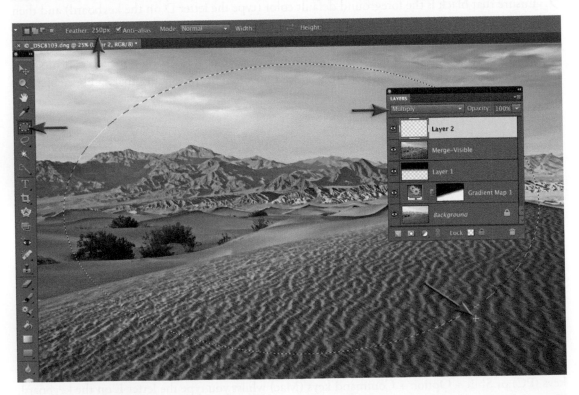

12. Choose the Elliptical Marquee tool from the Tools panel and choose a large amount of feather (increase the amount of feather as the resolution of the file gets bigger). Draw an elliptical selection in the image window.

Note > You can check how soft this edge is by using the Selection Brush tool. Choose Mask from the Mode drop-down menu in the Options bar.

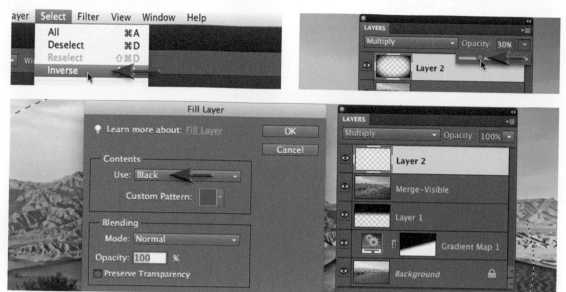

13. From the Select menu choose Inverse (Shift + Ctrl/Command + I) and then from the Edit menu choose the command Fill Selection. From the Contents section of the dialog box choose Foreground Color. Move the mouse cursor into the image, choose a deep blue color from the image window and then click OK. Lower the opacity of the layer until the vignette is subtle.

14. To warm the foreground sand dune, click on the Create a New layer icon in the Layers panel and set the mode to Color. Select the Brush Tool in the Tools panel and sample a color from one of the warm sand dunes (hold down the Alt/Option key as you click on the dune to sample the color). Adjust the Opacity of the Brush in the Options bar to 20% and then paint over the dune with a large brush with the hardness set to 0%. Hold down the Alt/Option key as you click on the visibility icon of the Background layer in the Layers panel to see just how far you have come. Save the final image as a Photoshop file with all of its layers as we can use this as a starting point for the Black and White project.

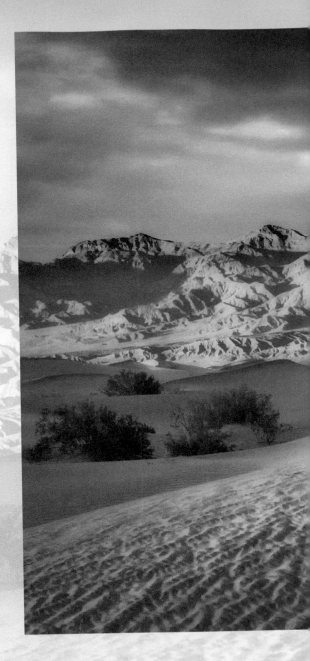

Project 7

Black & White

When color film arrived over half a century ago, the pundits who presumed that black and white images would die a quick death were surprisingly mistaken. Color is all very nice but sometimes the rich tonal qualities that we can see in the work of the black-and-white photographic artists are something to be savored. Can you imagine an Ansel Adams masterpiece in color? If you can – read no further

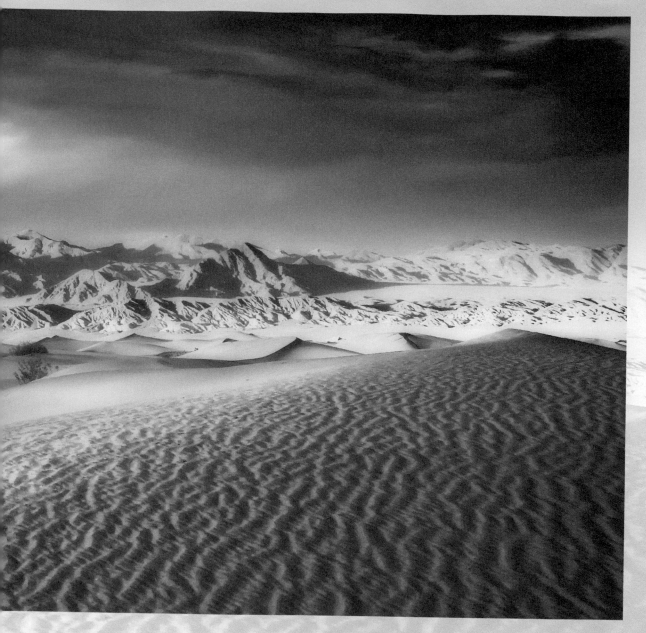

Create dramatic black and white images from your optimized color images

The original color image and the result of choosing the less-than-satisfactory Remove Color command

The conversion from color to black and white

The creation of dramatic black and white photographs from your color images is a little more complicated than simply converting your image to Grayscale mode or choosing the Desaturate command. Ask any professional photographer who is skilled in the art of black and white and you will discover that crafting tonally rich images requires a little knowledge about how different color filters affect the resulting tonality of a black and white image.

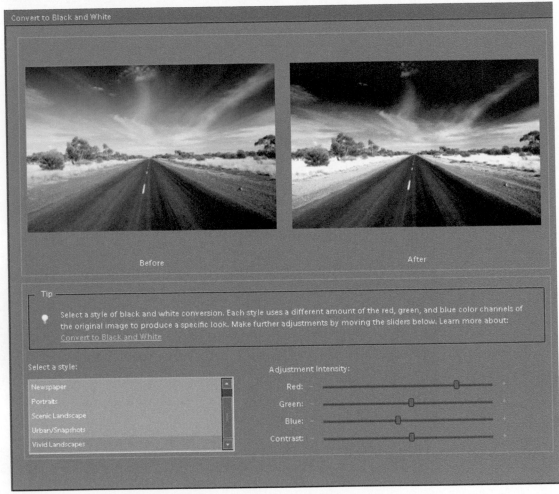

Convert to Black and White allows you to mix the tonal differences present in the color channels. Simply select a style and then adjust the Intensity sliders to create your own custom conversion

As strange as it may seem, screwing on a color filter for capturing images on black and white film has traditionally been an essential ingredient of the recipe for success. The most popular color filter in the black and white photographer's kit bag, which is used for the most dramatic effect, is the red filter. The effect of the red filter is to lighten all things that are red and darken all things that are not red in the original scene. The result is a print with considerable tonal differences compared to an image shot without a filter. Is this a big deal? Well, yes it is – blue skies are darkened and skin blemishes are lightened. That's a winning combination for most landscape and portrait photographers wanting to create black and white masterpieces.

PERFORMANCE TIP

The Maximum Performance actions on the supporting website include a series of automated black and white conversions. The Black&White_Luminosity action creates a single monochrome layer containing the luminosity values of the RGB file. The Red, Green and Blue Channel actions allow you to place one of the three color channels as a black and white layer. These actions would also be useful for accessing the best contrast in order to create a mask, as in the 'Depth of Field' project.

In the image to the left the Red channel was used as this offered the best detail in the dark skin tones. The contrast was then increased by duplicating the layer and switching the blend mode to Soft Light. The opacity of this duplicate layer was then dropped to 30%. A vignette was added to complete the project

The Convert to Black and White command (Enhance > Convert to Black and White) allows the user to selectively mix the differences in tonality present in the three color channels, but unfortunately it is not available as an adjustment layer. This means we are unable to make use of the layer mask that typically comes with an adjustment layer. It also means that we would be unable to modify the color conversion at a later date without returning to the original color file. This approach to the conversion (although vastly superior to anything present in previous versions of the software) limits the usefulness of the technique for those users who wish to extract the maximum amount of control and flexibility out of the process of black and white conversion. The famous digital guru, Russell Preston Brown, came up with a workaround that enables us to retain complete control over black and white conversion using multiple adjustment layers.

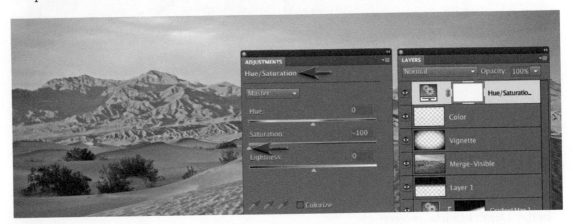

1. This project is an extension of the Curves project so open the Photoshop file that saved. Click on the Create new fill or adjustment layer icon and create a Hue/Saturation adjustment layer. Move the Saturation slider all the way to the left (−100) to desaturate the image. The image will now appear as if you had performed a simple Convert to Grayscale or Desaturate (remove color) command. Although the image looked great in color the Black and White version appears a little flat and uninspiring.

2. There are a couple of layers that we do not require for a the black and white version. Drag the Merge Visible and the Color layer to the trash can in the Layers panel or right-click on each layer and select Delete Layer.

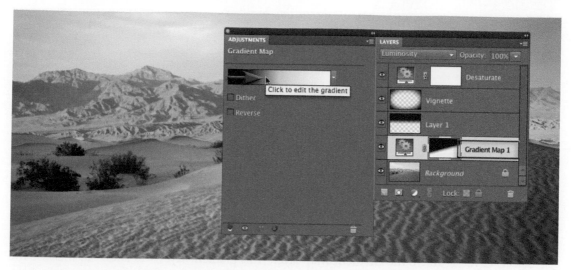

3. Select the Gradient Map layer and then click on the Gradient in the Adjustments dialog to open the Gradient Editor. This Gradient Map was created to increase the contrast in the foreground sand dune (the layer mask is concealing the adjustment in the upper part of the image). The contrast, however, could be optimized for the black and white conversion.

4. Drag the highlight slider underneath the gray ramp to the left to lighten the highlights and increase the contrast. Select OK to close the Gradient Editor. Notice how in the Black and White conversion we can raise the contrast to increase the impact and drama.

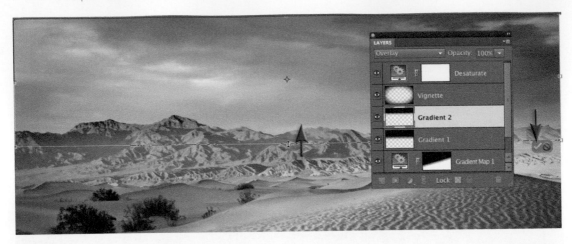

5. Select 'Layer 1' above the Gradient Map layer. This gradient layer was added to increase the contrast in the distant hills and lower the brightness of the sky. The sky, however, needs to have much more depth and drama in this black and white conversion. Rename the layer 'Gradient 1' by double-clicking on the layer name and then right-click and choose 'Duplicate Layer'. Rename this layer 'Gradient 2' and set the mode to Overlay. The Overlay mode provides more contrast than the Soft Light mode and we do not have to worry about upsetting saturation values in this project. To restore the brightness of the distant mountains use the keyboard shortcut Ctrl + T (PC) or Command + T (Mac) to access the Free transform bounding box. Raise the lower handle of the bounding box until the Gradient has been raised sufficiently.

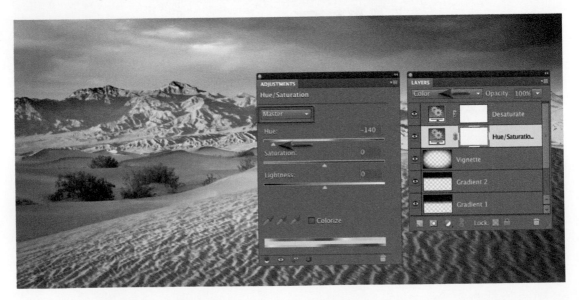

6. Click on the Vignette layer and then click on the Create new fill or adjustment layer icon in the Layers panel and scroll down the list to select and create another Hue/Saturation adjustment layer. This second Hue/Saturation layer should be underneath the first Hue/Saturation adjustment layer. Set the blend mode of this adjustment layer to Color and then drag the Hue slider to -140° to brighten the tones that used to be orange.

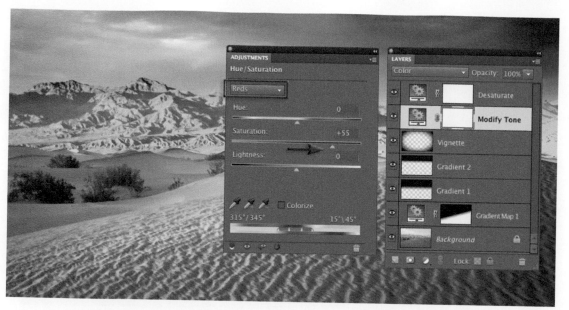

7. Select Reds in the Hue/Saturation dialog and move the Saturation slider to the right to increase the effect of the last adjustment. You can experiment with moving the Hue and Saturation sliders in all of the different colors to adjust the color conversion. Be careful not to introduce color artifacts that can occur when the saturation slider is moved too far in some of the color channels (especially Blue and Cyan).

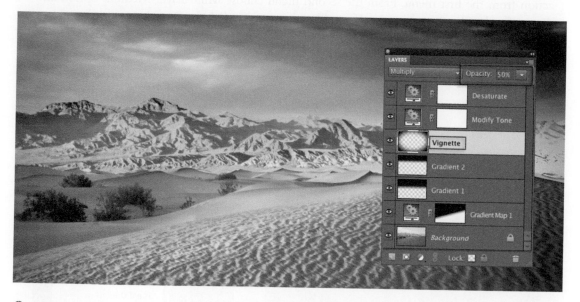

8. The strength or opacity of the vignette can be raised for the black and white conversion. You can also experiment with changing the blend mode from Multiply to Soft Light or Overlay. The Black and White conversion can be considered complete at this stage but, for those looking to take this project a little further, we can explore one of the Maximum Performance actions from the supporting website.

PERFORMANCE TIP

With the top layer selected in the Layers panel you can play one of the actions from the supporting website. This Smooth Tone action can create softer tones that provide the image with more apparent depth. If installed go to Guided > Action Player and select the Smooth Tone action from the first menu. From the second menu choose Multi-Layer-Medium option and then select the Play Action button. If you like what you see click the Done button and return to the Edit workspace.

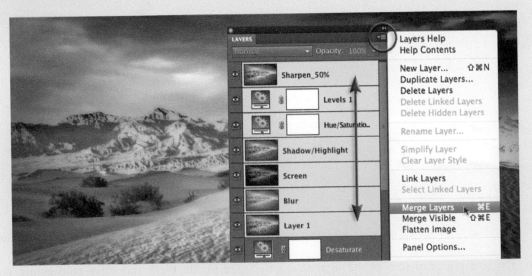

If you want to restore some of the original sharp detail in localized areas of the image, hold down the Shift key and click on the top layer and the layer directly above the Desaturate layer. From the fly-out menu choose Merge Layers (Ctrl or Command +E)

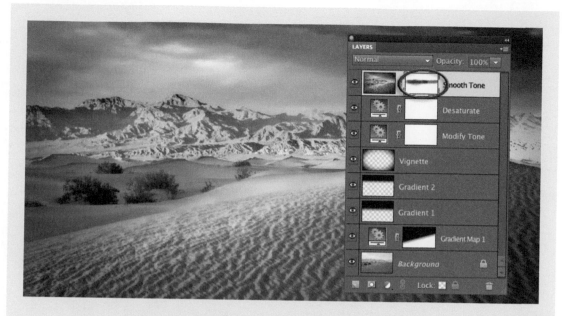

Rename the layer 'Smooth Tone' and then click on the Add layer mask icon at the base of the Layers panel. Select the Brush tool from the Tools panel and make Black the Foreground color. With the opacity set to 50% and the Hardness of the brush set to 0% (click on the brush on the Options bar to access the Brush settings) paint along any areas where you wish to restore sharp detail.

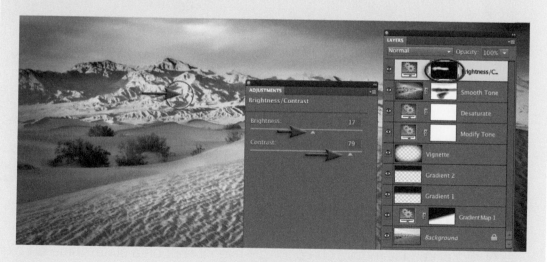

Complete the project by adding a Brightness/Contrast adjustment layer. Raise the sliders to improve the contrast in the distant mountains and then Invert the layer mask (Ctrl or Command + I). Paint with white at 50% to reveal the adjustment in localized areas. An image project such as this can be revisited many times as each layer can be adjusted and readjusted depending on the moods you wish to create. Ansel Adams compared the original image as the music score and the developing after the image was captured to be the performance.

Project 8

Unsharpened

Sharpening

All digital images require sharpening – even if shot on a state-of-the-art digital SLR in focus. Most cameras can sharpen in-camera but the highest quality sharpening is achieved in post-production. Photoshop Elements will allow you to select the amount of sharpening and the areas that require it the most. For images destined for print, the monitor preview is just that – a preview. The actual amount of sharpening required for optimum image quality is usually a little more than looks comfortable on screen.

Advanced sharpening – targeted for maximum impact

The basic concept of sharpening is to send the Unsharp Mask filter on a 'seek and manipulate' mission. The filter is programmed to make the pixels on the lighter side of any edge it finds lighter still, and the pixels on the darker side of the edge darker. Think of it as a localized contrast control. Too much and people in your images start to look radioactive (they glow); not enough and the viewers of your images start reaching for the reading glasses they don't own.

The art of advanced sharpening

The best sharpening techniques are those that prioritize the important areas for sharpening and leave the smoother areas of the image well alone, e.g. sharpening the eyes of a portrait but avoiding the skin texture. These advanced techniques are essential when sharpening images that have been scanned from film or have excessive noise, neither of which needs accentuating by the sharpening filters. So, let the project begin.

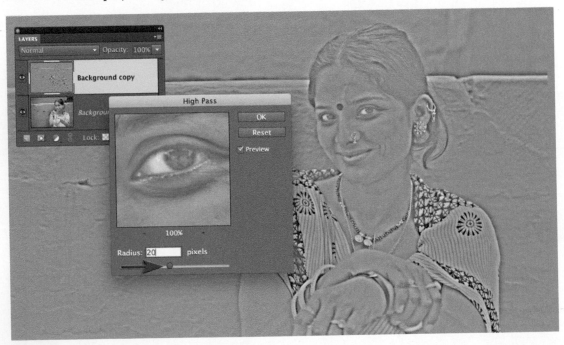

1. The first four steps of the project set out to create an edge mask that can then be used to restrict sharpening to just the edges of the image. Duplicate the background layer by dragging it to the New Layer icon in the Layers panel. Go to Filter > Other > High Pass. Increase the pixel radius to around 20 to 30 pixels for a 10 to 24 megapixel image. Select OK. Apply the Despeckle filter (Filter > Noise > Despeckle) and also the Dust and Scratches filter (Filter > Noise > Dust and Scratches) using a Radius value of 1 pixel and setting the Threshold slider to 0 Levels.

Note > The High Pass filter is sometimes used as an alternative to the Unsharp Mask if the duplicate layer is set to Overlay or Soft Light mode. In this project, however, we are using the High Pass filter to locate the edges within the image only.

PERFORMANCE TIP

If you have any sharpening options in your camera or scanner it is important to switch them off or set them to minimum or low. The sharpening features found in most capture devices are often very crude when compared to the following advanced technique. It is also not advisable to sharpen images that have been saved as JPEG files using high-compression/low-quality settings. The sharpening process that follows should also come at the end of the editing process, i.e. after adjusting the color and tonality of the image.

2. Apply a Threshold filter to the High Pass layer from the Filter > Adjustments submenu. The threshold adjustment will reduce this layer to two levels – black and white.

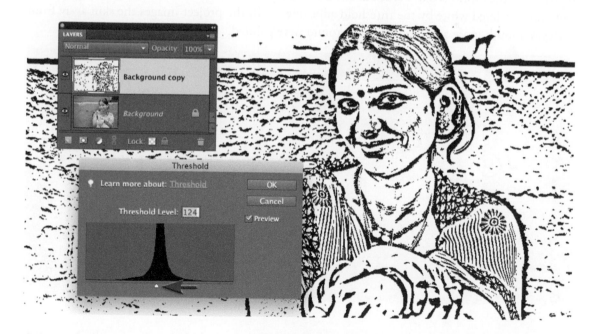

3. Drag the slider just below the histogram to isolate the edges that require sharpening. The aim of moving these sliders is to render all of those areas you do not want to sharpen white (or nearly white). Select OK when you are done. You are halfway to creating a sharpening mask. The mask will restrict the sharpening process to the edges only (the edges that you have just defined). Increasing or decreasing the radius in the High Pass filter will render the lines thicker or thinner.

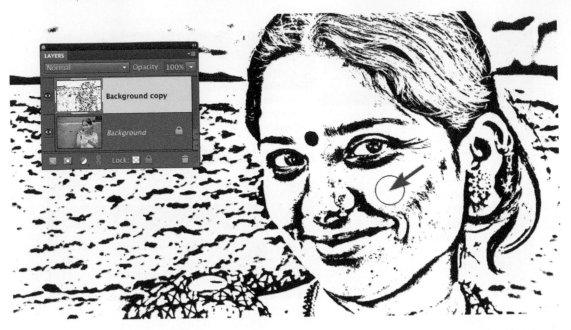

4. Select the Brush Tool from the Tools panel, set white as the foreground color and the Opacity to 100% in the Options bar. Paint out any areas that you do not want to be sharpened (areas that were not rendered white by the threshold adjustment). In the project images the skin away from the eyes, mouth, nose and even the background were painted.

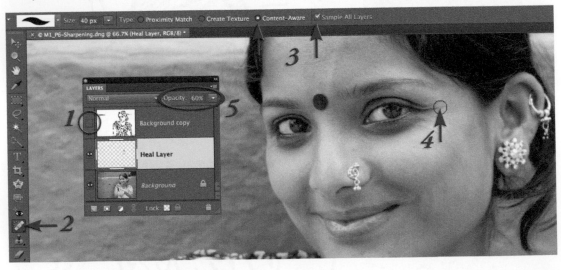

5. Click on the visibility icon of the background copy layer to hide it momentarily. Now click on the Background layer to select it and then click on the Create a new layer icon in the Layers panel to create an empty new layer. Select the Spot healing Brush Tool from the Tools panel and select the Content Aware and Sample All Layers options. Brush over any of the larger skin flaws and lines around the eyes. Lower the opacity of this layer in the Layers panel to reintroduce some of this detail if required. Double-click on the name of this layer and call it Heal Layer

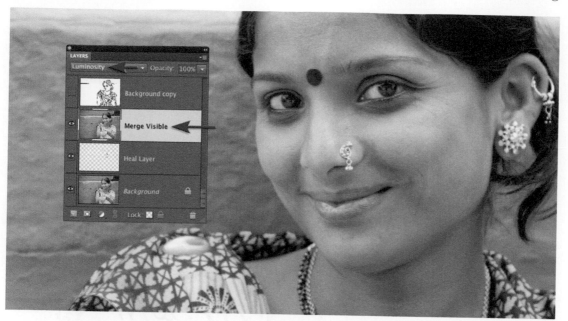

6. With the Heal Layer selected hold down the Ctrl + Alt + Shift keys (PC) or Command + Option + Shift keys (Mac) and then hit the E key on the keyboard to merge the visible elements to a new layer. Double-click on the name of the layer and call this layer Merge Visible. As this is the layer we will sharpen set the Mode to Luminosity in the Layers panel.

Note > The Luminosity mode will ensure that the edges do not become too saturated after the sharpening process that is applied in the last step of this project.

7. Select the Background copy layer and switch the visibility of this layer back on. From the Select menu choose All. Then from the Edit menu choose Copy. This copies this edge mask to the clipboard. Switch off the visibility of this background copy and select the Merge Visible layer.

8. With the Merge Visible layer selected click on the Add layer mask icon in the Layers panel. Hold down the Alt key (PC) Option key (Mac) and click on the Layer mask thumbnail to view the contents of this layer mask. The image preview will appear all white until we then choose Paste from the Edit menu. We have now successfully transferred the edge mask to the layer mask.

9. The black lines in this layer mask will define the areas of sharpening. The lines can be made thicker by holding down the Ctrl key (PC) or Command key (Mac) and clicking on the layer mask thumbnail to load the white areas of the mask as a selection. Go to Select > Modify > Contract and choose 2 pixels from the Contract dialog and then select OK. From the Select menu choose Inverse so that the black areas are now the selected areas.

10. From the Edit menu choose Fill selection. Select Black as the Contents and then select OK. The lines will now be rendered 2 pixels thicker on both sides. If this step does not produce the desired effect make sure the selection was inversed in the previous step prior to filling with black.

11. With the layer mask selected go to Filter > Adjustment > Invert. The lines in the mask should now appear white against a black background. To soften the edges of the mask go to Filter > Blur > Gaussian Blur and raise the radius to 6 pixels. Select OK.

12. This is the step where we get to sharpen our image. Select the Image thumbnail on the layer in the Layers panel. Go to Enhance > Adjust Sharpness. Adjust the Amount slider to between 100 and 300%. This controls how much darker or lighter the pixels at the edges are rendered. Choose an amount slightly more than what looks comfortable on screen if the image is destined for print rather than screen. The Radius slider should be set to 0.5 pixels for screen images and between 0.8 and 1.5 for print resolution images. The Radius slider controls the width of the edge that is affected by the Amount slider. The opacity of this sharpening layer can be modified to adjust the overall sharpening effect.

The image on the left shows the impact of the sharpening if a layer mask is not added. The image on the right uses the layer mask that was created in this project. The layer mask ensures areas of the image that would not benefit from the sharpening process are left unaffected. In Adobe Camera Raw it is possible to create quick and easy masks by raising the Mask slider but there is no option to paint into these masks. In the main editing space, however, the edge masks can be custom built to meet the needs of the image you are sharpening.

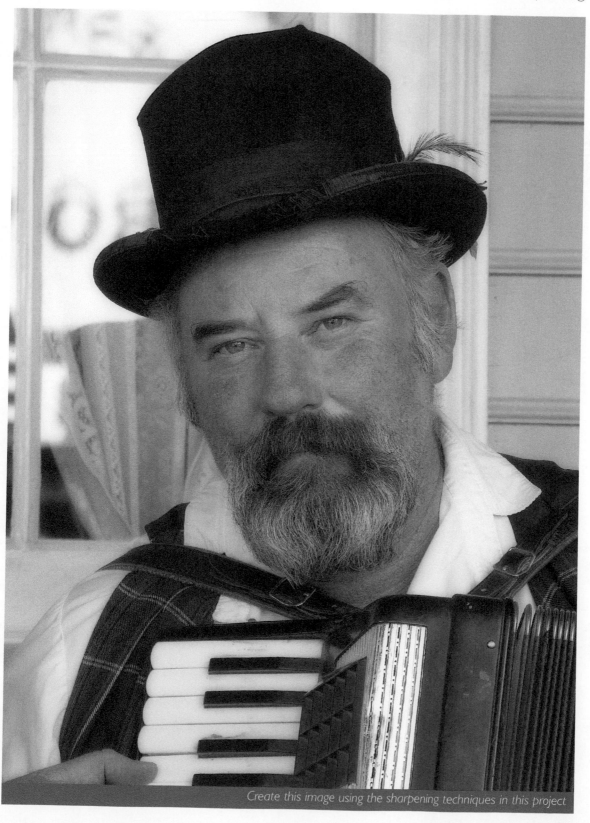

Create this image using the sharpening techniques in this project

part

2

enhance

Project 1

Depth of Field

The Gaussian Blur filter can be used creatively to blur distracting backgrounds. Most digital cameras achieve greater depth of field (more in focus) at the same aperture when compared to their 35 mm film cousins, due to their comparatively small sensor size. This is great in some instances but introduces unwelcome detail and distractions when the attention needs to be firmly fixed on the subject.

There is often a lot to think about during the capture of an image, and the time required to consider the appropriate aperture and shutter speed combination for the desired visual outcome often gets the elbow. Photoshop Elements can, however, come to the rescue and drop a distracting background into a murky sea of out-of-focus oblivion. Problems arise when the resulting image, all too often, looks manipulated rather than realistic. A straight application of the Gaussian Blur filter will have a tendency to 'bleed' strong tonal differences and saturated colors into the background fog, making the background in the image look more like a watercolor painting than a photograph. The Gaussian Blur filter will usually require some additional work if the post-production technique is not to become too obvious.

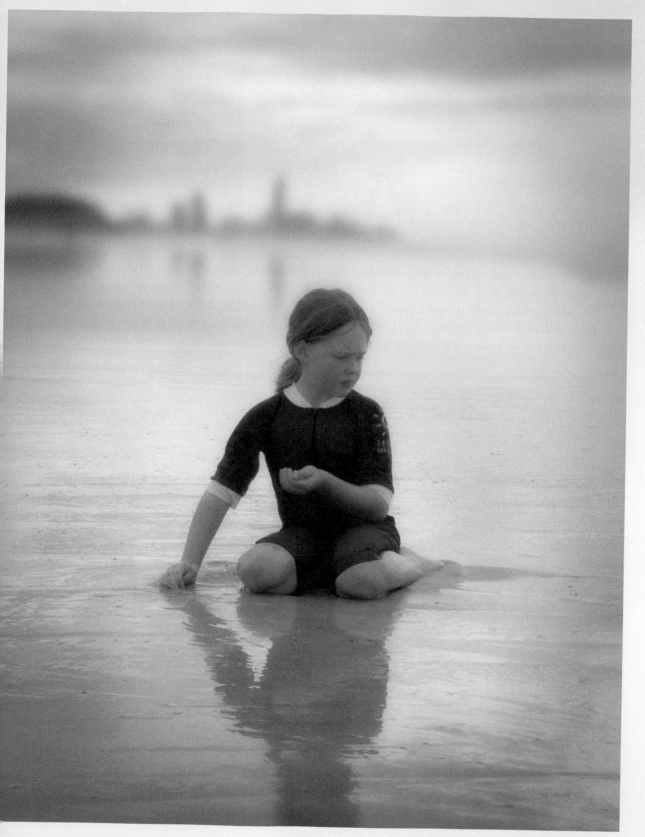

Decrease the depth of field to emphasize your subject

1. In the first half of this project we will create an accurate layer mask to protect the areas of the image where we want to retain focus. The mask will also have to allow a gradual transition from focus to out-of-focus in the background areas to simulate the shallow depth-of-field that would have been created if a wide aperture had been used on the camera lens used to capture this image. First duplicate the background layer by dragging it to the Create a new layer icon in the Layers panel.

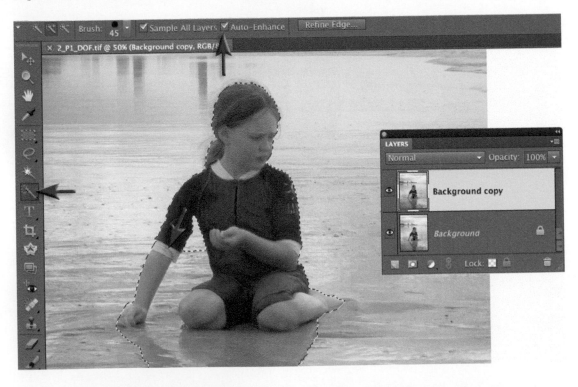

2. Choose the Quick Selection tool from the Tools panel and select the Auto Enhance option in the Options bar. Drag the tool over the girl and her reflection in the water. The Quick Selection tool will probably include the water underneath the girl's arm as part of the initial selection.

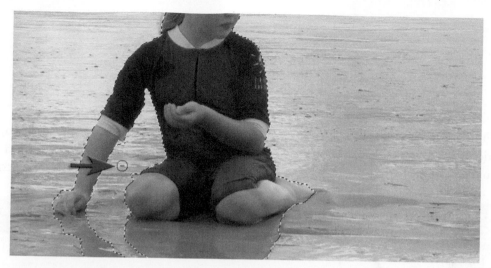

3. Reduce the diameter of the brush size by clicking on the Brush Picker icon in the Options bar. Hold down the Alt/Option key and then paint over any areas of water that need to be excluded from the selection.

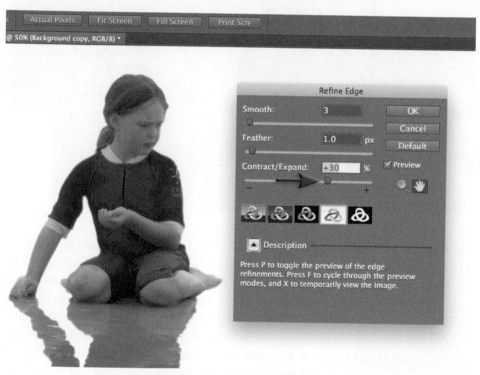

4. Click on the Refine Edge button in the Options bar and choose to view the selection with either the On White or the Custom Overlay Color option. Set Smooth to a value of 3 and enter a 1-pixel Feather to soften the edge of the selection. Drag the Contract/Expand slider to the right so that the edge of the mask color sits directly over the edge of the girl. Select OK to apply these adjustments to the selection.

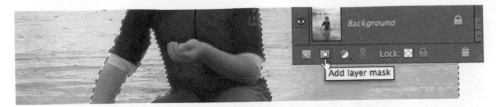

5. From the Select menu choose Inverse. In the Layers panel click on the Add layer mask icon. The selection will create a layer mask and this will become the area of sharp focus. Hold down the Alt/Option key and click on the layer mask to view the contents of the mask you have just created.

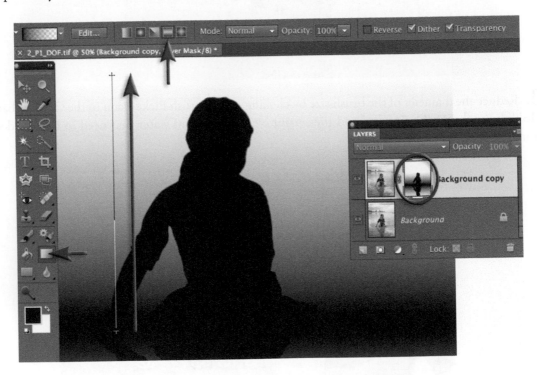

6. Focus is not a brick wall, i.e. it does not start and end suddenly – it gradually fades in and out. Think Gradient tool when you are thinking of fading between masked and unmasked (sharp and unsharp). Set the default colors in the Tools panel (press D and then the letter X on the keyboard). Choose the Gradient tool in the Tools panel. Choose the Foreground to Transparent gradient from the drop down menu in the Options bar and then select the Reflected Gradient option. Drag a gradient from the base of the girl to somewhere around the horizon line in the distance (holding down the Shift key as you drag will constrain the gradient so that it is not crooked). Drag the gradient a second time to darken the mask further. The resulting gradient will extend the focus in front and behind the girl. This will become our plane of focus.

Note > The file for this project has a path that can be converted into a selection. You will need to install the action that is available from the supporting website. Creating a layer mask with the active selection will automatically create the layer mask in Step 5.

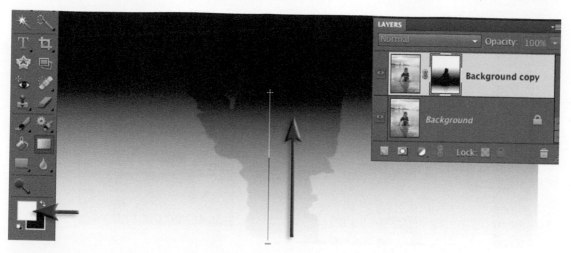

7. Switch the foreground color to white and then drag a gradient from the base of the image to the point just below where the girl is in contact with the sand. This will help to reduce focus in the reflection slightly. Hold down the Alt/Option key and click on the layer mask to return to the normal view.

8. Click on the image thumbnail to make this the active component of the layer. Then click on the link between the image thumbnail and the layer mask to break this link. Go to Filter > Blur > Gaussian Blur and apply a generous amount of blur (20 pixels in this project). How much you drop the focus is pretty much a subjective step. Very shallow depth of field is achieved with larger apertures, a close vantage point and larger format cameras. If you are generous with the pixel radius in the Gaussian Blur filter, the image will appear as though it was created with a large format film camera – something that is impossible to achieve with a digital compact unless you are shooting an insect or flower in macro mode. The power of this effect is to remove distracting background clutter, isolate the subject and keep the focus entirely on the focal point of the image. Unfortunately the effect at this stage has a few shortcomings. The effect of blurring the background has bled some of the darker and more saturated tones into the lighter, more desaturated background. A tell-tale halo is forming that indicates this effect has been achieved in post-production rather than in-camera.

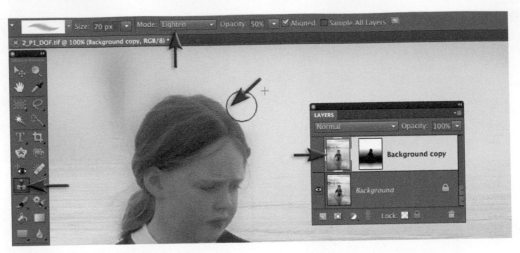

9. The problem is resolved by careful application of the Clone Stamp tool. Select the image thumbnail on the background copy layer, then select the Clone Stamp tool from the Tools panel. In the Options bar, check the Aligned option and set the mode to Lighten. Hold down the Alt/ Option key as you select some pixels further away from the edge, where the bleed has not extended to, and paint these pixels back into the affected border regions. Switch from Lighten to Darken modes if you encounter brighter tones bleeding into a darker background.

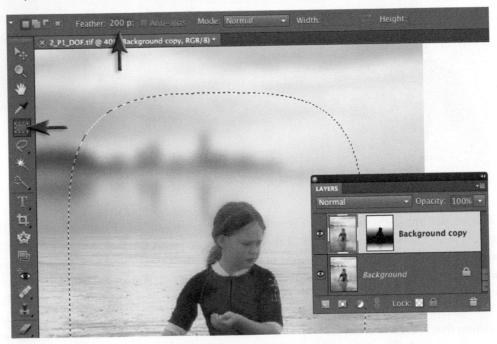

10. To complete this project we can add a vignette so that the image progressively gets brighter towards the center (we are visually drawn to the light). Choose the Rectangular Marquee tool from the Tools panel and enter a Feather value of 200 px in the Options bar. Make a selection of the central portion of the image and then from the Select menu choose Inverse.

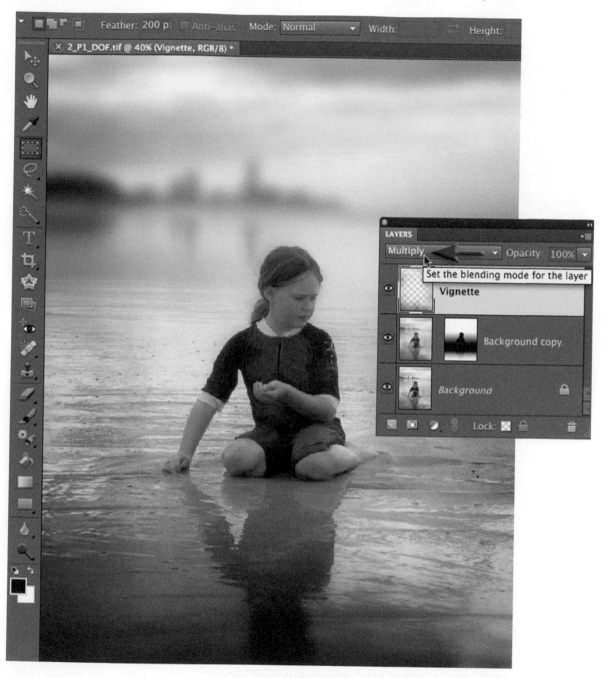

11. Choose Copy merged from the Edit menu and then Paste from the edit menu to paste the pixels on to a new layer. In the Layers panel set the mode of this new layer to Multiply. Lower the opacity of the layer if the strength of the vignette is too strong.

Note > There is vignette action available to download from the supporting website that automates the last two steps of this tutorial.

FUTURE DEVELOPMENTS SHIFTING FOCUS

If digital cameras are eventually able to record distance information at the time of capture, this could be used in the creation of an automatic depth map (the Lens Blur filter in the full version of Photoshop can already use channels or layer masks to create automated depth of field effects, but the channel must still be created manually using the techniques outlined in this project). Choosing the most appropriate depth of field could be relegated to post-production image editing in a similar way to how the white balance is set in Camera Raw.

Create this image using the techniques from this project - image by Dorothy Connop

Project 2

Shafts of Light

Here we explore the science of making good photographs even more memorable. Discover how to add drama to your landscape images using the 'Fingers of God' tool (aka the Gradient tool with customized settings). Creating effective landscape images is not exactly rocket science. Choose a beautiful landscape just after dawn, or just before sunset, and add dramatic natural lighting to create emotive and memorable landscape images.

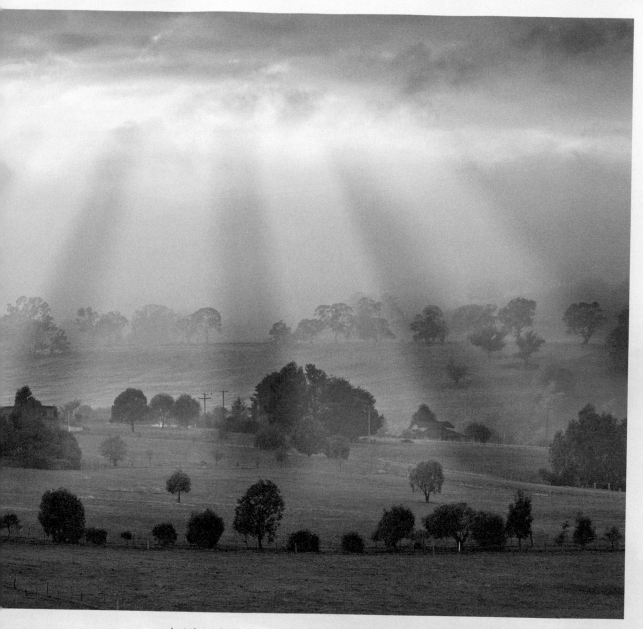

Let there be light – create dramatic lighting effects to enhance the drama of your images

Clear blue skies are great for holidays on the beach but the best natural lighting for photography is provided by broken or filtered sunlight through partial cloud cover. The most memorable of all lighting is when shafts of light break through the clouds. Finding partial cloud cover when the sun is low is relatively easy; being present when shafts of light flood your selected vista, however, can be an elusive and rare event. This final ingredient requires patience, persistence and good fortune – or a good helping of post-production editing courtesy of Photoshop Elements.

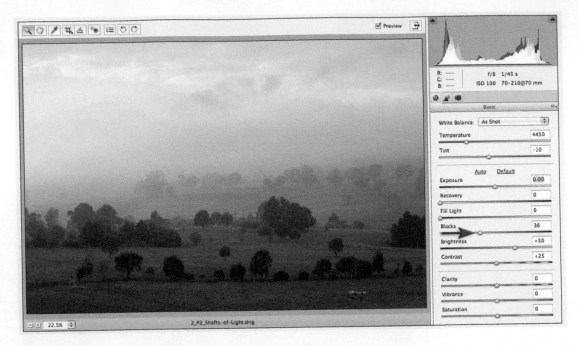

1. Open the Raw project from the supporting website into Adobe Camera Raw (ACR). We will optimize the tonality and color of the Raw file twice, once for the foreground and then again for the sky. The first step is to set a black point for the image as the darker tones are very weak due to the morning mist at the time of capture. Drag the Blacks slider just to the point where the blacks start to clip (the triangle above the left side of the histogram must remain black).

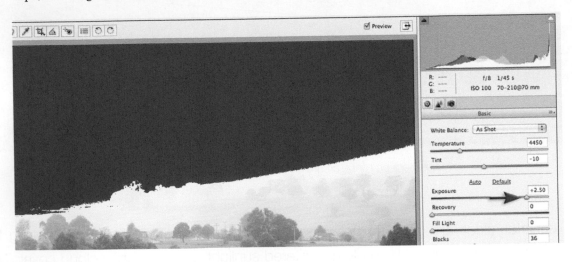

2. Hold down the Alt/Option key and drag the Exposure slider to the right to clip the lighter tones in the distant hills. The threshold view in the image preview will guide you to the point where clipping starts to happen in the foreground. An Exposure adjustment of around +2.50 stops will clip all of the middle distance sunlit hills and also the sky (we are expanding the contrast for the foreground fields only at this stage)

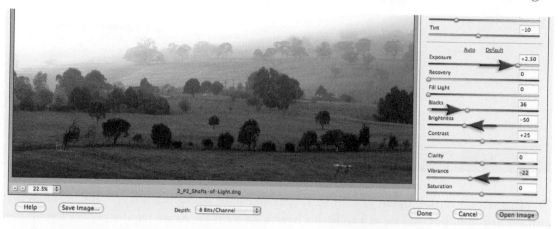

3. Finish optimizing the foreground by lowering the Brightness and Vibrance sliders. The Brightness slider can be moved significantly darker (approximately -50) due to the generous Exposure adjustment applied in the previous step. Click on the Open Image button to open the image in the main Edit space of Photoshop Elements.

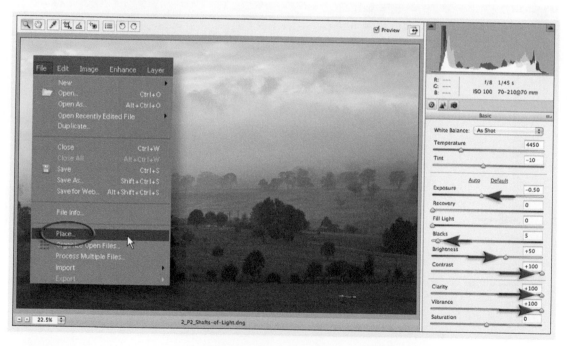

4. After the image has opened in the main Edit space go to File > Place and browse to and open the same Raw file. This time optimize the Raw file for the sky. Click on Default to zero the exposure settings. The Exposure can now be dropped half a stop from the default 0.0 setting while the Contrast, Clarity and Vibrance sliders can be pushed to their maximum settings of +100. Set the Brightness and Blacks sliders to their default settings (double-click the slider triangles). Select OK to open this version as a layer above the first version, opened in the previous step.

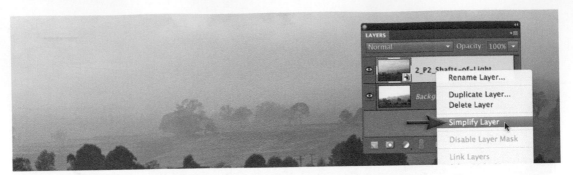

5. This second version opens as a Smart Object above the background layer. The big cross that you see first indicates that we can scale this layer if we want to. As we require perfect registration with the layer below (we don't want to scale this layer) commit the scaling by hitting the Enter/ Return key. We can right-click on the layer and select Simplify Layer to turn this Smart Object into a regular layer.

Note > Smart Objects can be scaled multiple times without losing any quality.

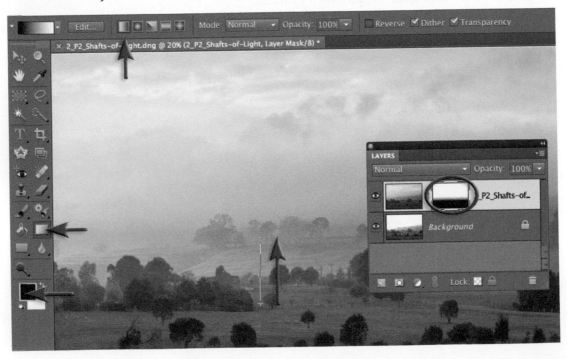

6. To selectively merge the best of both exposures on the two layers we will mask the foreground of the top layer. Click on the Add layer mask at the base of the Layers panel. Select the Gradient tool from the Tools panel and the Black, White and Linear options in the Options bar. Drag a short gradient from the dark foreground to the sunlit hills in the middle distance. If you need to reposition the gradient click on the link between the layer mask and the image thumbnail to remove the link. Then select the Move tool from the Tools panel and then click and drag the layer mask lower, while holding down the Shift key, to reposition the transition.

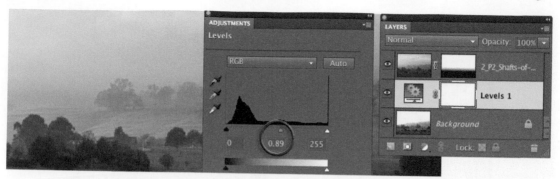

7. If the foreground fields appear too dark or too light then add a second Levels adjustment layer just above the background layer (click on the background layer before adding a new adjustment layer). Drag the central Gamma slider underneath the histogram to the left or to the right to perfect the foreground brightness.

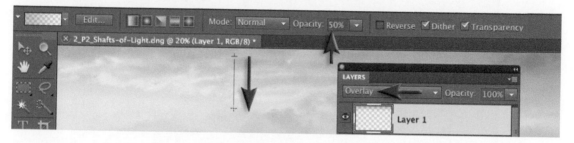

8. Select the top (Shaft-of-Light) layer and then add an empty new layer above it. Set the mode of this new layer to Overlay. Select the Gradient tool from the Tools panel and choose Black as the foreground color (Press D to select the default colors). Choose the Foreground to Transparent option from the Gradient drop-down menu in the Options bar. Select the Linear option and set the opacity to 50% in the Options bar. Hold down the Shift key and drag a short gradient from the top of the image preview to a position where the clouds are breaking to add drama to the top of the image.

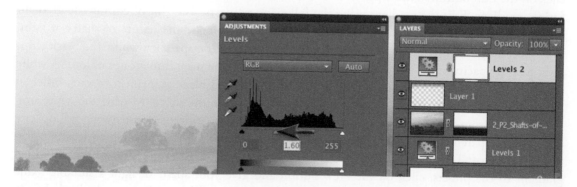

9. Over the next few steps we will instill a sense of drama throughout the image by creating some shafts of light to appear through those breaking clouds. Create a second Levels adjustment layer and increase the brightness of the image significantly by moving the central Gamma slider to the left (by around 1.6 in this project).

10. Choose black as the foreground color and select the Gradient tool in the Tools panel and click on the Edit button in the Options bar to open the Gradient Editor. Click on the Transparent Stripes gradient. Edit the gradient using the following pointers. The aim of editing the gradient is to make the stripes irregular widths with soft edges to emulate the nature of shafts of light. The white stops on the top of the editing ramp indicate full transparency whilst the black stops indicate full opacity of the foreground color. Click and drag the stops into groups of four. A white stop should be on either end of a grouping of four with two black stops next to each other in the middle. Moving the black stops further apart will broaden the stripe. Moving the white stop further away from the central black stops will broaden the area of transition between full opacity and full transparency. To add a stop hold down the Alt/Option key and drag an existing stop a short distance. To remove a stop drag it away from the gradient ramp. To add this modified gradient to the presets, click on the New button and give your shafts of light a suitable name (don't worry that the shafts are colored black for the moment). This gradient can be loaded from a preset that is available on the supporting website.

Note > A black stop can be changed to a white stop or vice versa by clicking on it and then adjusting the Opacity slider at the bottom of the Stops section of the Gradient Editor.

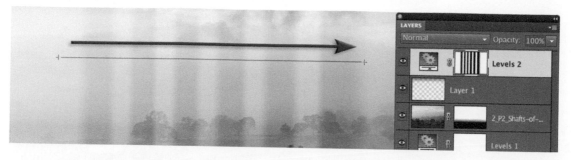

11. Make sure the Linear gradient option is selected in the Options bar and set the opacity to 100% and the mode to Normal, and check the Transparency option. The foreground color should still be set to black. Click on the left side of the image window and drag your mouse cursor to the right-hand side of the image window. The length of the line you draw will be the initial width of the shafts, although this can be modified using the Transform command outlined in the following step.

12. From the Image menu select Distort from the Transform submenu. Click on each of the corner handles and drag them to fan the shafts of light. Move the cursor into the Transform bounding box, and click and drag the bounding box to reposition the shafts of light. When you're satisfied with the shape, double-click inside the distorted bounding box to accept the transformation.

Note > You may need to extend the image window so that you can drag the corner handles to the required angle.

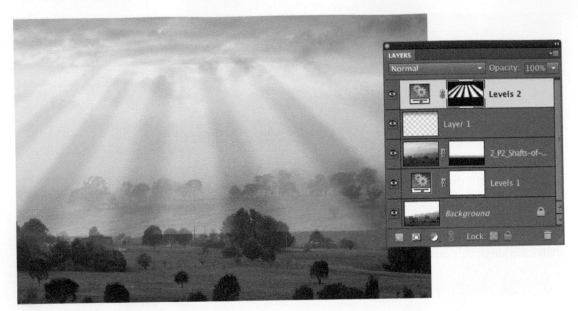

13. Go to the Filter menu and select Invert from the Adjustments submenu. This will turn the black stripes to white and return the brightness level of the rest of the image to normal. The next step will aim to fade the top and bottom edges of this striped gradient.

14. Select the Gradient tool and choose the Foreground to Transparent gradient. Drag a short gradient from just below the hard edges a short distance into the shafts to conceal the hard edges. Repeat the process to fade the bottom of the shafts, this time dragging from the bottom of the hard edge a short distance into the gradient. Drop the opacity of the Gradient tool in the Options bar to 50% and drag a gradient from either side to fade the intensity of the outer shafts.

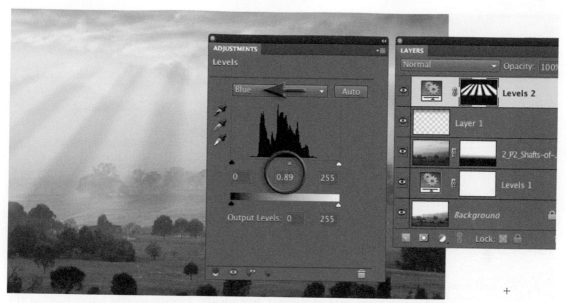

15. The brightness or color of the shafts of light can now be adjusted to suit the landscape. In this project I have selected the blue channel in the Levels dialog and moved the central Gamma slider underneath the histogram to the right slightly to warm the shafts of light.

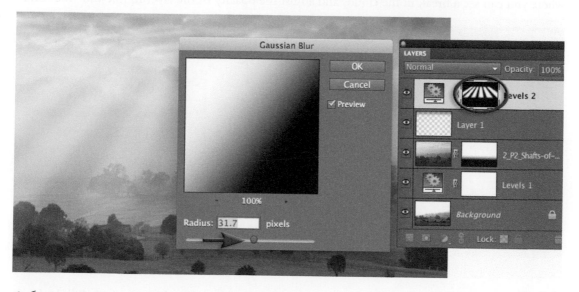

16. To soften the mask further, choose Filter > Blur > Gaussian Blur. Select a pixel radius that will soften the edges of the shafts so that the effect is subtle. Paint with white (using a large soft-edged brush at a low opacity setting) to introduce warm light on the foreground fields if required.

Note > It is possible to increase the intensity of the shafts of light by switching the blend mode of the adjustment layer to Screen. Adjust the opacity of the adjustment layer to fine-tune the effect.

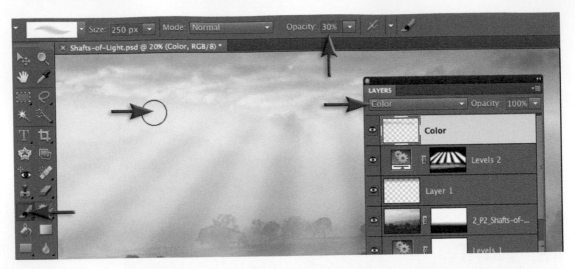

17. We will now improve the appearance of the breaks in the clouds so the shafts of light look like they could be appearing from behind them. Click on the Create a New Layer icon in the Layers panel. Switch the mode of the layer to Color. Click on the foreground color swatch in the Tools panel to open the Color Picker. Choose a bright blue color and select OK. Select the Brush tool and choose a soft-edged brush and drop the opacity to 30% in the Options bar. Paint blue where you can see a break in the clouds and adjust the opacity of the layer to fine-tune the color.

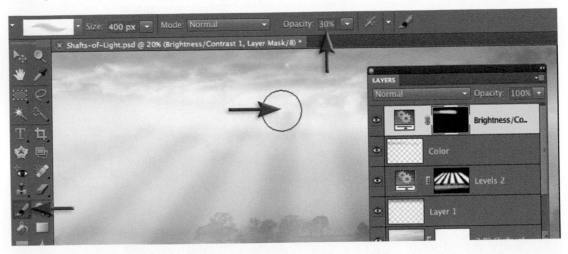

18. Create a Brightness/Contrast adjustment layer and raise the brightness to +50. Fill the Layer mask with black by going to Edit > Fill and choosing black as the contents. Select the Brush tool and choose white as the foreground color. Choose a soft-edged brush and set the opacity to 30% in the Options bar. Paint to brighten the break in the clouds at the top of the shafts of light. Paint multiple times to increase the brightness. Add a vignette to taste and the illusion is complete. Now, the only problem with this technique is that it is almost too effective and therefore tempting to sneak it into too many images in your personal portfolio. When this happens the cat will be well and truly out of the bag!

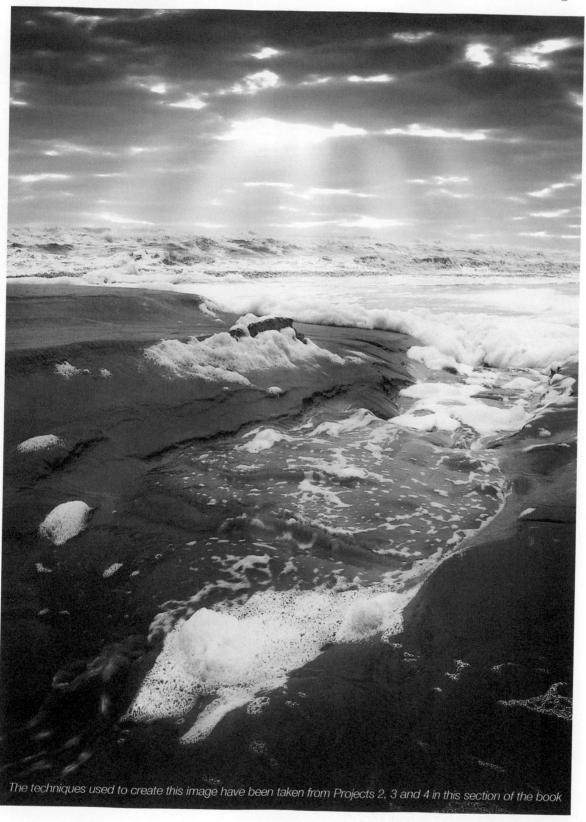

The techniques used to create this image have been taken from Projects 2, 3 and 4 in this section of the book

Project 3

Toning

Burning, toning, split-grade printing and printing through your mother's silk stockings are just some of the wonderful, weird and positively wacky techniques used by the traditional masters of the darkroom that are waiting to be exposed (or ripped off) in this tantalizing digital project designed to pump up the mood and ambience of the flat and downright dull. The tonality of the project image destined for the toning table will be given a split personality. Shadows and highlights will be gently blurred to add depth and character at the same time as retaining full detail for emphasis and focus. Selected colors will then be mapped to the new tonality to establish the final mood.

Toned images – exploring the land between black and white and color

It probably comes as no small surprise that 'color' injects images with mood and emotional impact. Photographers, however, frequently work on images that are devoid of color because of the tonal control they are able to achieve in traditional processing and printing techniques. Toning the resulting 'black and white' images keeps the emphasis on the play of light and shade but lets the introduced colors influence the final mood. With the increased sophistication and control that digital image-editing software affords us, we can now explore the 'twilight zone' between color and black and white as never before. The original image has the potential to be more dramatic and carry greater emotional impact through the controlled use of tone and color.

1. This first step will create some soft, smooth tones that we can use to recreate the early morning mood. Duplicate the background layer by dragging it to the Create a New Layer icon in the Layers panel. Go to Filter > Blur > Gaussian Blur and increase the Radius to 15 pixels.

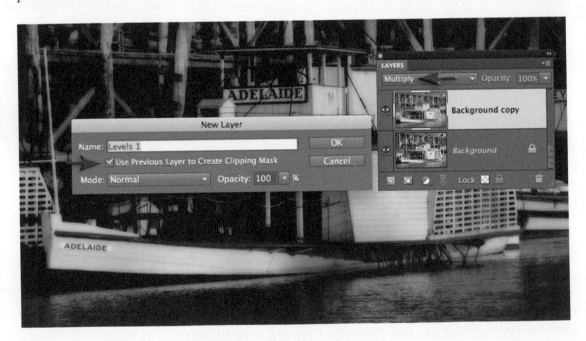

2. Set the mode of the layer to Multiply. The image will appear very dark until we restore the luminance values to the pixels over the next four steps. We can achieve this using a combination of two adjustment layers. Hold down the Alt/Option key while you select a levels adjustment layer from the Create Adjustment Layer menu in the Layers panel. In the New Layer dialog box that opens check the Use Previous Layer to Create Clipping Mask option. This will enable us to modify the tonality of the blur layer without affecting the background layer.

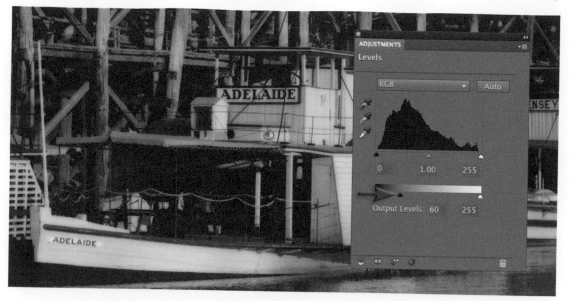

3. Move the Shadow Output slider to the right to prevent the deeper shadow tones from becoming too dark: Choose a value of 60 to 100 depending on how dark the shadow values in the image are. We can start with a value of 60 and refine this later, after applying the second adjustment layer.

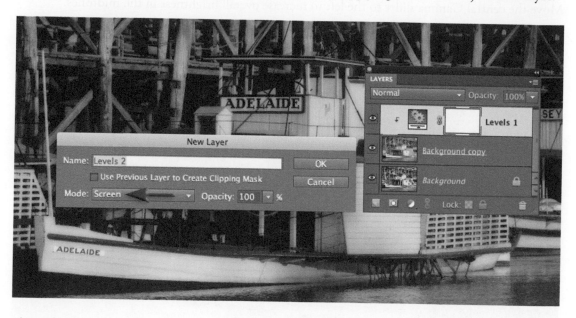

4. Hold down the Alt/Option key while you select a Levels adjustment layer from the Create Adjustment Layer menu in the Layers panel. In the New Layer dialog box that opens set the mode of the new layer to Screen. Select OK to open the second Levels adjustment layer.

Note > We do not need to select the Use Previous Layer to Create Clipping Mask option as we are about to adjust the overall tonality rather than just the background copy layer.

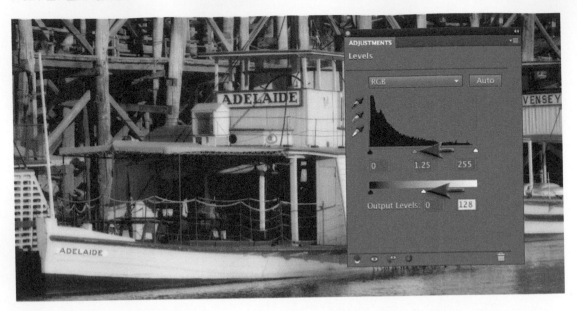

5. The Screen mode applied to this second adjustment layer will lighten all tones. Drag the white Output slider to the left to restrict this adjustment to just the shadow tones and midtones (a value of 128 has been used in this project). This will prevent the highlights from becoming too bright. Move the central Gamma slider to the left to increase overall brightness in the midtones.

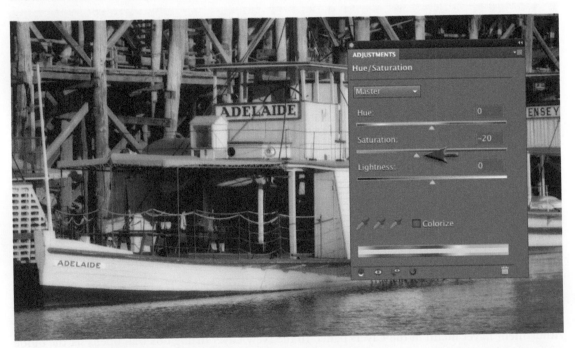

6. The original brightness of the image should now be restored but the saturation values will be slightly higher. Select a Hue/Saturation adjustment layer from the Create Adjustment Layer menu in the Layers panel and lower the saturation to -20.

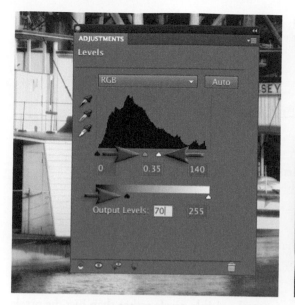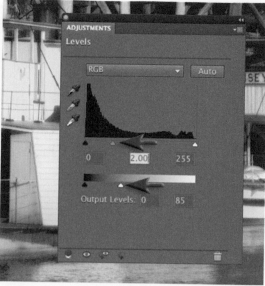

7. At any stage in this project you can modify the impact of the Blur layer on the image by adjusting the sliders in the two Levels adjustment layers. Select the first adjustment layer that is grouped with the background copy layer and then drag the white Input slider to 140 and the central Gamma slider to 0.35 to increase the apparent blur in the image. Raise the black Output slider to 70. Select the second adjustment layer (the one set to the Screen mode) and drag the central Gamma slider to 2.00 and the white Output slider to 85 to adjust the overall tonality.

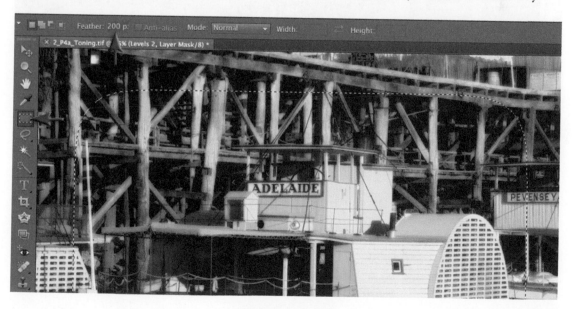

8. We will now add a vignette to this image. Select the Rectangular Marquee tool in the Tools panel. Set the feather radius to 200 pixels in the Options bar. Click and drag from the top left-hand corner of the image to the bottom right-hand corner to make a selection.

9. From the Select menu choose Inverse so that the edge, rather than the center, of the image is selected. From the Edit menu choose Copy Merged and then from the Edit menu again choose Paste.

Note > The Copy Merged command allows you to copy the visible pixels rather than just the pixels on the active layer.

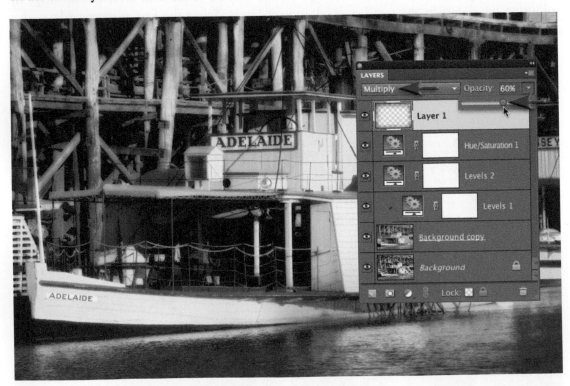

10. The pixels on this new layer (currently making no difference to the appearance of the image) can be used to darken the image by setting the mode of the layer to Multiply. Lower the opacity of the layer if the vignette is too dark, using the opacity control in the Layers panel.

11. Set the foreground colors in the Tools panel to their default black and white settings. Click on the Create Adjustment Layer icon in the Layers panel and choose Gradient Map from the menu. Click on the gradient in the Gradient Map dialog to open the Gradient Editor dialog.

Note > The gradient must start with black and end with white, otherwise your image will not use the full dynamic range possible.

12. The Gradient Editor dialog allows you to assign colors to shadows, midtones and highlights. Click underneath the gradient to create a new color stop. Slide it to a location that reads approximately 25% at the bottom of the dialog. Click on the color swatch to open the Select Stop Color (Color Picker) dialog.

13. Cool colors such as blues or cyans are often chosen to give character to shadow tones. In the project image the HSB values (hue, saturation and brightness) are adjusted to 208°, 19% and 35% (this brightness value is lighter than the 25% position of the color stop and opens up the dark shadow detail in this image). Select OK in the Select Stop Color dialog to assign this color.

14. Create another stop and move it to a location that reads approximately 75%. This time try choosing a bright warm color to contrast with the blue chosen previously. HSB values of 52°, 14% and 80% have been selected for the project image. Select OK to assign this color to the highlights.

15. The color stops can be moved to modify the contrast of the image. Pushing the two color stops further apart will reduce the contrast, giving increased detail to the shadows and highlights. When a color stop is moved, color midpoints are visible that can also be moved along the color ramp to fine-tune the effects of the gradient on your image.

Note > Avoid moving the color stops or Midpoint too close to each other as this can cause tonal banding or posterization in the image.

16. Add another color stop in the middle of the gradient for maximum control over the toning process. HSB values of 37°, 18% and 59% have been selected for the project image. Select OK to assign this color to the Midtones. This color stop increases the warmth in the midtones and completes the toning process.

17. A custom gradient can be saved as a Gradient preset. Enter a name for your gradient and then click on the New button. The New Gradient will appear in the presets. Gradients can be saved to other locations (such as your desktop or an external drive) so that they can be loaded into imaging projects using a different computer.

18. Select OK in the Gradient Editor dialog to commit the changes. In the Layers panel reduce the opacity of the Gradient Map layer to introduce some of the original colors to the image.

GRADIENT PRESETS
ON SUPPORTING
WEBSITE

PERFORMANCE TIPS

The gradient map used in this toning project can be downloaded from the supporting website and loaded directly from the Gradient Editor dialog or via the Preset Manager (go to Edit > Preset Manager > Gradients > Load). Then browse to the Maximum_Performance.grd preset and select OK. Quick split-tone effects can be accessed via the Maximum Performance split-tone actions available on the supporting website.

Try blurring the Vignette layer by going to Filter > Blur > Gaussian Blur. A 10-pixel blur will give the image an interesting soft-focus effect.

Project 4

Character Portrait

It is often possible to unleash the hidden potential of an image without the hassle of making fiddly selections. This project demonstrates how the tonality of an image can be enriched using duplicated layers, blend modes and a couple of filters to shape and sharpen. Dust off your trophy shelf – I feel an award coming on!

The beauty of these techniques is that we can let Photoshop Elements do all of the hard work and extract an image that has all of the hallmarks of a professionally lit studio-quality portrait from one that is illuminated with nothing more than ambient light. The secret to success, if you plan to reuse this recipe on one of your own images, is to start with a razor-sharp image illuminated by soft directional light (diffused window light is ideal).

Cooking up some character – a recipe for success

Preparing the image

Before we start our culinary masterpiece we should prepare the main ingredient – the image. This should include optimizing the histogram via a manual or auto Levels adjustment (if you have the luxury of accessing a 16 Bit/Channel file via a Raw capture or a 48-bit scan, your histogram will appreciate the Levels adjustment prior to hitting the 8 Bits/Channel option in the Image > Mode submenu). Start the project by removing any distractions in the image so that the viewer's focus will not wander from the *pièce de résistance* – the face containing the character and majesty of our sitter. Keeping it simple is a key to clean and effective design.

1. You can either paint directly on to the background layer or duplicate it if you want to preserve the background layer unadjusted. Remember you have the option to undo any brush stroke that is not absolutely effective. In fact, Photoshop Elements allows you to undo 50 steps by default. Check the preferences and adjust the number to suit your own workflow if required. I think 50 is overly generous and can consume excessive portions of the computer's usable RAM that would serve us better by being made available for the more memory-intensive editing tasks we are about to engage in. There is no need to restart the computer if you decide to lower the number of History States to 20.

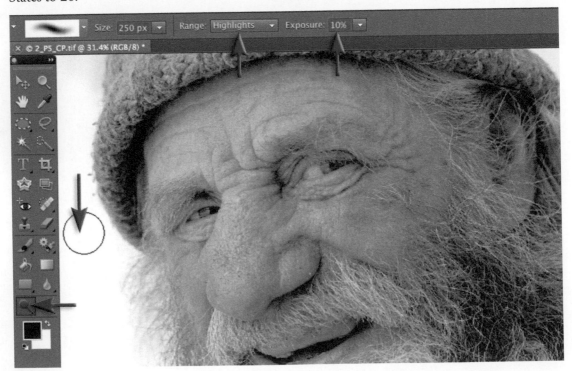

Dodge tool > Use a soft-edged brush and paint with the Dodge tool set to Highlights. Reduce the opacity to around 20–30% to ensure that you lighten the background in the top left-hand corner without unduly affecting the sitter's hat. Lower the opacity to 10% to lighten the rest of the background on this side (around the beard). The following steps will ensure that this backdrop will look like something from a studio (rather than the bus shelter where this image was captured).

Burn tool > Use a similar soft-edged brush and paint with the Burn tool set to Midtones to reduce the distracting pattern of the clothing. You are not aiming to remove the texture – just subdue it.

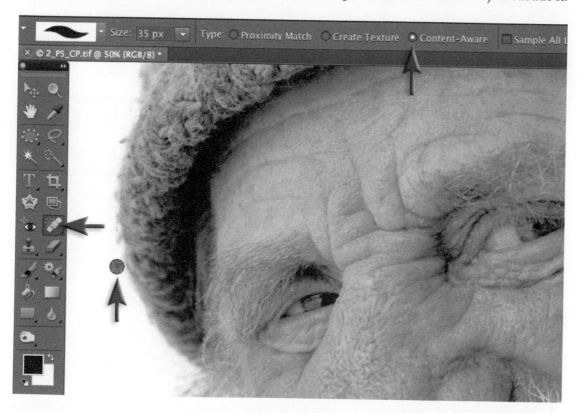

Spot Healing Brush > The Healing Brush tool is the best tool for removing distracting details or dust marks. Use a hard-edged Healing Brush when working in areas of large tonal difference, e.g. removing the dark woollen bobbles that are surrounded by the white background. This will ensure the healing area is not contaminated with the adjacent tones of the nearby hat.

2. To start working on the tonality we need to separate the 'luminance' or brightness values from the color component of the image. Start the process by dragging the background layer to the New Layer icon in the Tools panel to duplicate it (alternatively use the keyboard shortcut Ctrl/ Command + J). Go to Enhance > Adjust Color and then choose the Remove Color command from the submenu. This will create a desaturated layer sitting above the colored background layer.

3. The fine detail of this portrait is going to be more pronounced if we create some smooth underlying tones. These smooth tones will also help to increase the three-dimensional quality of the portrait. Duplicate the desaturated layer using the keyboard shortcut Ctrl/Command + J and then go to the Filter menu and choose Gaussian Blur from the Blur submenu. Choose a generous Radius value – one where the skin tones are very smooth but the facial features can still be made out. When the Blur Radius is selected select OK.

4. Switch the blend mode of the blurred layer to Multiply. The Multiply mode blends the blurred tones back into the sharp detail underneath but renders the image temporarily dark. The shadow information, although very dark, is not lost or clipped by this blending technique. The overall brightness of the image will be restored in the next step so that we can appreciate how effective this technique has been.

Multiply mode > The Multiply blend mode is one of the most useful blend modes for creative editing of digital images. The Multiply blend mode belongs to the Darken family grouping. The brightness values of the pixels on the blend layer and underlying layer are multiplied to create darker tones. Only values that are multiplied with white (level 255) stay the same.

5. To restore the majority of the brightness values to this image simply create a new Levels adjustment layer and switch the blend mode to Screen. The action of first multiplying and then dividing (screening) has, however, incorporated the Blur layer into the pixel stew and the visual outcome is altogether different from the starting image.

Screen mode > The Screen mode belongs to the Lighten family grouping and has the opposite effect to the Multiply blend mode.

PERFORMANCE TIP – BEFORE AND AFTER

When working on a long project it is often necessary, or reassuring, to perform a quick taste test, i.e. gain a quick reminder of how life started out for this image and whether the techniques you are using are creating positive or negative visual outcomes. Rather than clicking on each individual layer's Eye icon, to switch the visibility off (one by one), you can simplify the process by simply holding down the Alt/Option key and clicking only the Eye icon on the background layer or the first black and white layer. This action switches all of the other layers off in a single click, enabling you to see how life for this image started out. Alt/Option + click a second time to switch all of the layers back on. Looking good? Then let's proceed.

PERFORMANCE TIP – MERGE VISIBLE

One of the really essential techniques for multilayered image editing is the ability to take all of the combined elements from the visible layers and merge them to a single new layer. It is so important that Adobe have decided to keep the shortcut a secret. The long way to achieve this merging process involves choosing Select All from the Select menu, Copy Merged from the Edit menu, and then selecting Paste, again from the Edit menu.

Merge Visible – the mother of all keyboard shortcuts

The shortcut involves several key presses, but will save you considerable time as this technique is used over and over again in this style of editing. It will also impress the socks off image editors who are self-taught and who are most unlikely to have come across this permutation, as it involves holding down nearly all of the left side of the keyboard! Hold down the Ctrl/Command, Alt/Option and Shift modifier keys and then (while still holding down the modifier keys) press the letter E. If your new layer is not on top of the layers stack, click and drag it to the top of the Layers panel.

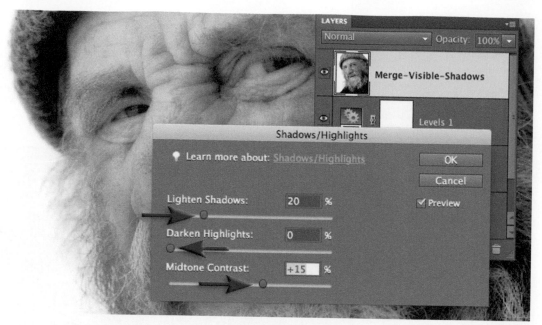

6. Sometimes tones need to be rescued if they are getting too close to 0 or 255. As the shadows are starting to make friends with level 0 and getting a little too close for comfort, we must instigate a rescue attempt. We will need to merge all of the visible elements to a new layer (see previous performance tip) if we are to utilize our good friend and ally – Shadows/Highlights. Choose Enhance > Adjust Lighting > Shadows/Highlights. Move the Lighten Shadows and Midtone Contrast sliders so that your shadows have depth but have a small amount of detail.

The Shadows/Highlights adjustment feature is an excellent tool for targeting shadow or highlight tones that need to be massaged in isolation and brought back into the range of tones that can be comfortably printed using an inkjet printer. Although the Screen blend mode did an excellent job of moving the midtones and highlight tones back to their former glory, the shadows of this image are still struggling to emerge above a level where they are likely to print with detail (between level 15 and level 20 depending on the type of paper, ink and printer being used). The adjustment feature can be accessed via the Enhance > Adjust Lighting menu. Before accessing the adjustment feature it is probably worth having either the Histogram panel and/or the Info panel open so that you can gauge when the shadows have been restored to a value that will print on your trusty inkjet printer. Raising the Midtone Contrast slider can also inject some life and drama into the tonality of the image. You may need to do a balancing act between the two sliders whilst observing the numerical or visual effects on your tonal range if you intend to make use of the Midtone Contrast slider.

PERFORMANCE TIP – SHADOWS/HIGHLIGHTS

The Shadows/Highlights adjustment feature is the most sophisticated tool for lowering excessive contrast in Adobe Elements. The tool made a very welcome appearance way back in Elements 3.0 and forms part of the sophisticated armory of adjustment features that can enable users to edit the tonal qualities of an image with control and confidence.

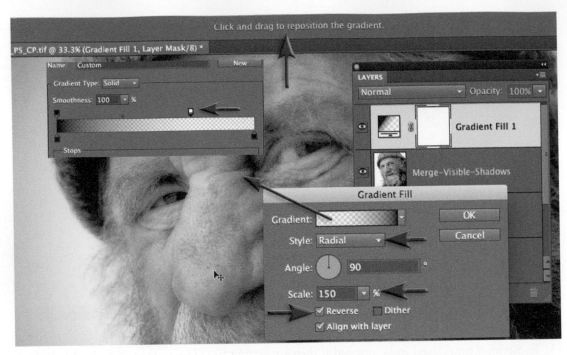

7. The next step involves getting rid of the distracting white background and replacing it with something a little more dramatic. Before creating a gradient make sure that black is the foreground color in the Tools panel (type D on the keyboard to return the color swatches to their default setting). From the Create Adjustment Layer menu in the Layers panel choose Gradient. The creation of a radial gradient or 'vignette' involves fours steps. First choose the Radial and Reverse options in the Gradient Fill dialog box and enter a value of 150% in the Scale field. The second step involves clicking on the gradient to open the Gradient Editor. Choose the Foreground to Transparent preset and move the opacity stop on the far right of the gradient ramp to the left to clear the face of any tone, thereby pushing the starting point of the gradient to the edge of the face. For the third step select OK to close the Gradient Editor and then drag inside the image window to move the center of the gradient to the perfect position. Finally (Step 4) select OK and adjust the opacity of the layer to balance the background tone with the portrait.

PERFORMANCE TIP – GRADIENT LAYERS

Although Gradient layers represent an important and powerful editing tool, the good people at Adobe have overlooked a very important aspect in this adjustment layer feature, making it one feature short of a full load. Gradients have a nasty habit of 'banding', either in the screen view and/or in the printed image, giving the tonal transition a posterized appearance that is not at all in keeping with the rich tonal qualities of advanced image-editing techniques. To ensure this banding does not raise its ugly head the user must add noise to any areas of smooth tone after any gradients have been applied. Gradient layers unfortunately do not contain pixels to which noise can be added, so this can become especially problematic and requires an additional Noise layer to resolve the problem.

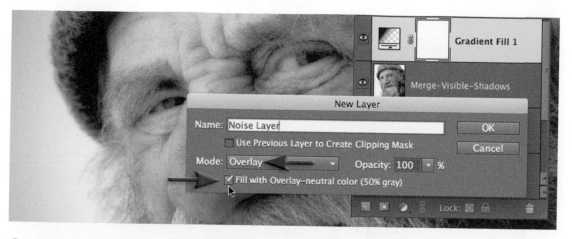

8. Adding rather than reducing noise may sound strange. One has to remember, however, that the gradient is completely artificial and noiseless – something that cannot be matched even with a low-noise image captured on a digital camera using a low ISO setting. By adding noise we are merely trying to match the noise present in the rest of the image and at the same time eliminate or reduce the problem of banding. You can add noise directly to the Gradient Fill layer but you will have more flexibility and control if the noise is added to a separate layer. To create a Noise layer hold down the Alt/Option key and click on the New Layer icon in the Layers panel. In the New Layer dialog box choose Overlay as the mode and click on the 'Fill with Overlay-neutral color (50% gray)' checkbox.

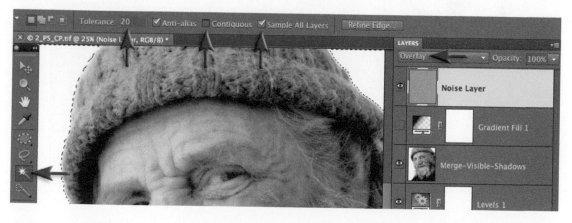

Select OK and then switch off the visibility of the Gradient layer so that we can see the original white background. Only one selection is used in this project and it is used to isolate the background for the noise treatment. Select the Magic Wand from the Tools panel and then the Sample All Layers option in the Options bar. Deselect the Contiguous box and lower the tolerance to 20 to ensure that the selection is painless – a single click should do the trick. You will need to add a generous amount of feather (100 pixels or more) to this mask to create a gradual transition between noise and no noise (Select > Feather). After feathering the selection, switch the visibility of the Gradient Fill layer back on. Zoom in to 100 or 200% (avoid magnifications that do not give an accurate screen view, e.g. 66%, 133% etc.).

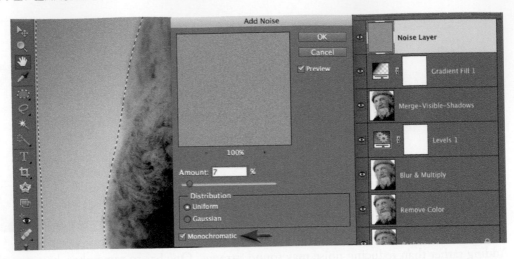

9. With the selection still active select the Add Noise filter from the Filter > Noise submenu. Select the Monochromatic option and choose an amount that will create a noise level that is consistent with the rest of the image file. To check that the noise level is OK zoom in to Actual Pixels (View > Actual Pixels) and then hold down the Spacebar to enable you to drag the image between the gradient (with added noise) and the face (with no added noise). When the texture is consistent select OK. From the Select menu choose Deselect.

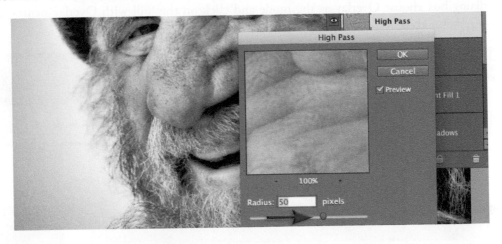

10. The localized contrast is already vastly improved from the original file, but if you want to see how far you can take this tonal manipulation you may like to try the following technique that can add depth and volume to a seemingly lifeless and flat image. Merge the visible elements yet again to another new layer (Ctrl/Command + Alt/Option + Shift and then type E) and then switch the blend mode to Overlay. From the Filter menu go to the Other submenu and choose the High Pass filter. When this filter is used as an alternative to the Unsharp Mask filter a small radius of between 1 and 5 is usually selected, depending on the resolution of the image file and the output medium, but in this case the Radius slider can be moved much higher whilst observing the effects on the image file. At the moment the effects may appear a little excessive, but lowering the opacity of the layer and/or switching its blend mode to Soft Light can refine the overall effect.

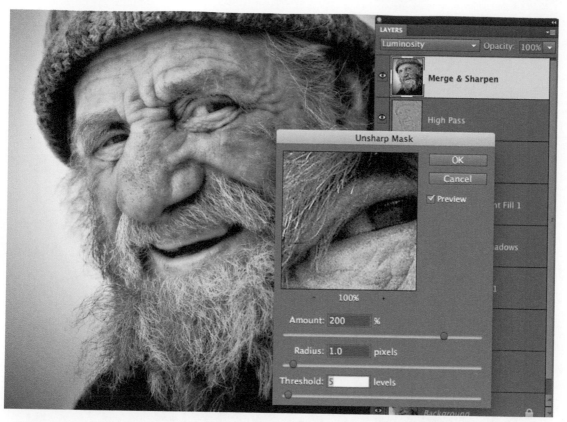

11. The rich tonality will now serve as an excellent canvas for the fine detail that we are about to sharpen. Sharpening should always be done late in the editing process to avoid exaggerating any image artifacts or non-image data. If you are to have maximum control over the sharpening process and the flexibility to adjust the level of sharpening after making a test print (images tend to look a little softer when compared to their screen counterparts – especially when using LCD displays), you need to apply the Unsharp Mask to a Copy Merged layer. You know the drill by now – merge visible to a new layer. When this has been done you should set the blend mode to Luminosity. Switching the layer to the Luminosity blend mode will have zero effect on the visual outcome of the image at this stage. The advantage of this mode change is seen when the color is switched back on in the next and final step of the project. If you are used to applying conservative values in the Unsharp Mask filter this is not the time to exercise restraint. Be generous – very generous – with the Amount slider (200 in this project) but keep the Radius slider to the usual amount (no more than 1.5). The Threshold slider, which is usually raised to avoid sharpening minor details, can either be left at 0 so that all of the image information comes under the global sharpening umbrella or raised to around 5 so that the image noise levels are not excessively sharpened. You will need to print a test strip to your favorite paper surface before you can assess whether the amount of sharpening for this image is correct. If the sharpening seems a little excessive simply lower the opacity of the Sharpening layer until you find the perfect setting for your paper.

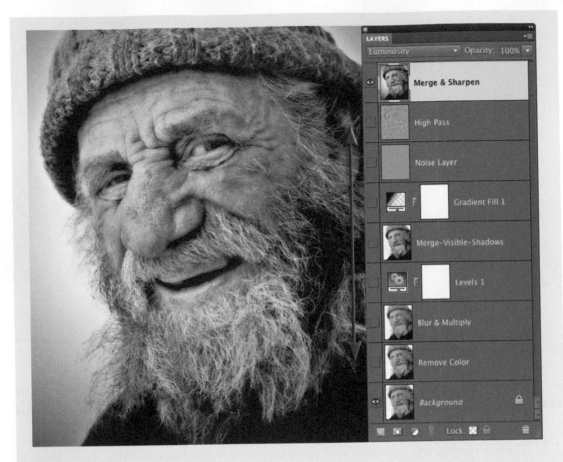

PERFORMANCE TIP

You might be so impressed with the tonal qualities of your monochrome masterpiece that the thought of switching the color back on gives you the shivers. It is important, however, to the learning curve of this project to discover how the luminance values of an image file can be edited independently of the color before being reunited. Color can be a major distraction when editing tonality. Switching off the visibility of the three monochrome or desaturated layers sitting directly above the background layer will allow the top layer in Luminosity mode to merge with the color of the background layer. The blend modes are one of the most under-utilized of the editing features to be found in Photoshop Elements. Perhaps it is because of their slightly abstract names and their mathematical approach to multilayered pixel editing, but their creative power and usefulness should not be underestimated. With the digitally remastered dish ready to serve up to your printer, you may need to savor both monochrome and color versions over a period of time before your own personal preference helps you make the final decision. Enjoy!

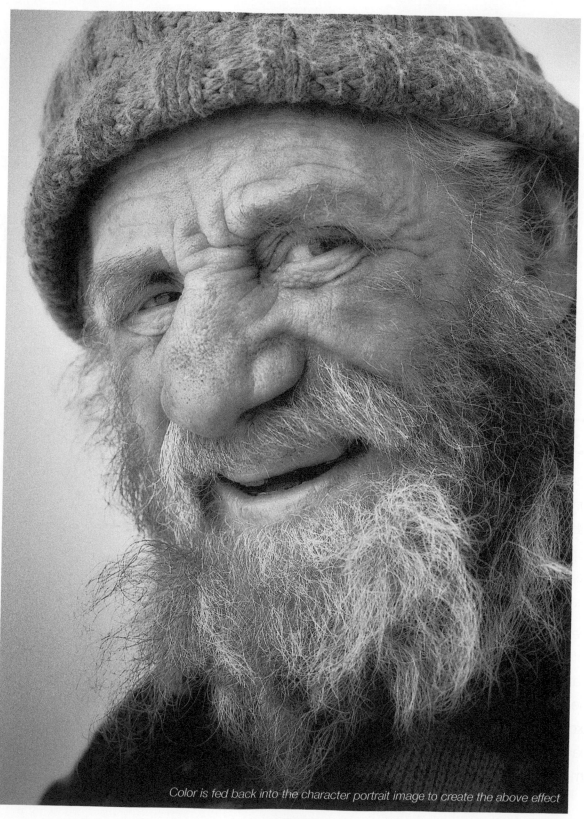

Color is fed back into the character portrait image to create the above effect

Project 5

Glamor Portrait

Cheaper (and more fun) than plastic surgery, we explore how pixel surgery can be used to craft perfect portraits that are bound to flatter the sitter every time. The glamor portrait offers an excellent opportunity to test the effectiveness of a variety of image-editing skills. The portrait is an unforgiving canvas that will show any heavy-handed or poor technique that may be applied.

We will start with a color portrait that has been captured using a soft, diffused light source. This project will aim to perfect various features and not to make such changes that the character of the sitter is lost to the technique. The techniques used do not excessively smooth or obliterate the skin texture, which would lead to an artificial or plastic appearance. The techniques used smooth imperfections without totally eliminating them.

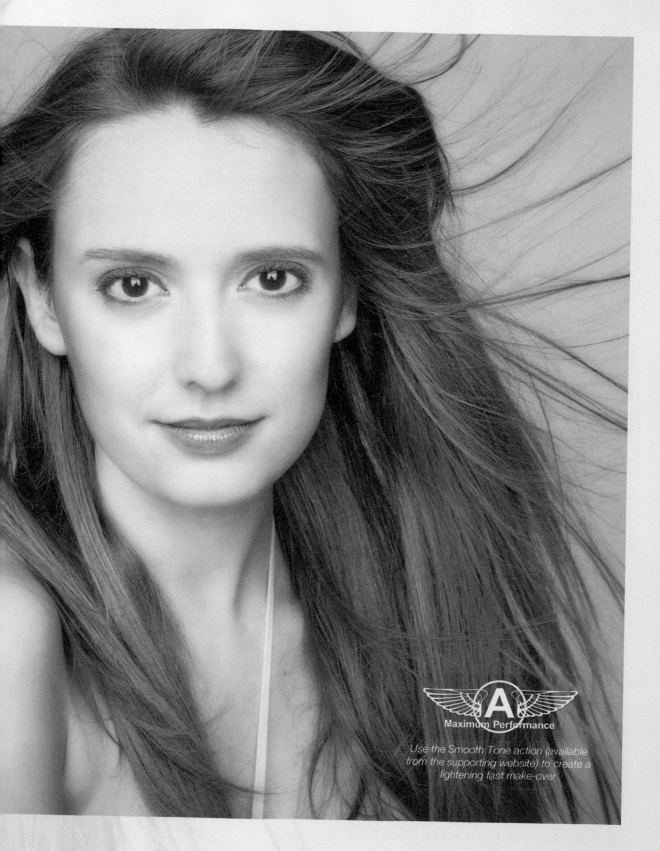

Maximum Performance

Use the Smooth Tone action (available
from the supporting website) to create a
lightening fast make-over

The 15-minute (after practice) makeover – techniques designed to flatter your model

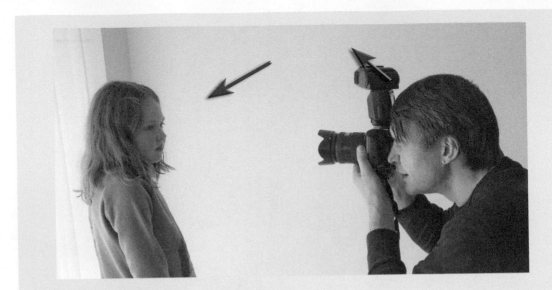

PERFORMANCE TIP

Use window light or diffused flash to obtain a soft, low-contrast light source to flatter the subject. Avoid direct flash unless it is diffused with a white umbrella. Stand back from your sitter and zoom in with your lens rather than coming in close and distorting the features of the face (the closer you stand, the bigger the nose of the sitter appears). A white background is difficult to create if you don't have a studio backdrop and multiple lights but, with a little practise, it is possible to get a near-white background by capturing the sitter in front of a white translucent curtain against a brightly illuminated window and with a single introduced light source.

1. The flowing hair in this project was created using a strong fan that caused the young woman to half-close her left eye. This was repeated for all of the images captured using the fan so we will use Photoshop to open her eye and restore her natural beauty. To start this process go to File > Duplicate and then in the Duplicate Image dialog select OK.

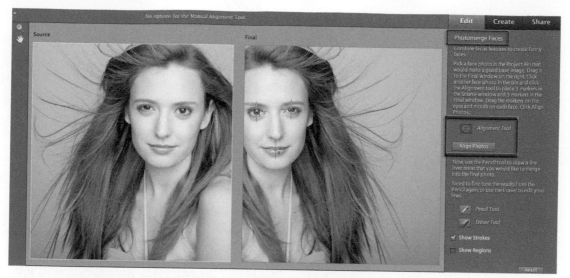

2. With the duplicate image go to Image > Rotate > Flip Layer Horizontal. Select OK when you are prompted to turn the background into a layer. Select both images in the Project Bin and then go to File > New > Photomerge Faces. Drag the original image into the place holder for the Final image and select the Flipped image as the Source. Align the Photos by placing the three targets over the eyes and mouth in both images and then hit the Align Photos button.

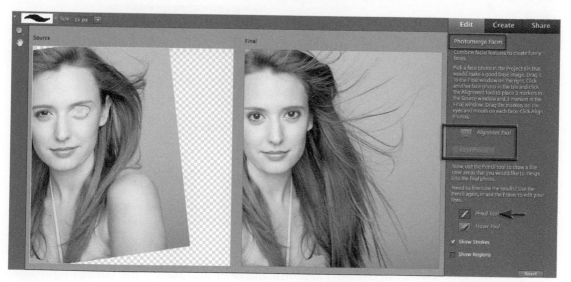

3. Select the Pencil Tool in the Photomerge Faces dialog and draw over the eye that is fully open. The Final image should now acquire the eye from the source image and the surrounding area is blended so that the composite view is seamless. Return to the Full Edit view after completing this process.

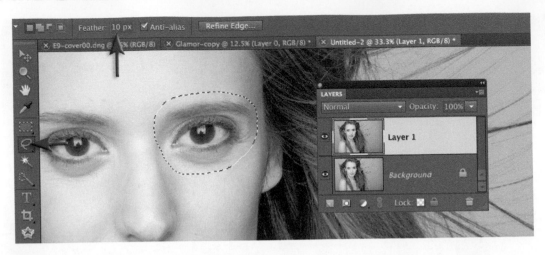

4. Although the new eye has been patched seamlessly you may find that the eye appears a little crooked due to the alignment issues in the Photomerge Faces dialog. To straighten this crooked eye we will need to make a selection of the eye and eyebrow on this top layer using the Lasso tool with a 10 pixel Feather. Make sure the edge of the selection passes through skin on all sides. From the select menu choose Inverse and then hit the Backspace key (PC) or Delete key (Mac) to remove the pixels surrounding the eye. Choose Inverse from the Select menu again.

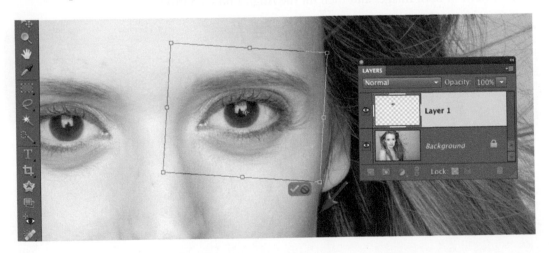

5. Go to Image > Transform > Free Transform and drag just outside the bottom right-hand corner handle to rotate the eye. You may also need to use the keyboard arrow keys to nudge the eye into position. Dropping the opacity of the layer or switching the mode of this layer to Difference may help you to locate an appropriate position for this eye as you will then be able to see the half-closed eye on the layer below. Hit the Commit icon when you have finished positioning the eye. As this project contains many layers I will rename each layer as I move through the steps by double-clicking the layer name and entering in a description of what each layer contains or serves to add to the final image.

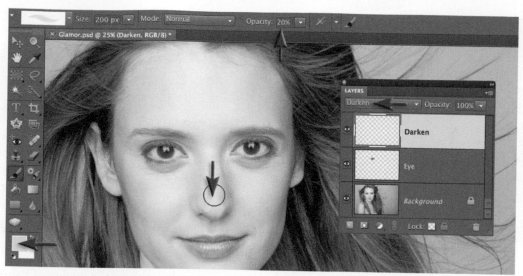

6. If the skin of your model appears shiny and is reflecting the lights you can create a layer that adds some foundation make-up to these areas to restore skin color. Click on the Create a new layer icon in the Layers panel and set the mode to Darken. Select the Brush tool from the Tools panel and then hold down the Alt key (PC) or Option key (Mac) and click on an area of good skin tone to sample the color. This skin color should now appear in the Foreground color swatch of the Tools panel. Drop the Opacity of the Brush to 20% in the Options bar and set the Hardness to 0% (click on the blue-tipped brush in the Options bar to access the Hardness settings). Now paint over any areas of skin that are too shiny, e.g. the nose and forehead. Painting a second time will build up additional tone. Too much painting will result in a loss of skin texture.

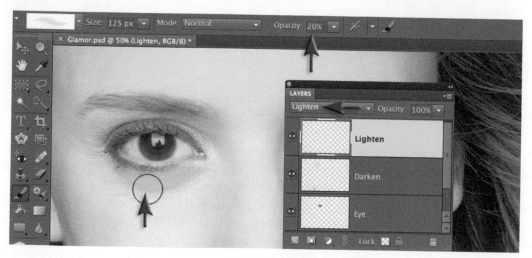

7. Add another new layer and set the mode of this layer to Lighten. With the same color you can now paint over any of the darker shadows on the face, e.g. painting below the eyes will reduce the shadows in this region. Painting several times will soften these shadows and create a smoother contour for the face.

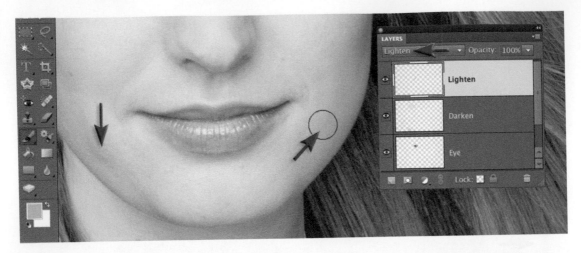

8. This Lighten brush is exceptionally useful as it can seemingly improve the quality of lighting to create gentle and soft contours. In this project image a little additional work around some of the small shadows around the jaw and to the nose will create a more flattering result.

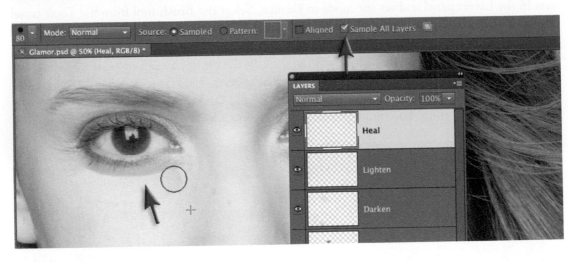

9. It is possible to remove all of the larger skin blemishes and wrinkles in a portrait image or just reduce their appearance (the detail produced by modern digital cameras can be very unflattering). Click on the Create a new layer icon in the Layers panel to add yet another new empty layer. Select the Healing Brush tool (behind the Spot Healing Brush tool) in the Tools panel and check the Sample All Layers option in the Options bar. Raise the Brush Hardness to 75%. Hold down the Alt key (PC) or Option key (Mac) and sample an area of clear skin below one of the eyes. Then click and drag in a single arc to remove the shadow under each eye. Avoid painting too close to the eyelashes otherwise you will draw this dark tone into the healing area. You can repeat the process to remove wrinkles. Switch to the Spot healing Brush to remove small skin blemishes. If your image is a portrait rather than an anonymous glamor image then it is recommended to drop the Opacity of this Heal layer to 50% to return some resemblance or reality.

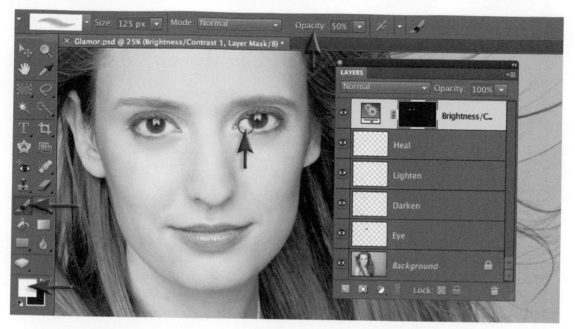

10. Click on the Create new fill or adjustment layer icon at the base of the Layers panel and choose a Brightness/Contrast adjustment layer. Raise both sliders to +20 and then use the keyboard shortcut Ctrl + I (PC) or Command + I (Mac) to Invert the layer mask to black. Select the Brush tool from the Tools panel and set White as the foreground color. Set the Brush Hardness and Opacity to 50% in the Options bar. Paint over each of the eyes to raise their luminance values.

11. Create a Hue/Saturation adjustment layer and raise the Saturation slider to +25 and again invert the layer mask to black. Paint over the lips and the iris of each eye to raise the vibrance of these colors. Make sure you do not paint over the whites of the eyes in this step. If the eyes appear bloodshot add a second Hue/Saturation layer and lower the Saturation slider to -90, Invert the layer mask and paint over the whites of the eyes to create clean tones in this region.

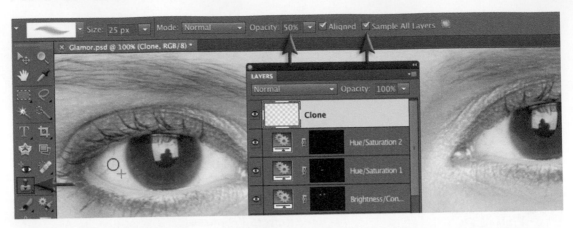

12. If there are any blood vessels that are too prominent in the eyes we can remove them using the Clone tool. Add an empty new layer and select the Clone Stamp tool from the Tools panel. Check the Sample All Layers option in the Options bar. Zoom in to 200% and then Alt/Option click some clean white tone in the eyes. Paint over the problematic areas at 50% Opacity to slowly reduce the visibility of the problematic areas.

13. Merge the visible pixels to a new layer using the keyboard shortcut Ctrl + Alt + Shift + E (PC) or Command + Option + Shift + E (Mac) and then duplicate this layer. Make sure this layer is on top of the layers stack in the Layers panel (usual if the top layer was selected when using this keyboard shortcut). Go to Filter > Blur > Surface Blur raise the Radius slider until you get smooth tones across some of the problematic areas (this model has goose bumps on her neck due to a combination of the cold studio and the fan being used). Set a value for the Threshold slider that keeps the blur behind the higher contrast edges (such as the side of the face). If the Threshold slider is too high the blur will bleed over the edges. If the Threshold slider is too low the smooth tone will be reduced.

14. Click on the Add layer mask icon in the Layers panel and Invert the layer mask (Ctrl/Command + I). Select the Brush tool and set the Opacity to 50% and the brush Hardness to 0%. Paint over any areas that need some help in creating smoother tones. This young woman has excellent skin so apart from the goose bumps on the neck there are only minor areas that have needed attention. I have painted in small localized areas around the mouth and the extreme edges of the face. If you paint more than once you will risk losing the skin pores that makes the skin look natural.

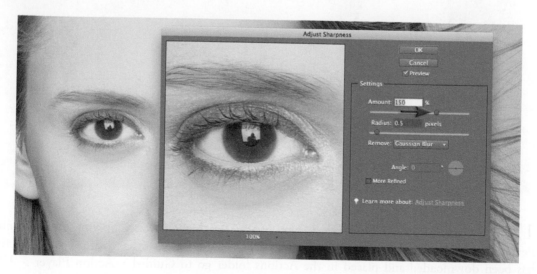

15. Create another Merge Visible layer (see Step 13) and then go to Enhance > Adjust Sharpness. Raise the Amount slider to 150 and reduce the Radius slider to 0.5. Select OK and then click the Add layer mask icon and invert the layer mask (Ctrl/Command + I).

16. Set the mode of the sharpening layer to Luminosity and add a layer mask. Invert the layer mask so that it is filled with black (Ctrl/Command + I) and then paint with white to reveal the sharpening. There is no reason to sharpen the skin so we are painting over the eyes, lips and hair only. To help see where you have painted hold down the Alt + Shift keys (PC) or Option + Shift keys (Mac) and click on the layer mask to reveal the mask as an overlay. Painting with white will remove the overall color and reveal the sharpening.

17. If you want to create a smooth dreamy quality for this image try applying the Maximum Performance Smooth Tone action that is available from the supporting website. After the action has been downloaded and placed in the Actions folder go to Guided > Action Player > APE-Smooth-Tone and select one of the Multi-Layer options. Click on the Play Action button to apply the Smooth Tone technique. If you find the technique too strong select all of the layers that produce this effect in the Layers panel and then select Merge Layers from the fly-out menu. Drop the opacity of the resulting Smooth Tone Layer to reduce the effect.

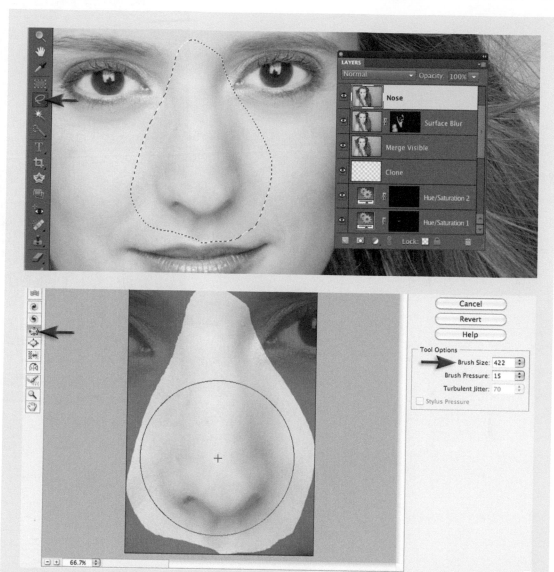

PERFORMANCE TIP

This is not recommended if this is to be a realistic portrait but if glamor is your goal it is possible to give your model a nose job using the Liquify filter. Create a Merge Visible layer (see Step 13) and then make a selection of just the nose. It is possible to 'freeze' pixels to protect them from the actions of the Liquify filter. There is a freeze brush in the Liquify filter of the full version of Photoshop – but not in Photoshop Elements. To activate the freeze in Elements simply make a selection prior to selecting the Liquify filter. Select the area to be modified, being careful to leave out sections of the face that should be protected from the pixel surgery. With the selection active, open the Liquify dialog box (Filter > Distort > Liquify). The areas outside of the selection are now frozen. Select the Pinch tool and then increase the brush size so that it is larger than the nose. A couple of clicks towards the top of the nose will narrow the bridge. A couple of clicks near the end of the nose will reduce its size.

Project 6

Tonal Mapping (Faux HDR)

In this project we will give your photographs 'the treatment' to create a signature style. We will boost detail by pushing some of Photoshop Elements's adjustments to the max. The final effect is one where the image seems to be part photograph, part illustration.

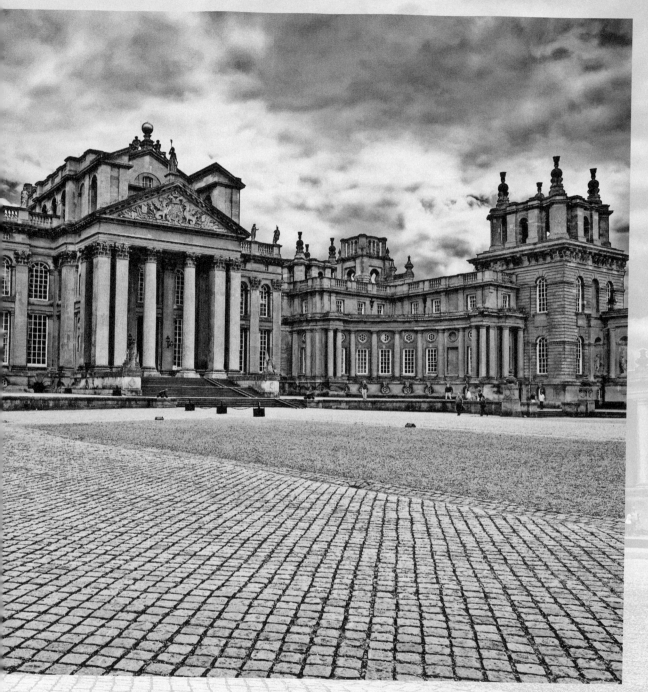

Blenheim Palace with the Faux HDR treatment - Enhanced detail to give a flat image depth and drama

In commercial photography the post-production treatment is discussed early in the pitch to the agency or client. One of the cutting-edge treatments in commercial photography, that is all the rage at the moment, is where maximum detail and surface texture is expanded along with mid-tone contrast.

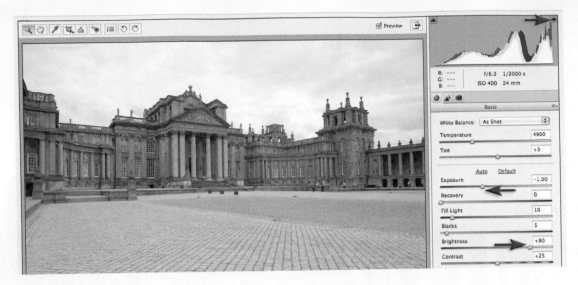

1. This project can be started from the original Raw file or the JPEG file that was created after processing the Raw in Adobe Camera Raw. The important aspect of the Raw processing is to protect highlight detail by lowering the Exposure slider and then raising the brightness slider. Although there seems to be very little worth recovering in the highlights of this image, one glance at the final image will show you just how much extra detail can be created by applying this tonal mapping technique.

2. Select the Magic Wand tool from the Tools panel. Use the default Tolerance of 32 and remove the check from the Contiguous box in the Options bar. Click on the sky to select it and if there is a portion of the sky that remains unselected, hold down the Shift key and click again to add this area to the selection.

Note > The Magic Wand is superior to the Quick Selection tool in this instance as it will select all of the tiny islands of sky in the balcony of the palace.

3. Select the Selection Brush tool in the Tools panel and choose the Mask option in the Options bar. Set the Hardness and Overlay settings to 100% and then paint over any of the areas in the foreground to create a solid mask.

4. Click on the Create new fill or adjustment layer icon at the base of the Layers panel and choose Levels. Drag the Black Input slider underneath the histogram to the start of the histogram (around 100) and move the central gamma slider to the right to darken the sky significantly (around 0.40).

5. The edge of the mask will need some work. Go to Select > Refine Edge and choose the blue Standard viewing icon. Use the keyboard shortcut (Ctrl + H (PC) or Command + H (Mac) to hide the selection edges. Soften the edge by raising the Feather slider to 2.0 pixels and raise the Contract/Expand slider to +10 to hide any halo that may be visible along the edge. Select OK.

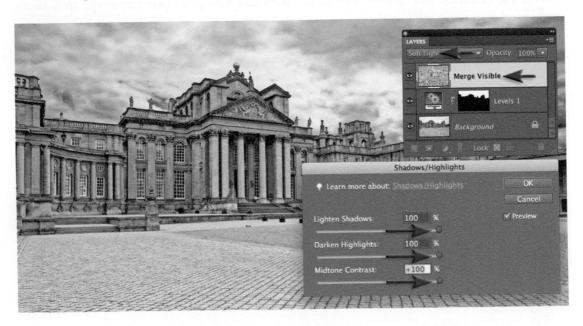

6. Merge the visible elements to a new layer using the keyboard shortcut Ctrl + Alt + Shift + E (PC) or Command + Option + Shift + E (Mac) and set the mode of this layer to Soft Light. Go to Enhance > Adjust Lighting > Shadows/Highlights and raise all three sliders to +100 and then select OK.

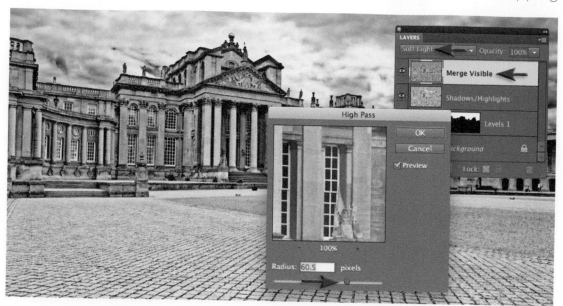

7. Double-click on the Merge Visible layer and rename it 'Shadows/Highlights'. Create another Merge Visible layer and again set the mode to Soft Light. Go to Filter > Other > High Pass and raise the Radius slider high until the apparent depth of the image increases (around 60 pixels for this project image).

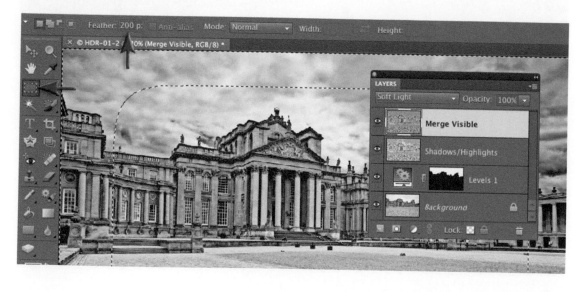

8. In the next two steps we will create a vignette to darken the outer edges of the image to increase the drama further. Select the Rectangular Marquee tool from the Tools panel. Enter a 200 pixel Feather in the Options bar and then drag from the upper left hand corner of the image to the lower right-hand corner. From the Select menu choose Inverse so that the outer edges of the image are selected.

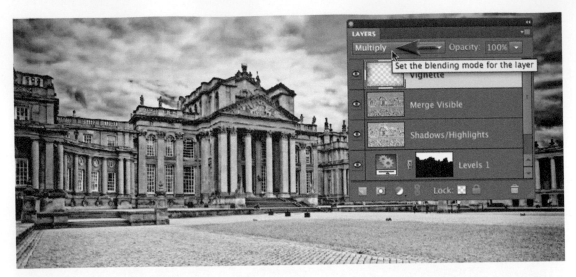

9. From the Edit menu choose Copy Merged (we are copying what we can see rather than what is on the active layer) and then from the Edit menu again choose Paste. Set the mode of this new layer to Multiply and adjust the Opacity of the layer if required. Double-click on the name of this new layer and call it 'Vignette'.

10. If you find the expanded contrast and detail a little too much you can lower the Opacity of the top three layers or add a small amount of Gaussian Blur to a background copy layer. To try this simply click on the background layer and use the keyboard shortcut Ctrl/Command + J to create a duplicate layer and then go to Filter > Blur > Gaussian Blur and enter in a value of around 3 pixels.

11. If you like your treatment crunchy rather than smooth, switch off the visibility of this background copy layer and select the Vignette layer to make this the active layer. Create a Merge Visible layer (see Step 6) and then go to Filter > Sharpen > Adjust Sharpness. Raise the Amount slider to 200 and reduce the Radius slider to 0.5 and then select OK.

12. This whole process is available as a Maximum Performance action that can be download from the supporting website. The action has to be placed in the Actions folder and then it can be accessed from the Action Player in the Guided Edit section of the Edit workspace. A one-click solution for people in a hurry!

TONAL MAPPING IN ADOBE CAMERA RAW

In the 'Toning' project we softened the majority of the tones and remapped the colors. In contrast to this smooth tone technique there are several techniques for expanding midtone contrast to give you the 'crunchy' look or treatment.

Detail can be boosted by pushing some of the sliders in ACR to the max. One of the cutting-edge treatments in commercial photography that has been all the rage recently, is expanding maximum detail and surface texture along with mid-tone contrast. The final effect is one where the image seems to be part photograph, part illustration. Take a look at http://www. davehillphoto.com/ to get an idea of how this treatment is being applied by one popular US photographer. It is also referred to as an HDR effect as this expanded midtone contrast can be created when photographers merge images with different exposures and then map the resulting detail. This effect can, however, be created in ACR and the main editing space of Photoshop Elements.

To expand the mid-tone contrast and edge detail within the image, move the Recovery, Fill Light, Contrast and Clarity sliders all the way to the right (to a value of +100). Lower the Vibrance slider to reduce the excessive saturation in the image that results from raising the contrast slider.

The massive adjustments may upset the brightness of the image. Click on both of the triangles above the histogram to switch the clipping warnings on. Adjust the white point of the image by dragging the Exposure slider to the left or right until thin red lines appear around the edges of the brightest parts of the subject. Adjust the black point of the image by dragging the Blacks slider to the left or right until thin blue lines appear around the edges of the darkest parts of the subject. Drag the Brightness slider to alter the overall brightness of the image and then click the triangles above the histogram to switch the clipping warnings off.

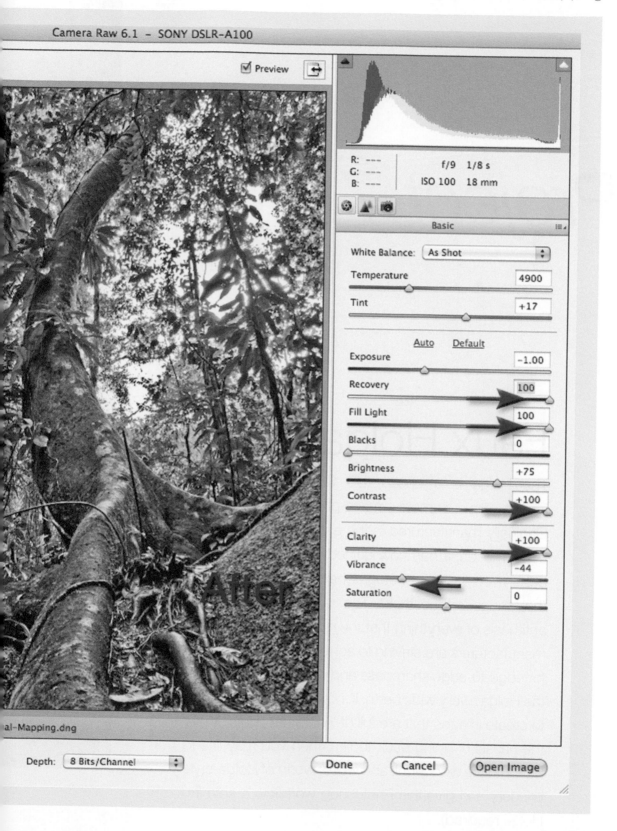

Project 7

Faux Holga

The Holga is a cheap (US $30) plastic medium format film camera mass-produced in China. Originally manufactured in the early 80s for the home consumption, it has now gained cult status amongst bohemian western photographers who are drawn to the grunge 'art' aesthetic. The camera represents the antithesis of everything that the modern digital camera manufacturers are striving to achieve. If you are looking for edge-to-edge sharpness and color-fidelity then give the Holga a very wide berth. If, however you are looking to create images that are full of 'character', but without the hassle of going back to film, then you may like to look into the wonderful, and weird, world of Holga-style imagery and give this Photoshop workflow a spin (no Holga required).

Use the Holga action (available from the
supporting website) to automate this style

Getting tired of pin-sharp, noise-free, character-free images from your 24 Megapixel Pro DSLR?
Then try this grunge effect to give your images the toy camera aesthetic – think WEIRD – think GRUNGE, think ART!

1. Images produced by the Holga camera are square so grab the Crop Tool from the Tools panel, hold down the Shift key to constrain the crop marquee to a perfect square and drag over the central portion of the start image. Hit the Commit icon or Return/Enter key to get rid of the unwanted pixels.

2. Duplicate the background layer using the keyboard shortcut Ctrl + J (PC) or Command + J (Mac). The background layer will serve as a resource to tone down the final effect in localized areas (if required). The next few steps will start to degrade the sharpness of your image (the Holga camera has a single simple lens element). With Layer 1 selected in the Layers panel go to Filter > Blur > Radial Blur

3. In the Radial Blur dialog box set the Amount to 3 and then select the Zoom and Best options. Click where you would like to preserve maximum sharpness in the Blur Center control box (to the right of the Zoom and Best options). There is an element of guesswork in this step but sharpness can be restored later in the process. I have selected the region in the lower center (where I estimate the pedestrians to be crossing the bridge in the actual image). Select OK to apply the blur to Layer 1.

4. Go to Filter > Blur > Gaussian Blur. Select a Radius of 1.0 pixel and then select OK to apply the blur to Layer 1. The next blur is called Diffuse Glow but to make sure the glow is white and not any other color we must set the Foreground and Background Colors to their Default setting (either click on the small Black and White box icon in the Tools panel or press the D key on the keyboard).

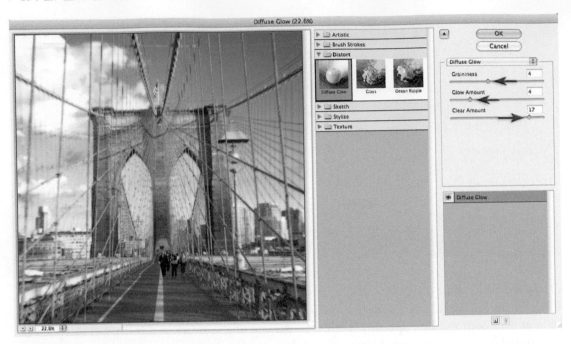

5. Try setting the Graininess and Glow Amounts to 4 and the Clear Amount to 17 as a starting point. You can increase the Graininess to simulate a high ISO film. Alternatively the grain can be set low in this dialog as we will have more control over how the grain looks if we apply it to a separate layer. Select OK to apply the Diffuse Glow to Layer 1.

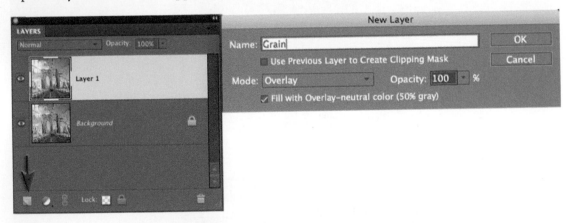

6. To create a Grain layer, hold down the Alt key (PC) or Option key (Mac) and click on the Create a new layer icon at the base of the Layers panel. Holding down the Alt/Option key while clicking on the icon will open the New Layer dialog. Name the layer 'Grain', set the mode to Overlay and check the Fill with overlay-neutral color (50% gray) checkbox. Select OK to create the Layer. The effects of the layer will be invisible at this point in time (courtesy of the blend mode) until the grain is added in the next step.

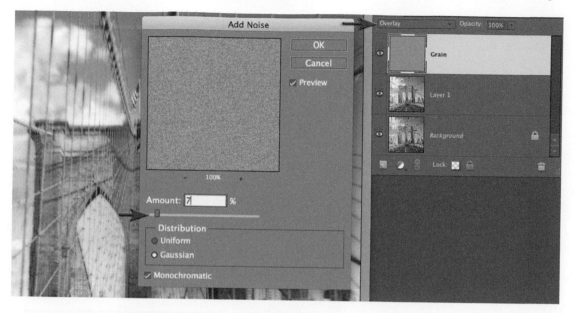

7. In the Add Noise dialog set the Amount to 7% for a 12-Megapixel image (adjust it higher or lower if you are using a higher- or lower-resolution image). Choose the Gaussian option and select the Monochromatic checkbox before selecting OK to apply the Noise to the Grain layer. Adjust the opacity of the layer if the noise is too prominent.

8. We will now replicate the dark vignette that is a characteristic of Holga images. Select the Rectangular Marquee Tool and set the Feather to 150-pixels (adjust this higher or lower if you are using a higher- or lower-resolution image). Drag a rectangular selection so that the central portion of the image is selected (this will leave a border around the edge of the image that is not selected. From the Select menu choose Inverse and from the Edit menu choose Copy Merged to copy the edge pixels to the clipboard. From the Edit menu choose Paste.

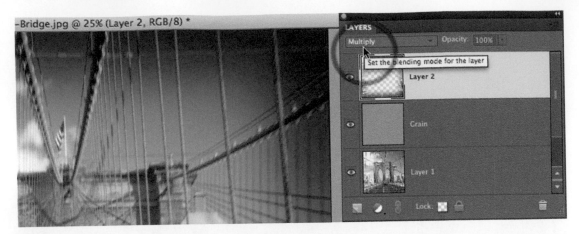

9. The pixels will be pasted to a new layer (Layer 2). At the moment they are identical to the pixels on Layer 1 but when we select the Multiply mode from the Layers panel they can be used to darken down the edges of the image.

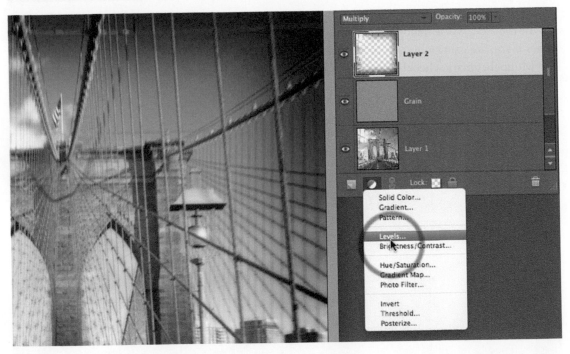

10. Another characteristic of the Holga image is the surreal color-palette that is present in many (but not all) Holga images. This is a result of either poor processing or cross processing of the film (cross processing intentionally uses the wrong chemicals for the film stock used). We can replicate this look with just a few Adjustment layers. From the Create new fill or adjustment layer menu (accessed from the Layers panel) choose a Levels adjustment layer.

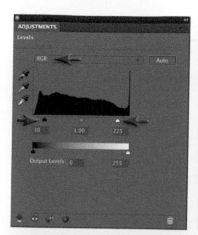

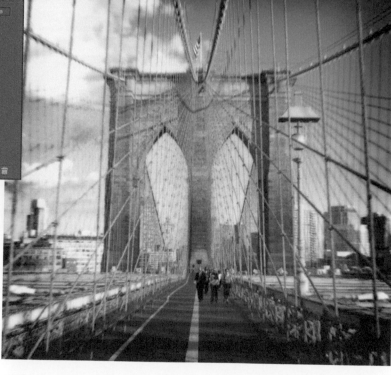

11. Clip the shadow and highlight tones by setting the Black input slider to 30 and the White input slider to 225 (these sliders are located directly underneath the histogram). Select the Blue Channel from the drop-down menu in the Levels dialog and then drag the Output Levels sliders to 64 and 190. The Output Levels sliders are located directly underneath the Input sliders. This action will weaken the blacks, render the whites slightly dull and introduce a color cast in both. Select the Green Channel and set the Output sliders to 40 and 230 to increase this effect. Finally, select the Red channel and drag the central gamma slider (directly underneath the histogram) to the left so that it reads 1.10.

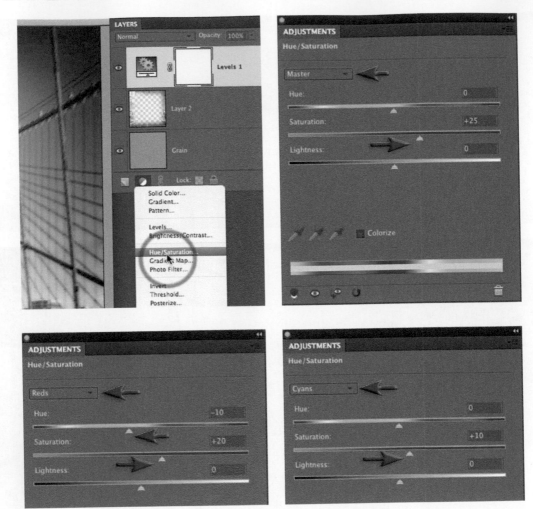

12. We can alter the color and tone using a Levels adjustment but we will need to use a Hue/Saturation adjustment layer to alter global saturation levels and target specific colors for further attention. Start by raising the Saturation level to +25 in the Master channel. In the red channel Adjust the hue to -10 and raise the saturation to +20. In the Cyan and Blue channels raise the Saturation to +10 for both.

Note > Use these target values as a starting point only. When applying this technique to your own images you may like to try experimenting by raising the saturation levels of key colors within a specific image.

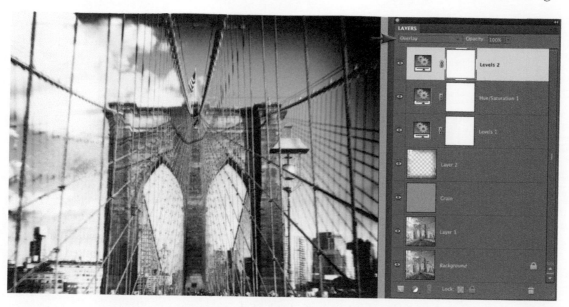

13. To increase the overall contrast you can add another Levels adjustment layer and set the Mode to Overlay. If the colors become too 'intense', either lower the opacity of the Hue/Saturation layer below or change the mode of this second Levels adjustment layer to Soft Light. If this contrast adjustment layer compromises shadow detail, raise the Levels Output slider to a value of approximately +25.

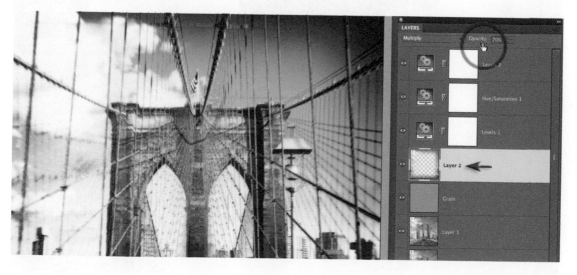

14. Many aspects of the final result can be fine-tuned by going back to the individual layers and adjusting either the settings or the opacity. In the example above, the effects of the vignette layer (Layer 2) is reduced by lowering the opacity. Paint with black as the foreground color into any of the adjustment layer masks to reduce the effects in a localized region of the image. Be sure to paint with a large soft-edged brush with the opacity setting in the Options bar reduced to around 50%. Use the Eraser Tool at a low opacity on Layer 1 to restore fine-detail where required.

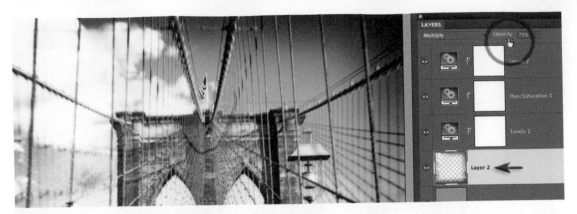

15. Some Holga images 'suffer' (or are 'blessed with' - depending how you look at it) from serious edge clipping and/or light leaks. The corner clipping can be unevenly distributed and more severe than your typical vignette. The corner clipping can be replicated by first creating a new layer and then making another edge selection using the Rectangular Marquee Tool with a 150-pixel feather as we did in Step 8. Choose Inverse from the Select menu.

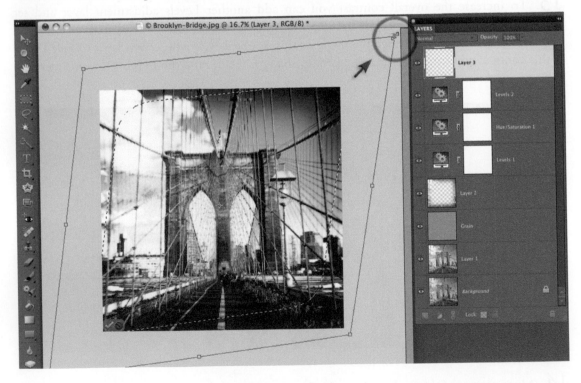

16. Go to Select > Transform Selection (this feature only became available in Photoshop Elements 8). Zoom out so that you can see the corner handles of the Transform bounding box. Hold down the Ctrl key (PC) or Command key (Mac) and drag two of the four corner handles out in a diagonal direction. Commit the transformation by hitting the Return/Enter key.

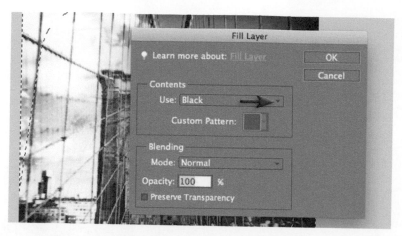

17. Go to Edit > Fill selection and choose Black as the contents before selecting OK. Lower the opacity of the layer depending on how severe or subtle you want the effect to appear.

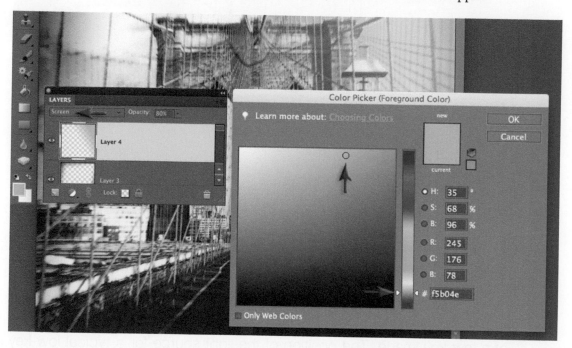

18. Light leaks in Holga cameras appear as light orange patches on some frames (some Holga camera owners use black tape around the film loading area of the camera in an attempt to minimize this problem. These light leaks (if required) can be simulated by adding a new empty layer and setting Mode to Screen. Click on the Foreground color swatch in the Tools panel to open the Color Picker. Select an orange color (around Hue 35°) with Saturation value of around 65 to 70%. Select OK and then select the Gradient Tool in the Tools panel. Choose the Foreground to Transparent gradient and the Linear Gradient options in the options bar and then drag a diagonal gradient across one of the corners of the image. Lower the opacity of the layer if you need more subtlety – although to be honest, subtlety is not the name of the game here.

Project 8

Low Key

A low-key image is one in which the dark tones dominate the photograph. Small bright highlights punctuate the shadow areas, creating the characteristic mood of a low-key image. The position of the light source for a typical low-key image is behind the subject or behind and off to one side so that deep shadows are created. In the olden (pre-digital) days choosing the appropriate exposure usually centered around how far it could be reduced by the photographer before the highlights appeared dull. In the digital age this approach to exposure at the time of capture should be avoided at all costs, especially when black velvet-like tones are your benchmark for quality.

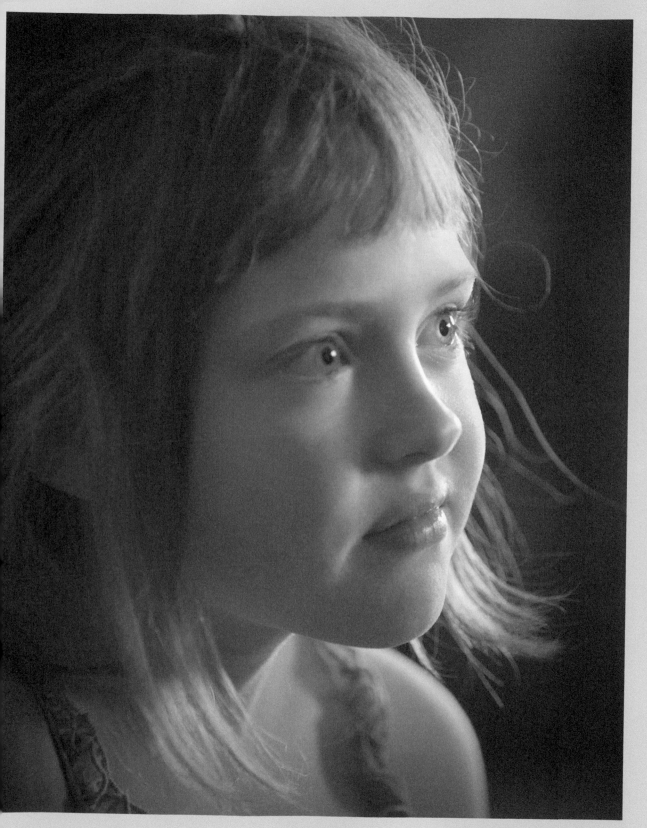

The classic low-key image – redefining exposure for a digital age

Exposure for low-key images

For those digital photographers interested in the dark side, an old SLR loaded with a fine-grain black and white film is a hard act to follow. The liquid smooth transitions and black velvet-like quality of the dark low-key prints of yesteryear is something that digital capture is hard pressed to match. The sad reality of digital capture is that underexposure in low light produces noise and banding (steps rather than smooth transitions of tone) in abundance. The answer, however, is surprisingly simple for those who have access to a DSLR and have selected the Raw format from the Quality menu settings in their camera. It is to be generous with your exposure to the point of clipping or overexposing your highlights and to only attempt to lower the exposure of the shadows in Adobe Camera Raw (ACR).

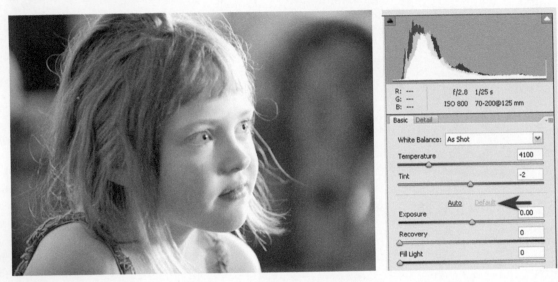

1. The first step is the most difficult to master for those who are used to using Auto or Program exposure modes. Although the final outcome may require deep shadow tones, the aim in digital low-key exposure is to first get the shadow tones away from the left-hand wall of the histogram by increasing and NOT decreasing the exposure. It is vitally important, however, not to increase the exposure so far that you lose or clip highlight detail. The original exposure of the image used in this project reveals that the shadow tones (visible as the highest peaks in the histogram) have had a generous exposure in-camera so that noise and banding have been avoided (the tones have moved well to the right in the histogram). The highlights, however, look as though they have become clipped or overexposed. The feedback from the histogram on the camera's LCD would have confirmed the clipping at the time of exposure (the tall peak on the extreme right-hand side of the histogram) and if you had your camera set to warn you of overexposure, the highlights would have been merrily flashing at you to ridicule you of your sad attempts to expose this image. The typical DSLR camera is, however, a pessimist when it comes to clipped highlights and ignorant of what is possible in ACR. Adobe Camera Raw can recover at least one stop of extra highlight information when the Exposure slider is dragged to the left (as long as the photographer has used a DSLR camera that has a broader dynamic range than your typical fixed-lens compact digicam).

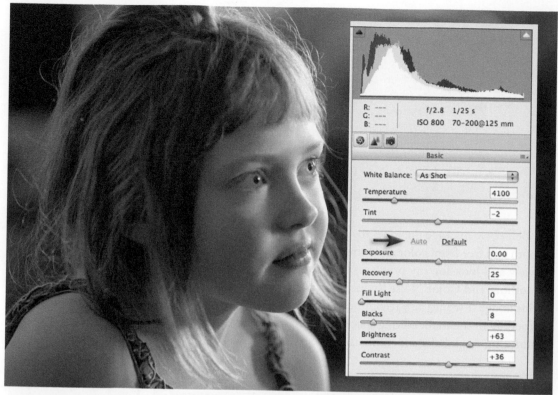

Adobe Camera Raw rescues the highlights – sometimes automatically

'Exposing right'

When the Auto checkbox in the Exposure slider is checked, ACR often attempts to rescue overexposed highlights automatically. With a little knowledge and some attention to the histogram during the capture stage, you can master the art of pushing your highlights to the edge. So if your model is not in a hurry (mine is watching a half-hour TV show) you can take an initial exposure on Auto and then check your camera for overexposure. Increase the exposure using the exposure compensation dial on the camera until you see the flashing highlights. When the flashing highlights start to appear you can still add around one extra stop to the exposure before the highlights can no longer be recovered in ACR. The popular term for this peculiar behavior is called 'exposing right'.

PERFORMANCE TIP

If the highlights are merrily flashing and the shadows are still banked up against the left-hand wall of the histogram the solution is to increase the amount of fill light, i.e. reduce the difference in brightness between the main light source and the fill light. If you are using flash as the source of your fill light it would be important to drop the power of the flash by at least two stops and choose the Slow-Sync setting (a camera flash setting that balances both the ambient light exposure and flash exposure) so that the flash light does not overpower the main light source positioned behind your subject.

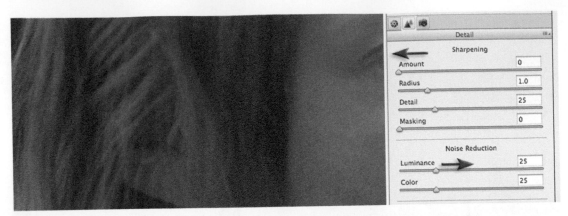

2. Before we massage the tones to create our low-key image we must first check that our tones are smooth and free from color and luminance noise. Zoom in to 100% magnification for an accurate preview and look for any problems in the smooth dark-toned areas. Setting both the Luminance Smoothing and Color Noise Reduction sliders (found in the Detail tab) to 25 removes the noise in this image. I would also recommend that the Sharpness slider be set to 0 at this point. Selective sharpening in the main editing space may help to keep the tones as smooth as possible rather than committing to global sharpening using the ACR dialog box.

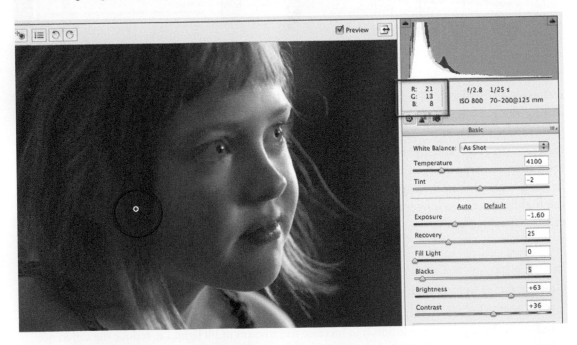

3. Create the low-key look by dropping the Exposure and/or the Brightness sliders in the Adjust tab. You can continue to drop these sliders until the highlights start to move away from the right-hand wall of the histogram. Select the White Balance tool and move your mouse cursor over the deeper shadows – this will give you an idea of the RGB values you are likely to get when this image is opened into the editing space. Once you approach an average of 15 to 20 in all three channels the low-key look should have been achieved.

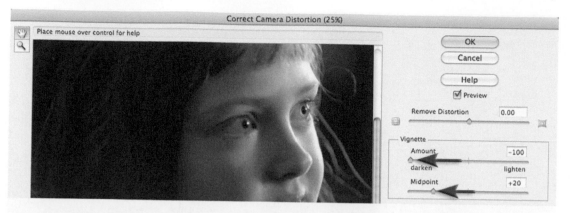

4. To enhance this image further a vignette has been added. This can be achieved in the ACR dialog box in the full version of Photoshop but in Photoshop Elements the vignette has to be added in the main editing space. In Photoshop Elements the Correct Camera Distortion filter can be used to add the vignette. Uncheck the Show Grid option at the bottom of the dialog box and then drag the Amount slider to the left to darken the corners. Dragging the Midpoint slider to the left will slowly move the darkening effect towards the center of the image.

Note > If you are in 8 Bits/Channel mode and you want to add a vignette using layers, first create a new layer in Multiply mode and fill this layer with white. Hold down the Alt/Option key as you click on the New Layer icon in the Layers panel to access the New Layer dialog box to give you these options.

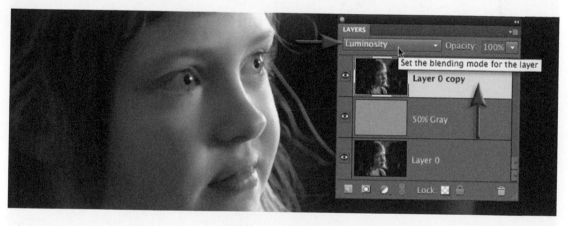

5. To drop the RGB to black and white I have used a technique that extracts the luminance values from the RGB file. I usually find that this gives a superior result to lowering the saturation or choosing the Remove Color command. Simply click the Create a new layer icon in the Layers panel and then go to Edit > Fill Layer. In the Fill Layer dialog box choose 50% Gray as the contents color (Edit > Fill Layer > 50% Gray). Create a duplicate of the background layer or Layer 0 (or merge the contents if you have placed the vignette on a separate layer) and then move this duplicate background layer to the top of the layers stack. Switch this layer to Luminosity to create a black and white image from the Luminance values.

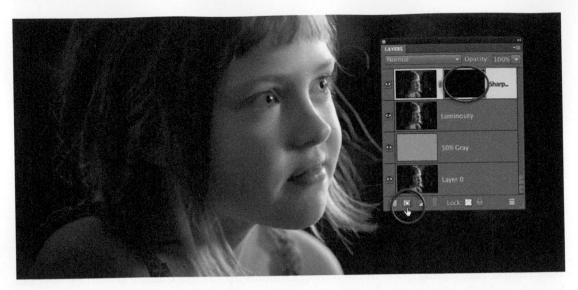

6. Create a Merge Visible layer (hold down the Ctrl/Command, Shift and Alt/Option keys and press the E key). Hold down the Alt/Option key and click on the Add layer mask icon at the base of the Layers panel. This will ensure the layer mask is filled with black. Hold down the Shift key and click on the layer mask to switch the visibility of the mask off while we now sharpen the layer.

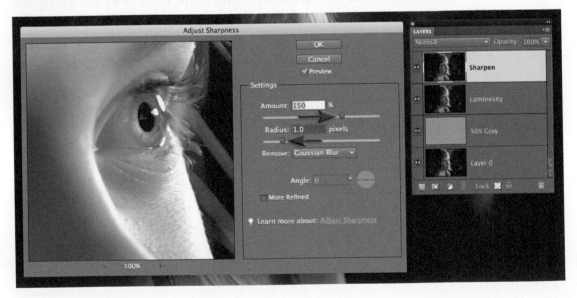

7. Click on the image thumbnail to make this the active component of the layer. Then go to Enhance > Adjust Sharpness. This is an excellent alternative to the Unsharp Mask for sharpening images that have little to no noise. To ensure the image does not appear over-sharpened, restrict the Radius to no higher than 1.5.

Note > If the Adjust Sharpness is making the smoother soft-focus tones appear anything but liquid smooth then consider a localized sharpening technique as described below.

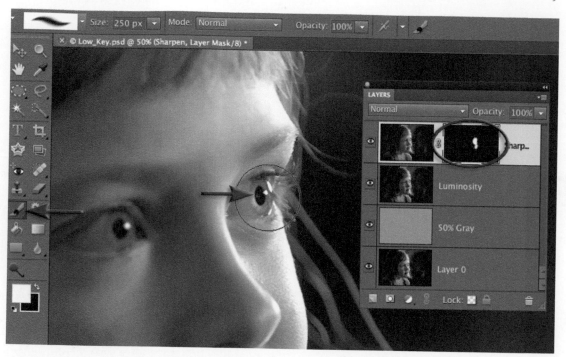

8. Select the Brush tool from the Tools panel. Select white as the foreground color. Choose a soft brush from the Options bar and drop the opacity of the brush to 50%. Click on the layer mask in the Layers panel to make this active and then move your attention to the main image window. Zoom the image to either 50% or Actual Pixels (100%). Paint in the areas where you would like to increase the sharpness of the image. Painting several times in the same region will slowly build up the sharpness.

PERFORMANCE TIP – A FINAL WORD OF WARNING

To extract the maximum quality from your low-key image you will need to print it on premium quality photo paper or have the image printed at a professional quality print service provider. All the work will be for nothing if the printer or surface quality of the paper cannot handle all of these smooth dark tones. If printed well the print will stand up to close – really close – scrutiny.

Project 9

Channels

You can spend a long time making pointless selections when all Elements needs is to be shown the differences between 'that which must be changed' and the pixels that need to be left alone, based on hue, saturation or brightness. I have learnt to resist the temptation to jump in early with the lasso or tragic wand tool and instead to utilize and exploit the differences that may be lurking beneath the RGB surface of the image. The differences that Photoshop Elements thrives on for selection-free editing can usually be found in the component channels of the RGB image.

*The Apostles – the finished image together with the starting image and the red and blue channels.
The red channel is employed to enhance the sky while using the blue channel to mask the effects.*

The red channel in this seascape image is information-rich in the sky, whilst the blue channel has excellent contrast that could be utilized for the creation of a mask to control localized adjustments. Users of the full version of Photoshop have this information available in the Channels panel. The Photoshop Elements user must find another way, as the Channels panel is out of bounds. Although Photoshop Elements uses the three primary color channels to create the RGB image, Adobe feels that the Photoshop Elements user does not need to see the component information. Just because you can't see the channels doesn't mean you can't use them.

Part 1 – Extracting the red channel

1. To start the ball rolling duplicate the background layer by dragging it to the New Layer icon in the Layers panel and then add a Solid Color adjustment layer from the Create Adjustment Layers menu in the Layers panel. Select red in the Color Picker (255 Red, 0 Green, 0 Blue).

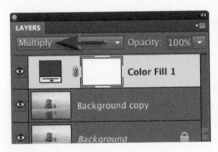

2. Set the blending mode for the layer to Multiply and then choose Merge Down from the Layer menu. It will probably come as no surprise, but your image has just turned bright red.

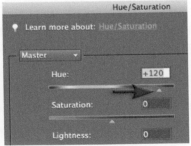

3. Duplicate the red layer (background copy) by dragging it to the New Layer icon and from the Enhance menu choose Adjust Hue/Saturation from the Adjust Color submenu (Enhance > Adjust Color > Adjust Hue/Saturation, or use the keyboard shortcut Ctrl/Command + U. Move the Hue slider to +120. Your 'Background copy 2' layer is now bright green.

4. Change the blend mode of this green layer (Background copy 2) to Screen (this will turn the main image yellow as the filtering process begins to take place) and then drag the green Background copy 2 layer to the New Layer icon to copy it. Use the Hue/Saturation adjustment again to change the hue to blue by dragging the Hue slider to +120. The image in your main image window should now appear black and white – these are not just any shades of gray but the gray values that are only present in the red channel of your image. It is a bit too early for the round of applause as we are currently using three layers to achieve this effect.

5. Select all three colored layers by holding down the Ctrl/Command key and clicking on each in turn so that all three are highlighted. From the Layer menu choose Merge Layers. This red layer (dropped to grayscale values) is a useful way to create dramatic black and white images, due to the fact that red filtration of a full color scene makes blue skies darker without darkening any clouds that may be present in the sky. We will, however, take this a few steps further if you are able to stay along for the ride.

6. I have named the background copy layer as 'Red Channel' (really a layer) by clicking on its name in the Layers panel (just so things don't get too confusing). Duplicate the Red Channel layer by dragging it to the New Layer icon and change the blend mode to Multiply. This step is designed to darken the sky and create a lot more drama. Choose Merge Down from the Layer menu to create a single darkened Red Channel layer. We will use a layer mask on this layer to mask or hide everything in the Red Channel layer except the sky, which we will leave visible in order to darken it.

7. Click on the Red Channel layer to make it active and then click on the Add layer mask icon at the base of the Layers panel. Change the blend mode of the Red Channel layer to Luminosity. The Luminosity blend mode will allow all of the color from the background layer to become visible but retain the brightness or 'luminance' values of the Red Channel layer. The mask can hide any of the luminance values that are not required. Adjust the opacity of the Red Channel layer if the drama needs to be lowered a little. You could now just paint in the mask to hide the unwanted luminance values but the idea behind this tutorial is to let Photoshop do all of the work – we are just providing the brains. My brain cells tell me that a mask for those rocks probably already exists in the blue channel of this RGB file. We will typically find that the sky is very light in the blue channel and everything that has no blue component will be dark, i.e. the rocks and foreground beach.

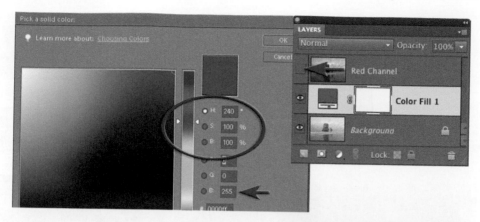

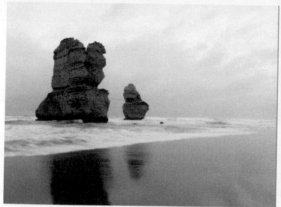

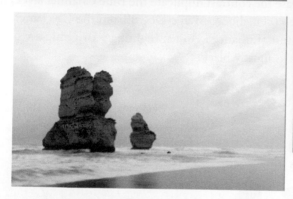

Part 2 – Channel masking

8. Switch off the visibility of the top two layers by clicking on the eye icon next to each layer thumbnail. Using the same technique as in Part 1 of this tutorial create a Blue Channel layer. Instead of selecting red as the Solid Color in Step 1, choose 255 Blue (the other two channels should be set to 0 in the Color Picker). The rest of the procedure is identical (hallelujah!), using the same +120 Hue value in the Hue/Saturation dialog box each time and the same sequence of blend modes (first apply the Multiply mode to the blue solid color adjustment layer, then apply the Screen mode to the subsequent color layers and Merge Layers).

9. After merging the three color layers to create a Blue Channel layer you should see that the rocks in the sea are very dark against the bright sky (the basis of a really effective mask) – the contrast, however, is not quite high enough to act as a layer mask just yet. The aim is to render all of the sky white and the rocks black. To increase the contrast duplicate the Blue Channel layer and then set the duplicate layer to Overlay mode. Then choose Merge Down from the Layer menu. Apply the Brightness/Contrast adjustment feature (Enhance > Adjust Lighting > Brightness/Contrast) to render the sky mostly white and the rocks mostly black.

10. Apply a Levels adjustment to this layer (Enhance > Adjust Lighting > Levels) and drag the white slider underneath the histogram to the left until no traces of gray sky are left. Drag the black slider underneath the histogram to the right until the rocks are solid black. Click OK to apply the changes and create your mask – the only problem now is that it needs to be in the layer mask above and not in its own layer. Switch on the visibility of the Red Channel layer.

11. To transfer this high-contrast Blue Channel layer to the layer mask above select All from the Select menu and then choose Copy from the Edit menu. Hold down the Alt/Option key and click on the adjustment layer mask thumbnail on the Levels 1 layer. The main image window should momentarily appear white, as you are now viewing the empty contents of this layer mask. Choose Paste from the Edit menu to paste the contents of the clipboard into this layer mask. Hold down the Alt/Option key again and click on the layer mask thumbnail one more time to switch off the layer mask view. Go to Select > Deselect. Nothing will appear to have changed until you switch off the visibility of the Blue Channel layer by clicking on the eye icon next to the layer thumbnail. Don't expect perfection just yet as the water and the reflections on the beach will appear slightly weird at this point in time.

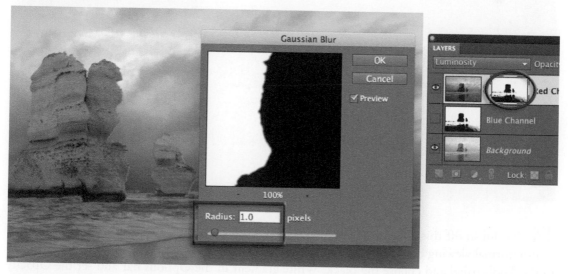

12. Apart from some strange tones in the water and on the beach you will probably also notice a halo, or white line, appearing around the rocks where the sky has not been darkened. To remove this halo, first apply a 1- or 2-pixel Gaussian Blur filter to the layer mask to soften the edge (Filter > Blur > Gaussian Blur). This step serves to soften the edge whilst the next step will attempt to realign it.

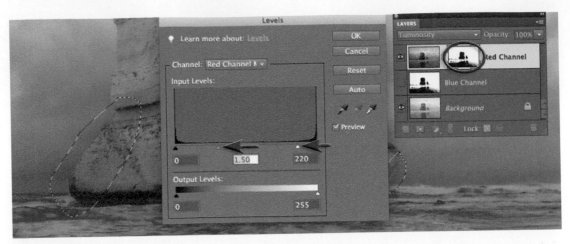

13. Make a selection with the Lasso tool around any edges that have a thin white halo around them. Apply a Levels adjustment to the mask. Moving both the central Gamma slider underneath the histogram in the Levels dialog box and the white Highlight slider to the left should remove the halo. Go to Select > Deselect when you are done.

14. To finish off this edit we must hide the foreground pixels in the red channel, in order to return normal viewing to both the water and the reflections on the beach. Select the Gradient tool in the Tools panel and choose the Black, White gradient in the Options bar and set the Opacity to 100%. Make sure the Linear gradient option is also selected and change the blend mode to Multiply. Move your mouse cursor into the main image window (this is the only painting tool used in the entire edit), click just around the base of the central rock and drag a short stroke to a point around halfway up the rock. Let go of the mouse clicker to apply the gradient to the layer mask. As the blend mode of the Gradient tool is set to Multiply, this gradient will be added to the existing mask rather than replace it.

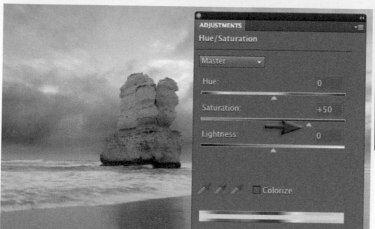

15. The last step of this edit is to replace some of the saturation in the sky that was upset when we changed the Red Channel layer to Luminosity mode. It is a really painless process to pick up the selection from the layer mask we have just crafted. Hold down the Ctrl/Command key and click on the layer mask thumbnail. This will load the mask as a selection. With the active selection simply select a Hue/Saturation adjustment layer from the Create Adjustment Layer menu in the Layers panel and increase the intensity of the color to taste.

Not convinced?

You may be thinking that this is a very long process to simply darken the sky of this image. I have, however, learnt all the keyboard shortcuts for every step of this process (including all of the blend modes and merge commands) and I reckon most people would only be halfway around the first rock with their Lasso tool before I had completed the entire editing procedure (all 15 steps). This image edit would normally only take you three or four minutes when you know where you are going. If this is not fast enough be sure to check out the action that comes with this book. Remember – just one click and you have all three channels as layers installed in the Layers panel. A little more brains and a little less playing with your tools now will pay dividends in the amount of time you save later.

part

3

composites

Project 1

Creative Montage

Masks can be used to control which pixels are concealed or revealed on any image layer except the background. If the mask layer that has been used to conceal pixels is then discarded the original pixels reappear. This approach to montage work is termed 'non-destructive'. In the full version of Photoshop the mask can be applied to any layer. In Photoshop Elements layer masks are only available on adjustment layers, but these can be used to mask the pixels on the layer, or layers, above.

Forget cutting and pasting – learn the craft of professional montage using advanced masking techniques

1. Select the Quick Selection tool in the tools panel and then deselect the Auto Enhance option in the Options bar. With subjects that are easy to select, the Auto Enhance option can save you time as the edge quality will be refined as you select. The edge contrast of this subject is low in places and no one tool can easily select the entire subject in this image. When this is the case it is better to turn the Auto Enhance feature off and refine the edge later. After selecting the gold man you will notice the selection may not be perfect. You will almost certainly have to remove the areas from under the arms and between the legs from the selection. To do this hold down the Alt/Option key and click and drag over these areas. You may need to reduce the size of the brush when painting over these regions. Do not spend too long trying to perfect difficult regions of the selection using the Quick Selection tool as we will use additional techniques to complete the process.

2. With the selection active go to the Layers panel and add a Levels adjustment layer from the Create new fill or adjustment layer menu. The selection will be converted into a layer mask. We can use this layer mask to perfect the selection. Hold down the Alt/Option and Shift keys and click on the adjustment layer mask to view the mask and the image at the same time. The mask is currently indicating the area that is not selected. Select the Polygonal Lasso tool from the Tools panel and set the Feather value to 0 pixels in the Options bar. Click around any area where the mask color needs to be extended to meet the edge of the gold man. Check that you have black as the foreground color in the Tools panel and then use the keyboard shortcut Alt/Option + Backspace/Delete to fill the selected area with the mask color.

3. To create the perfect selection it will be necessary to remove any mask color that appears over the subject. To do this make a selection and fill with the background color (Ctrl/Command + Backspace/Delete). When the edge is difficult to see because the mask color extends over the edge of the subject go to Filter > Adjustments > Invert (Ctrl/Command + I). Now you will be able to see the edge clearly and can then make your selection and fill with the foreground color.

4. If you have a steady hand you can also choose to paint directly into the mask using the Brush tool. Choose a brush setting of 100% hardness in the Options bar and then paint with black to add to the mask or with white to remove the mask color. Zoom in to the image (Ctrl/Command + Spacebar) to ensure the mask is accurate and use the Spacebar to access the Hand tool that will enable you to drag around the image while you are zoomed in. Alternatively use the Navigator panel to navigate around the edge of your subject.

Important > Before leaving the mask view make sure that the background is covered in the mask color rather than the gold man (Ctrl/Command + I will invert the mask if required). Alt/Option + Shift click the layer mask to return to the normal view.

5. The edges of the mask will need to be refined before it can be used for a high-quality montage. Select Refine Edge from the Select menu and from the View menu choose Selection to hide the selection edge. Double-click the Custom Overlay Color option in the panel to open the Options dialog and set the Color to dark gray and the Opacity to 100%. Select OK to apply the color change. Set the Smooth slider to 5 and the Feather slider to 1.0 and slide the Contract/Expand slider to the left to conceal the white edge that surrounds your subject.

Note > If the subject is gray instead of the background you need to cancel the process and invert the mask before choosing the Refine Edge command.

PERFORMANCE TIP

The fact of life is that some extractions can be as painful as pulling teeth! With this in mind Adobe offers you even more magic – the Magic Extractor (Image > Magic Extractor). This is yet another alternative for getting rid of problematic backgrounds. This tool takes a little more time than the Quick Selection tool and is destructive in nature (it deletes the pixels you select with the Background Brush tool) so I would advise duplicating this layer before proceeding. You make little marks or squiggles to advise Photoshop which regions of the image you would like to keep and which regions you would like to delete. Click on the Preview button to see how Photoshop does the hard maths to extract your subject from the background. From the Preview menu choose a matte color to view your extracted subject (choose a different tone from the original background or one that is similar to the new background).

In the Touch Up section of the dialog box select a Feather value (usually 1 or 2 pixels) and then choose a Defringe Width to remove any of the remaining background. Not a bad job – if you don't mind losing the background pixels.

6. Open the new background image. Click on the Arrange Documents icon in the Application Bar and choose 2-up. Select both layers in the gold man file (hold down the Ctrl or Command key and click on each layer) and then drag the layers into the new background file to create a file containing all three layers.

7. Hold down the Ctrl key (PC) or Command key (Mac) and click on the layer mask thumbnail to load the mask as a selection. Select the layer containing the gold man and then click on the Add layer mask icon at the base of the Layers panel. Click on the visibility icon of the Levels adjustment layer to switch off the visibility or drag it to the trash can in the Layers panel to delete it permanently. The mask on this layer has now served its purpose and can be discarded to reduce the overall file size.

8. Go to Image > Transform > Free Transform (Ctrl/Command + T). Use the keyboard shortcut Ctrl/Command + 0 to fit the Transform bounding box on the screen. Drag a corner handle to resize the image so that it sits nicely against the new background (you will not require all of the legs to replicate the framing in this project). Press the Commit icon or Enter key (PC) or Return key (Mac) to apply the transformation.

9. Zoom in and take a close look at the edges. You may notice a white halo along some of the edges (the old background). This can be removed by making a selection of the problem area (use a 5-pixel feather when making selections that cross over the edge of your mask) and then applying a Levels adjustment (Enhance > Adjust Lighting > Levels or Ctrl/Command + L) to move the edge of the mask. Move the central Gamma slider and the Black input slider to the right to remove any of the old lighter background that may still be visible on the layer above.

10. Click on the background layer in the Layers panel and then choose a Hue/Saturation adjustment layer from the Create new fill or adjustment layer menu (new adjustment layers are always placed above the active layer). Select Reds from the Edit menu in the Hue/Saturation dialog and move the Hue slider to the right until the red stripes in the image turn yellow. Adjust the saturation to taste.

11. Select the top layer in the Layers panel (the one with the gold man) and choose another Hue/Saturation adjustment layer from the Create new fill or adjustment layer icon. Click on the Clipping icon in the bottom left-hand corner of the Adjustments dialog. Clipping the Hue/Saturation adjustment layer to the layer below will ensure the adjustments do not flow down and affect the colors on the background layer.

12. Adjust the saturation of the gold man to match the saturation of the yellows on the background layer. Notice how the adjustments are only affecting the layer below. The ability to match the color and tonality of a number of different layers in a composite image is an essential skill for montage work.

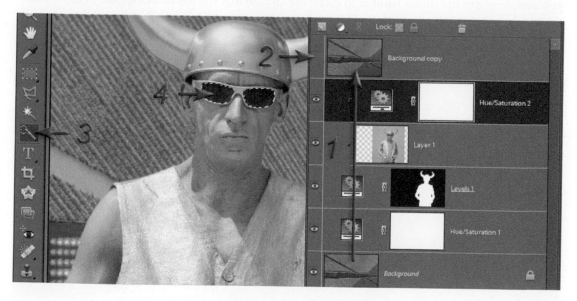

13. The basic task of replacing the background is complete. We will now paste a copy of the background layer into the lenses of the dark glasses. First select, and then duplicate the background layer (Ctrl/Command + J) and then drag this copy layer to the top of the layers stack. Switch off the visibility of this copy layer by clicking on the Visibility icon. Select the Quick Selection tool in the Tools panel and click the Sample All Layers option in the Options bar and the Auto Enhance option. Click on each lens in the glasses to select them.

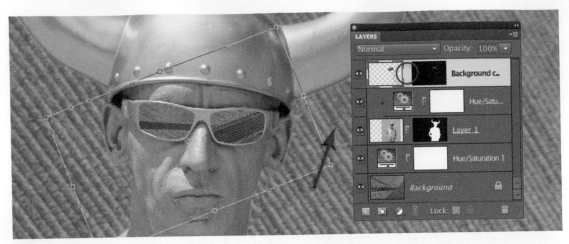

14. Click on the Add layer mask icon in the Layers panel to convert the selection into a layer mask. Click on the link between the layer thumbnail and the layer mask to break the link between the two components of the layer. Select the image thumbnail on the layer and then go to Image > Transform > Free Transform and enter in a value of around 20% in either the width or height field of the Options bar. Then click and drag inside the Transform bounding box to reposition the resized layer over the glasses. Click and drag on a corner handle to resize further and click and drag just outside one of the corner handles to rotate the layer so that the red stripes appear in the lenses of the sunglasses. You have the option to lower the opacity of the layer in the Layers panel if required.

15. Hold down the Alt/Option key and click and drag the Hue/Saturation 1 adjustment layer to the top of the layers stack. This action will copy the adjustment layer and change the red stripes to yellow but it will also affect the color of the golden Viking. Go to Layer > Create Clipping Mask to clip this adjustment layer to the transformed background copy layer and limit the changes to the reflections in the glasses. You can also clip a layer by holding down the Alt/Option key and clicking on the dividing line between the two layers.

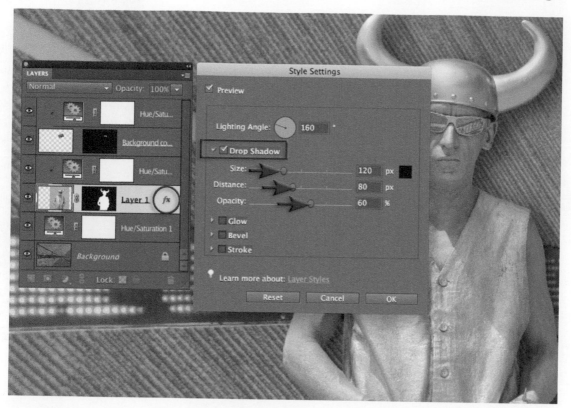

16. Select Layer 1 in the Layers panel and then go to Layer > Layer Style > Style Settings. Check the Drop Shadows box in the Style Settings dialog. Increase the Size to 120 px, the distance to 80 px and the Opacity to 60%. You will see a drop shadow appear behind the gold man and when you select OK you will see an 'fx' icon appear on the layer. Double-clicking the 'fx' icon will reopen the Style Settings dialog. Move your mouse cursor into the image window and drag the shadow to the right-hand side of the image (the left-hand side of the gold man) to match the direction of the light source in this image.

Note > This project has introduced a completely non-destructive approach to montage. Any aspect of the composite image can be re-edited as no pixels were permanently changed or deleted on any layer during the process. Although there is a Mask option when using the Selection Brush tool, you are prevented from using the Lasso tools in Elements when working in this mask mode – hence the work we carried out directly on the adjustment layer mask with the mask visible. Same result as the full version of Photoshop – slightly different workflow required to get there.

Project 2

Replacing a Sky

For people who seem to find themselves in the right place at the wrong time! Have you ever traveled long and far to get to a scenic vista only to find that the lighting is useless and the sky is a little short of inspiring? Do you make camp and wait for the weather to change or reluctantly and humiliatingly buy the postcard? Before you hit the Delete button or assign these 'almost rans' to a never-to-be-opened-again folder to collect digital dust, consider the post-production alternatives Photoshop Elements lets you revisit these uninspired digital vistas to inject the mood that you were looking for when you first whipped the camera out from its case.

Drama in Venice – change the sky to change the weather

I think every photographer can relate to the intrepid explorers of the Australian Outback who, after scaling the highest peak in the area with great expectations, decided to call it Mount Disappointment! One can only conclude that they were expecting to see something that was simply not there. This something extra could be made real so that all of your landscapes live up to your high expectations – with just a little digital help.

Check out the supporting website to access an extensive stock library of royalty-free skies

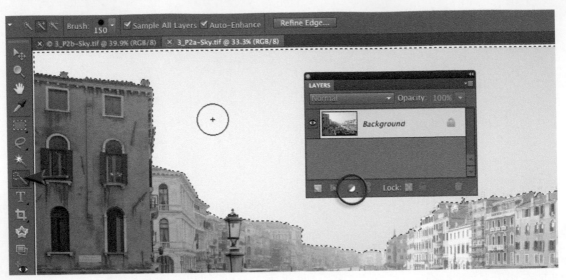

1. Open the two project images (Venice and the replacement sky). Select the Quick Selection tool from the Tools panel and drag the tool across the sky to make an initial selection. As the edge contrast is low the selection is unlikely to be accurate at the first attempt. Click on the Create new fill or adjustment layer icon at the base of the Levels panel and choose Levels. The selection will be converted to a layer mask. We do not need to make any adjustment in the Levels dialog.

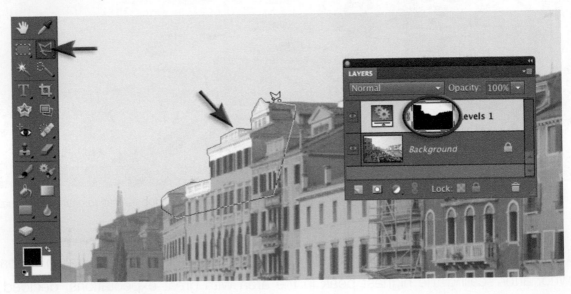

2. Zoom in to 100% or Actual Pixels (Ctrl + 1 on a PC or Command + 1 on a Mac) and then by holding down the Alt + Shift keys (PC) or Option + Shift keys (Mac) click on the Adjustment layer mask to display the mask as a color overlay. Make a selection of the buildings that were not included in the mask and then fill with black (Edit > Fill Selection > Black). You can exclude the scaffolding and the TV aerials from the mask. Hold down the Alt/Option key and click on the layer mask to return to the normal view when the mask is perfected.

3. Click on the Arrange Documents icon in the Application Bar and choose 2-up. Select the sky image and then click on the thumbnail in the layers panel and drag it to the Venice image to create a multi-layered document.

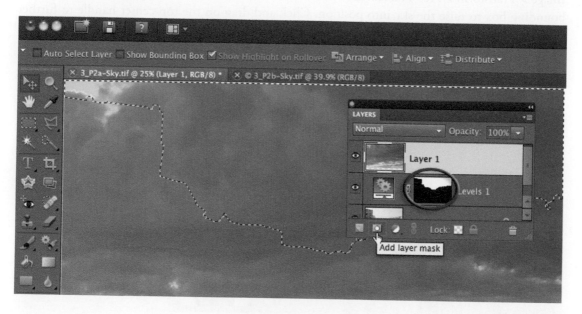

4. Hold down the Ctrl key (PC) or Command key (Mac) and then click on the layer mask thumbnail to load it as a selection. Select the layer with the sky image and click on the Add layer mask icon at the base of the Layers panel. Don't be alarmed at how bad the composite view is at this stage; we have several more steps to go before things start to look OK. For the moment we must be content that the sky was captured at a similar time of day to the Venice image and that the direction of that light is also similar. Click on the visibility icon of the Levels 1 adjustment layer to hide this layer.

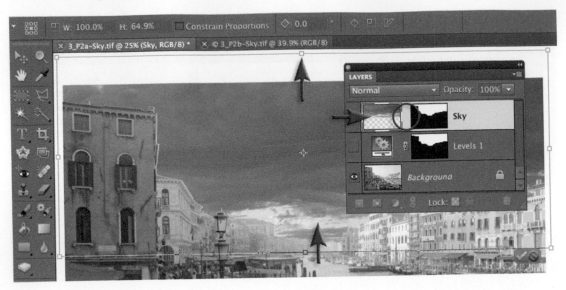

5. Double click on the name of Layer 1 and rename it 'Sky'. Click on the link between the layer thumbnail and the layer mask to break the link between the two components of the layer. Go to Image > Transform > Free Transform (Ctrl/Command + T). Click and drag inside the Transform bounding box to raise the sky into position. Click and drag on the top-center handle to further enhance the location and shape of the sky to fit the host image. Press the Enter key (PC) or Return key (Mac) to commit the transformation.

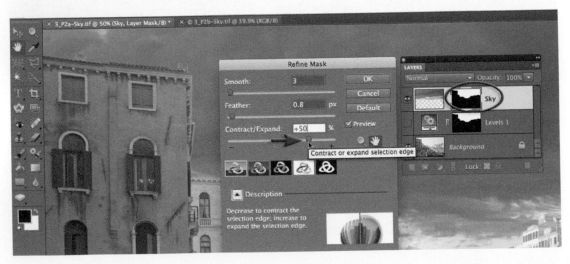

6. Click on the layer mask to make it active and then go to Select > Refine Edge. Choose a setting of 3 for the Smooth slider and a 0.8-pixel feather and then move the Contract/Expand slider to the right until the light halo from around the majority of the buildings has disappeared. It is not possible to remove the halo around the buildings on the extreme left-hand side of the image without removing too much edge detail from the rest of the skyline. The halos around these buildings can be fully corrected using the Levels adjustment technique as outlined in Project 1 of this section.

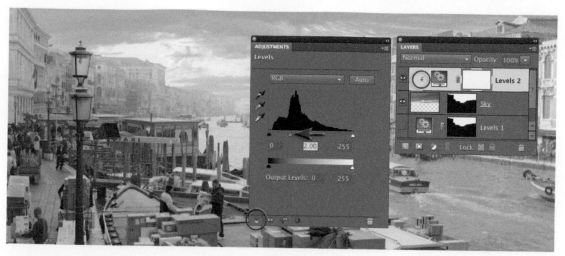

7. Select the Sky layer and then select a Levels adjustment from the Create Adjustment Layer menu. Click on the clipping icon in the bottom left-hand corner of the levels dialog (this action will limit the adjustments to the sky only). Move the central Gamma slider underneath the histogram to the left to render both the highlights and midtones of the sky very bright so that they match the tones of the distant buildings. Skies that have been captured in less humid conditions will always require this adjustment if they are to look at home in a location where there is reduced contrast together with lighter tones in the distant subject matter.

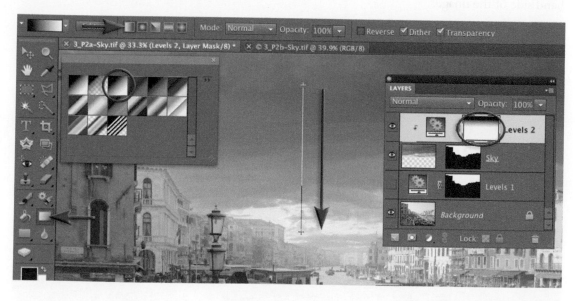

8. Select the Gradient tool from the Tools panel. In the Options bar choose the Black, White and Linear gradient options and an Opacity setting of 100%. Click and drag the gradient from the top of the image to a position just above the horizon line. Hold down the Shift key to constrain the gradient. The gradient should appear in the Levels 2 layer mask. This will give the sky depth and ensure it retains its drama above the buildings in the foreground.

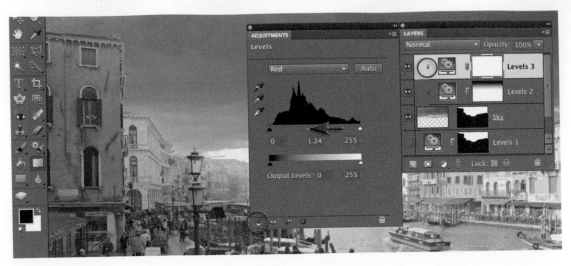

9. Create a second Levels adjustment and clip this to the layer below. The purpose of this second adjustment layer is to increase the intensity of the light on the left-hand side of the image. This will help establish the realism of the effect of the light source that is bathing the buildings on the right-hand side of the image in a warm afternoon glow. Increase the warmth by moving the Gamma slider to the left in the red channel and to the right in the blue channel. Raise the overall brightness in the RGB channel. Observe the effect above the foreground buildings on the left-hand side of the image.

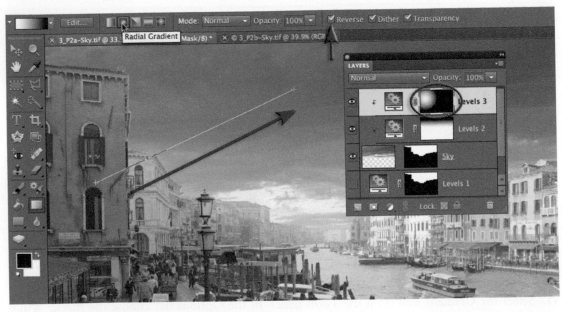

10. Select the Gradient tool from the Tools panel. Select the Black, White and Radial options. Select the Reverse checkbox in the Options bar. Drag a short gradient from behind the buildings on the left-hand side of the image to the top-center. This gradient will enhance the effect of the setting sun.

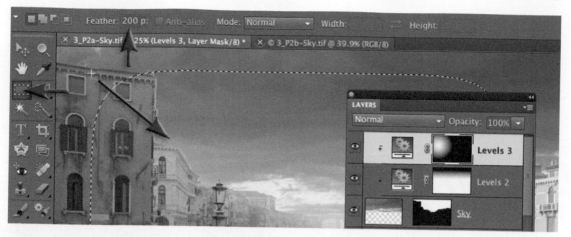

11. Select the Rectangular Marquee tool in the Tools panel and set the feather to 200 pixels in the Options bar. Click and drag a selection from the upper right-hand corner of the image to the lower left-hand corner. Go to Select > Inverse or use the keyboard shortcut Shift + Ctrl/Command + I. From the Edit menu choose Copy Merged and then Paste.

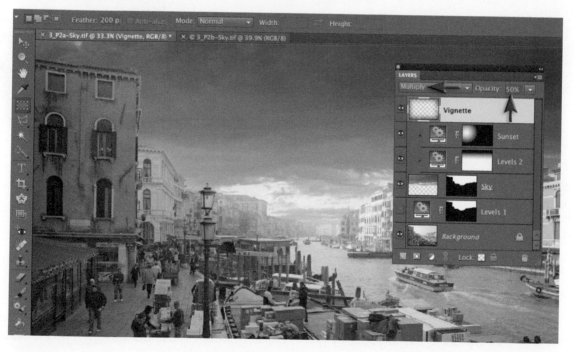

12. Using the information from the file itself to create a vignette prevents the highlights at the edges of the image from excessive darkening. Set the mode of this new layer to Multiply and adjust the opacity of the layer to make the vignette a little more subtle. Duplicate the background layer, switch the mode of the layer to Luminosity and then go to Enhance > Adjust Sharpness. Sharpen to taste and the project will be complete. The scene now carries all of the mood of an old Venetian painting, courtesy of a dramatic sky.

Project 3

Decisive Moments

Attributed to the legendary Henri Cartier Bresson the *decisive moment* describes that split second when intuition aligns with the universe to capture an unplanned moment unfolding before the camera. This is a challenge when capturing images of lively groups, a rapidly changing scene, or delicate moments. Despite grabbing a quick succession of frames, one might find that no single frame truly captures the emotional impact of the original scene. Here, we shall explore techniques to merge a series of images to construct our own decisive moment.

Merge the best aspects of several images to create a single image with the strongest impact

The resulting image is no longer a frozen moment but a record of the passage of time over a fleeting moment. Everybody represented in this image is exactly where they were at the moment the camera shutter was released. It is just that the shutter was released three times instead of just once. Photoshop Elements offers the powerful Photomerge feature that automatically aligns images, even when they are shot hand-held, and allows us to selectively reveal the best aspects of the component images to create a compelling final outcome. Especially useful when someone in a group has blinked or looked away.

1. Open each of the three files we will be using for this project in Photoshop Elements 9. The files should be visible in the Project Bin. Hold down the Ctrl key on a PC or the Command key on a Mac and select each of the images displayed in the Project Bin. From the File menu, select File > New > Photomerge Group Shot.

2. Select the image that has the widest coverage of the scene, in this case the image where the elderly lady is smiling at the child, and drag it to the pane titled Final, which is on the right hand side of the screen. The stage is set for our composite image. Although key elements such as the smiling lady and the man with the bicycle are in place, there are minor weaknesses. The child is looking away, reducing the impact of the image. We shall introduce a few new elements to increase the drama in the current scene.

3. Next, select the image where the child is looking directly into the camera, the Source pane will update itself to display the image that has been selected. Paint over the child in the source pane and the final composite image takes shape in the panel on the right. Photoshop Elements has also adjusted this image for changes in focal length and perspective, revealing an additional bit of scenery not present in the other images. Paint over the blue shutters and the bowl on the right of the image to increase the field of view of the final composite. Note, that each mask in the source pane appears in a different color for easy identification as the complexity of masking increases in the scene.

4. Finally, in the Project Bin at the bottom of the screen, select the image where the passerby in the blue shirt is walking past. Once the Source pane, on the left, has updated itself paint over the man using the cursor, take care not to paint over the old lady or she will be included in the final image. The pane on the right will update to show that the man in the blue shirt now appears in the composite image. Introducing this person adds depth to the image and adds to the sense of serendipity, we have gradually accumulated several coinciding events and the sense of drama in the scene has grown. All key elements of the scene are now in place, click on Done.

5. There are a few areas where image information is missing. To correct this, we shall take advantage of the new Content Aware features introduced in Photoshop Elements 9. This amazing new feature is designed to analyze parts of the image surrounding an area being filled in and guesstimates what should be included. The results can be quite startling, however it's not an exact science and may require more than one attempt before a successful outcome is achieved.

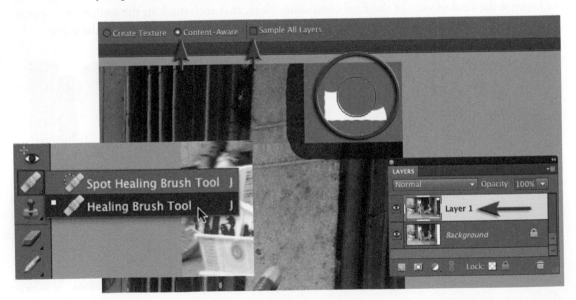

6. Select the Spot Healing Brush tool, ensure the Content-Aware mode is selected and that the Sample All Layers option is unchecked. Using the Spot Healing Brush tool, go over the blank area of the image in the upper right hand corner. In order for the Content Aware feature to be effective, ensure that the brush covers parts of the existing image information. This particular area of the image includes several colors, textures, and intersecting lines making it a particular tricky region to fill in. You may need to try more than once if the initial outcome was unsatisfactory.

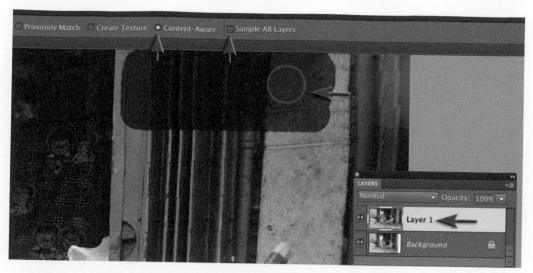

7. Once the missing area has been filled in, we shall address the region directly next to it. This area is displaying some warping artifacts, due to shifts in perspective between the original images and Photoshop Element's initial attempts at Content Aware fill. You may need to go over this area with the Spot Healing Brush tool more than once before an acceptable result is created.

8. We shall complete the process of filling in missing bits of the image by addressing the large blank area at the bottom of the image. Once again we use the Spot Healing Brush Tool and go over the blank area making sure we overlap with the surrounding image information. Including additional image information guides Photoshop Elements towards using those areas of the image to guess the missing content. Once the blank area has been filled in, you may choose to go over the edges of the image where warping or other artifacts might be noticed. Alternatively, you may wish to remove the problematic areas from the image using the crop tool to select the most pristine view of the finished composite.

9. Photoshop Elements completes its magic and presents us with the finished composite image. Although, for all intents the image is now complete in terms of its composition, we shall apply a treatment to the image to give it a distinct look. We shall take advantage of some unique features of the Adobe Camera Raw interface to achieve the look we desire.

10. Save the finished image as an uncompressed TIFF file, without layers. This will give us a file with sufficient information to manipulate colors and textures in Adobe Camera Raw without compromising the quality of the final outcome. Once the file has been saved as a TIFF image, open it in Adobe Camera Raw.

11. The look we are going to create increases textural detail and selectively desaturates the image. Moving the Clarity slider to its maximum value increases detail. Reduce Vibrance and increase Saturation till the reds in the image begin to pop. You may reduce exposure to darken the image slightly and add a bit of mood.

12. The image is now complete. As a final touch, you may wish to add a vignette to guide the viewer's attention. We describe a technique to add vignettes in Project 4 of Part 1.

UNLOCKING LAYER MASKS WITH PHOTOMERGE PANORAMA

One drawback of using the Photomerge Group Shot technique is that the final result is a flattened image. Those of us who demand more control over our images may wish for layer masks, and indeed there is another approach we can take that produces a finished composite that includes layer masks.

Once the set of files to be merged are open, choose the File > New > Photomerge Panorama option. In the dialog box, click on Add Open Files and make sure the Auto layout and Blend Images Together options are selected. Photoshop Elements will analyze the images and present the user with the option to "automatically fill in the edges of the panorama", choose yes.

The Photomerge Panorama process has no way of knowing which parts of each image should be included in the final composite, however it does a good job of capturing as much information from each image possible to create a composite with a nice wide field of view made up of separate layers each with its own layer mask. Now, we can re-arrange layers and adjust layer masks to reveal parts of the image we wish to include in the final composite. Begin, by dragging the layer with the child looking at the camera to the top and painting into the layer mask with a large, soft, white brush over the child to reveal the area we want.

Next, drag the layer with the pedestrian in the blue shirt to the top and brush over the layer mask to include him in the final image. The image is starting to take shape now and we have the freedom to make precise selections of which elements are visible in the final result.

Using this approach, we are able to enjoy the best of both worlds. Photoshop Elements warps and perspective corrects each image to compensate for changes in point of view or focal length and also offers us the combined flexibility of individual layers each with its own layer mask. The resulting outcome can be quite astonishing.

This powerful technique can be used in a range of scenarios, from dealing with fidgety subjects in group shots, to creating fantasy visuals where the same subject appears multiple times, or as in this instance layering moments in time to produce a slice of reality that only you as the photographer could have experienced. Creativity is only limited by one's imagination.

Project 4

Faux Renaissance

In this project we take a slight detour and create an image that has more creative license. The subject is a bit more exotic and we are going to apply a *faux renaissance* treatment to achieve the final outcome – a distinctly vintage feel. This marks a departure from our focus on photorealism, where the emphasis has been on convincing representations of reality.

A knight's tale - we travel back in time, using grunge textures to create a pseudo renaissance masterpiece

We shall combine many of the skills we have covered in previous projects to achieve this effect. In particular, we introduce a technique of using layered textures and Gaussian noise to give the image an aged look. The treatment is characterized by warm tones, dense textures, and heavy dramatic skies. This particular look is very popular commercially, and can be seen in use in film posters and album covers.

1. We are going to shift the castle so that it sits lower in the image, making room for the knight to appear in the image without covering up too much of the period architecture. Begin by double clicking on the Background and unlocking the layer. We need to do this in order to introduce layers behind the background and to adjust the overall composition.

2. Using the Move tool shift the background layer about a third of the way down and across, this reveals blank areas on the canvas. We shall extend the background image to fill the area to the left of the image. Duplicate the original background and shift it down so that the horizon lines between the two identical background images match up. The seam between the two sections does not have to be perfect as it will be covered by the knight when he is placed into the scene. The blank area at the top of the image will be replaced later by a new layer containing a sky with dramatic clouds.

3. Add a layer mask to the copy of the background image. Using a soft brush, paint over the seam between the two images. There is sufficient overlap between the two images so that the edges between the images can be blended in to create an imperceptible join.

4. Add the image of the knight to the scene and using the Quick Selection Tool create a selection that separates him from the black background against which he was originally photographed, add a layer mask to complete this step. You may need to use the Select > Refine Edge dialog to fine tune the mask.

5. Add the layer containing the new sky with dramatic clouds. Drag it down so that it is the bottom layer and select Image > Transform > Free Transform to adjust its dimensions. Drag the horizontal dimension handles to resize the image and make sure it fits the width of the canvas. Move the image to ensure the top of the clouds layer is aligned with the top edge of the canvas. This removes any remaining blank areas on the canvas.

6. Now that extending the background has been resolved, we no longer require the two overlapping background layers to be separate. Holding down the Shift key, select the two layers then from the menu bar choose Layers > Merge Layers.

7. Add a layer mask to the flattened background layer. Using the linear gradient tool, drag down from the sky towards the castle. This starts solid but begins to fade as it gets closer to the horizon in the image. This allows us to create a smooth blend between the new sky layer and the existing sky in the background image.

Note > The gradient must start with black and end with white or transparent.

8. Using a soft black brush, go over the castle towers and make sure the mask is not hiding any of the castle details. This technique is a interesting way to *cheat* instead of making careful masks that preserve minute detail in the horizon or sky line. It works well in this instance because the color of the sky being introduced into the scene is quite close to that of the existing sky. The key elements of the image, in terms of composition, are now falling into place.

9. To protect against the scrutiny and barbs of the critical observer, we shall go over the scene and minimize any evidence of modern influence within the landscape. Using the Spot Healing Brush in Content Aware mode, we shall go over buildings, tourists, traffic signs, and any other anachronisms that might distract from the visual narrative. When removing large buildings, we don't need 100% accuracy, any artifacts that might remain shall be lost in the grunge of the textures we shall introduce next.

10. This is where the most dramatic changes in the look of the image start to take place. Add the texture layer over the image. This particular texture is an image of wet cardboard shot by window light. From the Image Menu choose Transform > Free Transform, and stretch the texture layer so that it covers the entire image. Change the blend mode for this layer to Soft Light. Duplicate this layer by dragging it to the Create New Layer icon at the bottom of the layers palette.

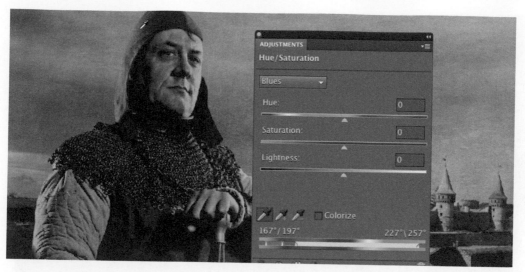

11. Hold down the Alt key as you create a Hue Saturation adjustment layer above the knight to create a clipping mask layer. Reduce the Master saturation slightly, then select the blue channel. Using the eye-dropper tool pick a swatch of blue from the knight's livery. Next, shift the Hue slider for the blue channel to change the royal blue livery to a rich maroon which fits in better with the warm color palette of the rest of the image.

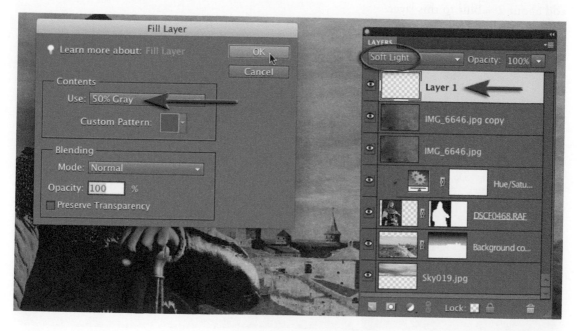

12. Create a new layer and from the Edit menu choose Fill Layer to fill it with 50% Gray. Change the blend mode for this layer to Soft Light, and the layer becomes invisible. Not to worry, the layer is still very much present, and allows us to introduce the final element of texture and age to the image.

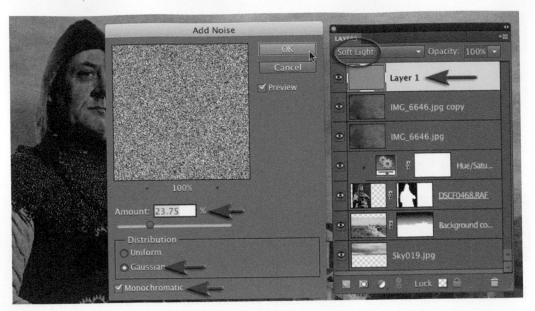

13. From the Filters menu choose Noise > Add Noise. We can be quite liberal with the amount of noise we add to this layer, but must ensure that the Gaussian Distribution and Monochromatic options are selected. Once the noise has been added, choose Filters > Blur > Gaussian Blur and add about 2% blur to this layer.

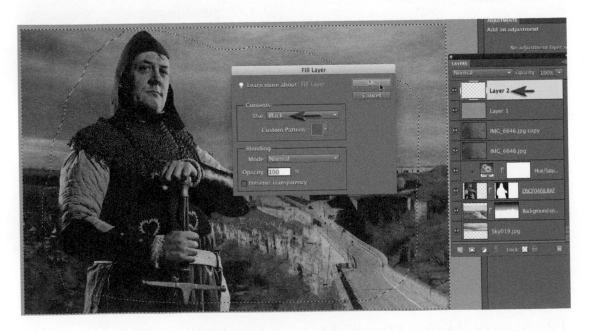

14. Using the Lasso tool, make a coarse elliptical selection of the image. Use the Ctrl/Command + Shift + I keys to invert the selection. From the Edit menu choose Fill Layer and fill the selection with black.

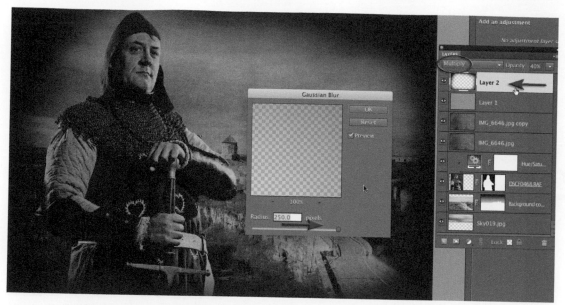

15. Set the mode of this layer to Multiply, from the Filter menu choose Blur > Gaussian Blur and use a generous radius to feather the edges of the fill area. Reduce the Opacity of the layer to about 40-50%.

16. Add the finishing touches to the knight by adding a layer mask to the texture layer in Multiply mode, and going over it with a soft black brush with low opacity. Masking this layer has a dodge like effect by making the knight appear brighter than the rest of the image, it also removes excess grunge texture from this layer. As a final step, you may sharpen the image for print or screen use.

Project 5

Photograph by Abhijit Chattaraj

Layer Blending

The blending technique enables the texture or pattern from one image to be merged with the form in another image. Blending two images on the computer is similar to creating a double exposure in the camera or sandwiching negatives in a traditional darkroom. Photoshop Elements, however, allows a greater degree of control over the final outcome. This is achieved by controlling the specific blend mode, position and opacity of each layer. The use of adjustment layer masks can help to shield any area of the image that needs to be protected from the blend mode.

Body art – Blend a texture or pattern with your subject to create a dramatic or surreal effect

1. Click and drag the layer thumbnail of the raindrops image into the body image window. Hold down the Shift key as you let go of the drops thumbnail to center the image in the new window. Use the Move tool to reposition the texture if required. Use the Free Transform command (Image > Transform > Free Transform) if required, to resize the texture image so that it covers the figure in the image. Set the blend mode of the drops layer to Soft Light or Overlay. Experiment with adjusting the opacity of the layer using the Opacity slider in the Layers panel.

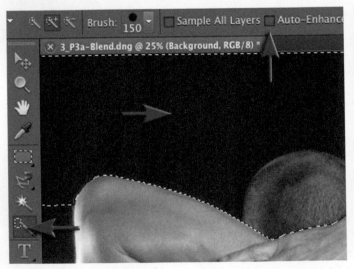

2. Turn off the visibility of the water layer. Select the Quick Selection tool in the Tools panel. Deselect the Auto Enhance option in the Options bar. Make an initial selection by dragging the tool over an area of the background. Click and drag over the islands of black background between the subject's fingers to add these areas to the selection (reduce the size of the brush if necessary). Hold down the Alt/Option key and drag over any areas that need to be removed from the selection, e.g. the head.

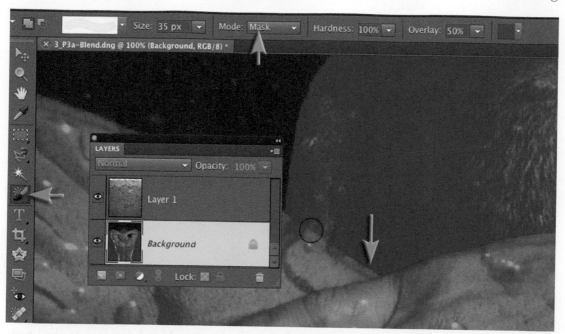

3. Select the Selection Brush tool in the Tools panel and select the Mask option in the Options bar. Paint over any gaps in the mask (using a brush at 100% Opacity) to perfect the resulting selection. Zoom in and move around the edge of the body to ensure all of the body is fully masked. Switch back to selection mode in the Options bar when this step is complete.

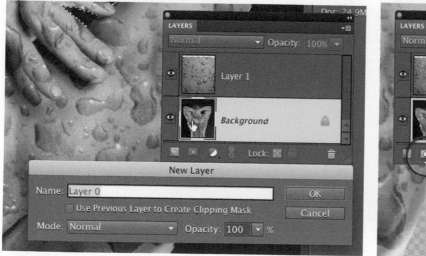

4. We need to unlock the background layer to perfect this composite image. Double-click the background layer in the Layers panel to open the New Layer dialog and select OK to accept the 'Layer 0' name. We will now be able to add a mask to this layer and a new layer below (not possible when the layer is a background layer). With the selection (created in Step 3) still active, select the newly created Layer 0 then click on the Add Layer Mask icon at the bottom of the layers panel.

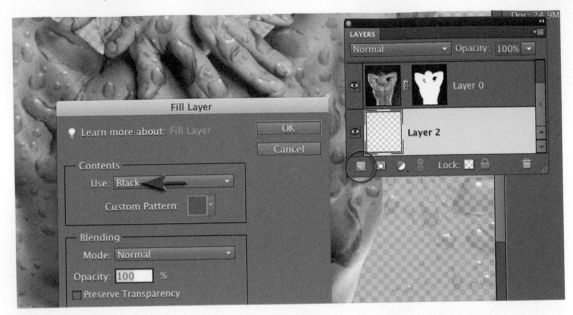

5. Hold down the Ctrl/Command key and click on the Create a New Layer icon in the Layers panel to create an empty new layer below Layer 0. Go to Edit > Fill Layer and choose black as the contents color. Select OK to create a black layer (Layer 2).

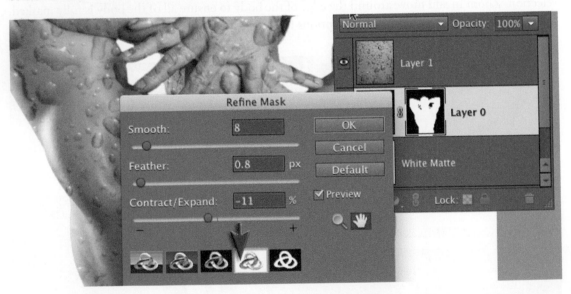

6. Click on the layer mask thumbnail in the Layers panel and then from the Select menu choose the Refine Edge command. Double-click the Custom Overlay Color option to access the Overlay options. To get an accurate view of how appropriate the edge of the mask is for our final result and to help us choose the optimum settings click on the On White preview option in the Refine Edge dialog. This displays the selection against a white background and any flaws in the mask are easier to locate.

7. Adjust the Smooth and the Feather sliders to help refine the edge, then drag the Contract/Expand slider to the right to hide any of the dark edges from the old black background. Select OK when you have achieved a good clean edge.

8. Hold down the Ctrl/Command key and click on the layer mask thumbnail to load the mask as a selection. Click on the raindrops layer (Layer 1) to make this the active layer and then select a Levels adjustment layer from the Create Adjustment Layer menu in the Layers panel.

9. Go to Select > Inverse to invert the layer mask. In the Levels dialog drag the black Output Levels slider to the right to lighten the background to a dark gray tone. From the Channel menu select the blue channel and once again drag the black Output Levels slider to the right to introduce a blue color to the gray background. The precise shade of blue can be controlled by adjusting the black Output levels slider in either the red or green channel.

10. Select the Gradient tool in the Tools panel. Select the Foreground to Transparent and Radial Gradient options with black selected as the foreground color. Set the opacity to 100% and select the Reverse, Dither and Transparency options. Click and drag from a position in the center of the man's body out past the top right-hand edge of the image window to create a backlight effect.

11. Select Layer 0 in the Layers panel and use the keyboard shortcut Ctrl/Command + J to duplicate the layer. Group this copy layer with the layer below and from the Enhance menu choose Adjust Sharpness. Select a generous Amount of sharpening with a low Radius setting (300 and 0.8) and click OK. The opacity of this duplicate layer can be lowered to adjust the levels of sharpening for your required output device.

This image was created using the techniques from this project and Project 8 in this module

Project 6

Need for Speed

Motion, or the suggestion of motion, is used in images to convey a sense of energy and can help a still visual come alive – giving it a dynamic edge. The world of advertising and fashion photography uses movement within an image to lend an element of *je ne sais quoi* to the visual stories it creates.

In this project, we liberate a man and his motorbike from the confines of a backyard and place them in the great outdoors. We then create the illusion of speed using the motion blur technique, the static images combine to form an expression of exuberance and a celebration of being alive.

Zooming along – we combine two still images, creating an expression of freedom and the illusion of speed

While it is possible to create a similar effect using a single image of stationary subjects, protecting the main subject from the streaking and blurring that bleeds in from the background is a lot more challenging. The most convincing and technically accurate results will be obtained when the foreground interest and background (or *plate*) have been captured separately.

But with great power, comes great responsibility – used incorrectly, the motion blur effect can look tacky, reducing a strong image to kitsch. Used with care and in moderation, this technique breathes life into static images and brings with it the gasps of amazement and admiration all image-makers secretly enjoy.

1. This first step will create a graduated filter that will help soften the sky and give the scene a bit of mood. On a new layer, create a linear gradient using a dark shade of blue selected from the sky using the color picker tool. The gradient should reach half way down the sky, but we must ensure that it stops short of the wispy clouds just before the horizon.

2. Gradients may lead to stepping or banding of colors when printed or viewed on screen. We can avoid this by adding a bit of noise, from the menu bar select Filter > Noise > Add Noise. Using the amount slider introduce between 1-2 % of noise, ensure the Gaussian Distribution and Monochromatic options are selected.

3. Add the image of the man on the motorbike to the scene and use the selection techniques discussed in Project 1 of this Part to set him free from the backyard. To speed up this process, you may wish to download the Load Embedded Selection Action from the companion website. The action extracts the selection included within the image, however you will need to refine the mask using the Select > Refine Edge command to optimize it for this project.

4. We are now ready to add some motion into the image. Our aim is to create an image where the motorbike and the rider are in sharp focus but the background is blurred giving the illusion that the motorbike was speeding through the landscape when the image was captured. To achieve this practically would require a camera rig mounted on a utility vehicle, road closures, possibly a stunt crew, and the expense of flying the entire production to an exotic location. Given our limited budget, we are going to achieve the same outcome using layer masks, the gradient tool, and the all important motion blur filter. To begin this process, we Right click (or Ctrl + click) on the background layer to duplicate it.

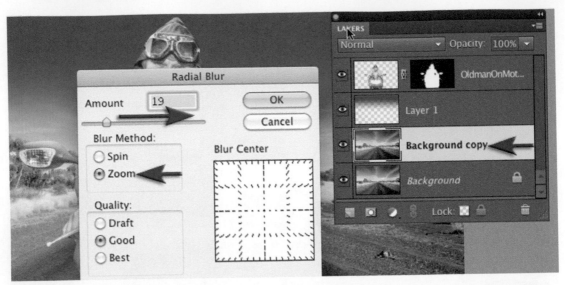

5. With the copy of the background layer selected, choose Filter > Blur > Radial Blur. Choose the blur method as Zoom and an Amount between 15-20; leave the quality settings on Good. Since the zoom effect in this image is directly through the middle, the default setting for Blur Center (aligned with the middle of the image) should be fine.

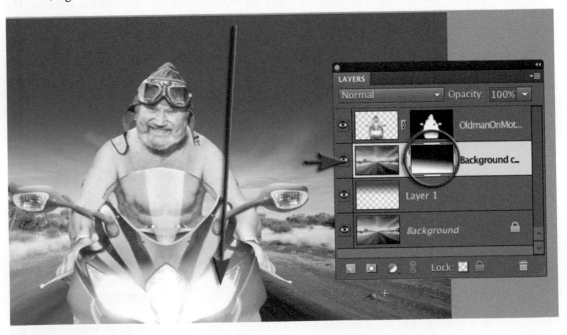

6. In a scene such as this, objects furthest from the camera don't appear to be moving as quickly (or as blurred) as objects that are closer. We require a gradual increase in the blurring effect from the background to the foreground. Add a layer mask to the layer to which we applied the radial blur. With black as the foreground color apply a linear gradient to the layer mask.

Note > The gradient must start with black and end with white or transparent.

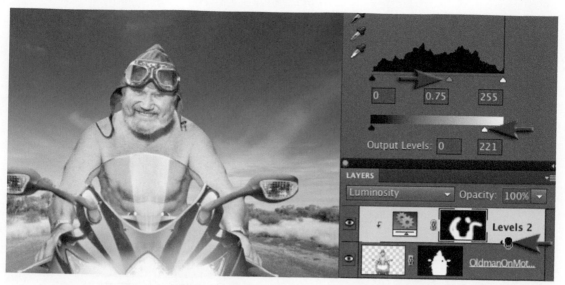

7. The illusion of speed is complete, however the eye does not accept that the man and the background belong together due to differences in color temperature and subject brightness. In this step and in the next step, we will tackle the tonal differences between the two layers. Create a new Levels Adjustment Layer, clip it to the layer containing the motorbike rider by holding down the Alt key and clicking between the two layers. Pull back the output slider for highlights and adjust the gamma slider to darken the image slightly. With the layer mask for the adjustment layer selected, choose Edit > Fill Layer and fill it with black. Then with a large, soft, white brush go over the edges of the man and the motorbike gradually darkening the parts that are too bright.

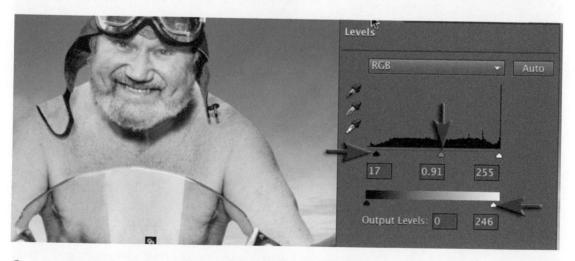

8. The previous adjustments were local in nature (courtesy of the layer mask). Now we will make some adjustments to reduce the overall brightness of the rider and the motorbike. Add another Levels Adjustment Layer, clipped to the motorbike layer. Play around with the sliders until you get the correct balance of tones. There is no right or wrong. The input sliders can increase contrast and adjust overall brightness while the Output sliders can reduce contrast or control saturation.

9. Add a Hue Saturation Adjustment layer to the layer containing the man, make sure it is a clipping layer that will only affect this layer. Reduce the Master saturation of this layer to about -25, this is just to help bring the saturation between the background and foreground elements closer to each other.

10. The two original images were shot under different weather conditions, resulting in a difference in color temperature. We shall add a warming Photo Filter adjustment layer to warm up the foreground.

11. Add a Hue Saturation layer above the background layer, reduce the Master Saturation so that the saturation levels for the man and the background are closer. Select the Blue channel and reduce the Hue slider to -18, this shifts the overall colors giving the image a distinct look

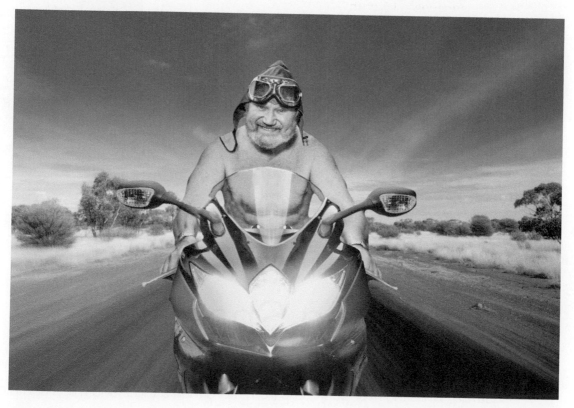

12. Sharpening can be applied to the finished image depending on whether the image is intended for print or screen viewing. Further, due to the wide field of view, we also have the option of changing the composition of the image using the crop tool. This image would work both as a landscape or portrait image.

Project 7

Preserving Shadows

The truck used in this project was photographed in the hills of southern Queensland, Australia, while the river dock hails from more than a thousand miles south on the banks of the Yarra river in Melbourne, Victoria. Unlikely bedfellows, but with a little craft the two can lie together comfortably within the same frame – but only if the shadow retains all of its subtlety and is delicately transplanted to its new home on the wooden dock.

The 'shadow catcher' technique – designed to preserve the natural shadows of a subject

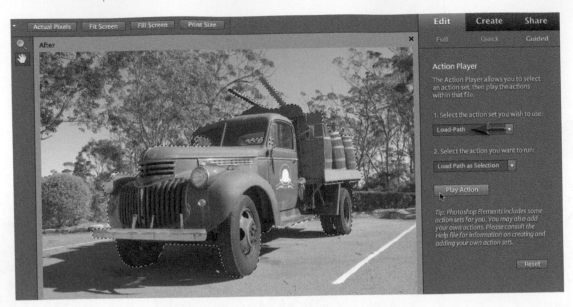

1. Open the project image. Make an accurate selection of the truck (without its shadow) using the skills from the previous projects or load a pre-made selection using the Load Path action from the supporting website. If this action has been placed in the Actions folder go to Guided Edit > Action Player and look for the Load-Paths action. Click on the Play Action button to fast track this process.

Note > The selection is being loaded from a vector path that was created in the full version of Photoshop and saved with the JPEG file. JPEGs can support paths but not saved selections.

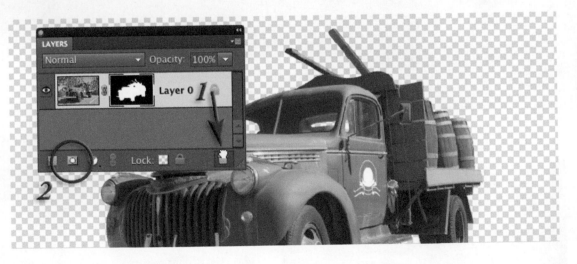

2. In the Layers panel drag the lock icon on the background layer to the trashcan in the corner of the Layers panel. This will allow us to add a layer mask to the layer. Click on the Add layer mask icon at the base of the Layers panel to hide the background surrounding the truck. Don't worry about losing the shadow at this stage as it will reunited later in the project.

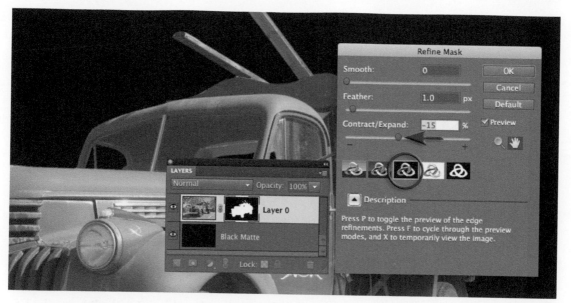

3. The path that was embedded in this file has a hard edge and will need to be refined. Go to Select > Refine Edge and raise the Feather slider to 1.0 and move the Contract/Expand slider to -15 to ensure there is no halo surrounding the truck. Selecting the Black Matte option in the Refine Mask dialog will enable you to see if the edge has been contracted enough. Select OK when the edge is looking good. Save this file as a Photoshop (PSD) file and name it 'Truck'.

Important > Do not close the file as we will now modify the file to isolate the shadow.

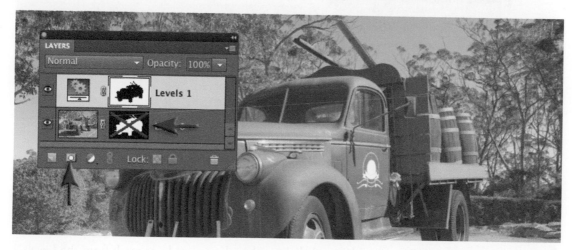

4. Hold down the Ctrl key (PC) or Command key (Mac) and click on the layer mask to reload it as a selection. Hold down the Shift key and click on the layer mask to switch the visibility off. From the Create new fill or adjustment layer menu choose a Levels adjustment. The active selection will be turned into a new layer mask. Use the keyboard shortcut Ctrl + I (PC) or Command + I (Mac) to invert this mask. Check that your layers in the Layers panel now resemble the illustration above.

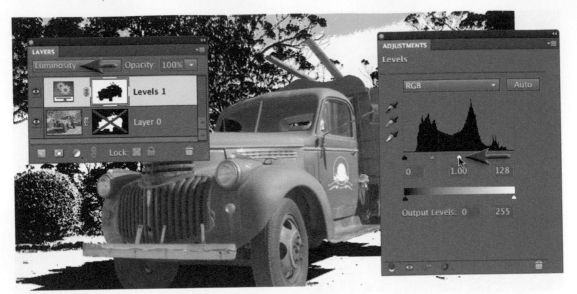

5. Hold down the Alt/Option key and click and drag the white input Levels slider to the left. The Alt/Option key will give you a threshold view and as you drag the slider to the left you will see increasing areas of tone being clipped to white. Continue to drag the slider to the left until the shadow appears as an island of black tone surrounded by white clipped tone. Set the mode of the Levels adjustment layer to Luminosity to preserve the original Hue and Saturation values of the shadow tones.

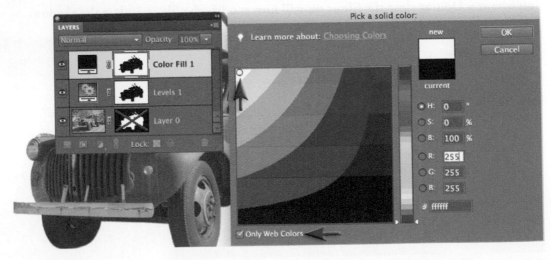

6. Hold down the Ctrl/Command key and click on the adjustment layer mask from the Levels 1 layer to load it as a selection. From the Create new fill or adjustment layer menu in the Layers panel choose a Solid Color adjustment layer. Select White as the color and then select OK to create a Color Fill layer.

Note > Make sure the white you pick from the Pick a Solid Color dialog is 255 in all three channels. A quick way of doing this is to select the Only Web Colors option and then click in the top left-hand corner to select white.

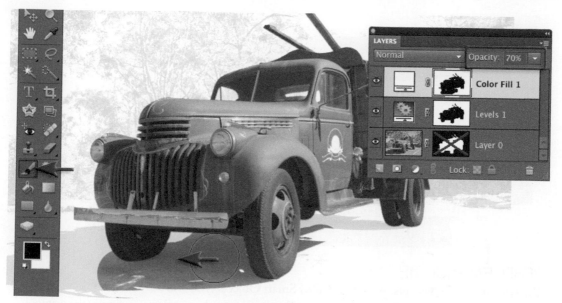

7. Lower the opacity of the Color Fill (Solid Color) layer. Select the Brush tool from the Tools panel and choose a hard-edged brush set to 100% Opacity in the Options bar. Paint over the shadow in black to mask this area on the Color Fill adjustment layer mask (no accuracy is required). When the masking is complete set the opacity of the Color Fill layer back to 100%. The end-result of this step should be a truck and a shadow with nothing else visible from the old background. Save this file as a Photoshop (PSD) file and name it 'Shadow'.

8. Open the river dock image and then go to File > Place and choose the Shadow image that you saved in the previous step. The shadow file will appear with a large bounding box with a cross through it, inviting you to scale the image. Hit the commit icon or right click and choose Place from the context menu. Go to File > Place again and now choose the Truck image that was saved in Step 3. When the file appears commit the file without altering the size.

PERFORMANCE TIP

The two layers you have just placed are called Smart Objects (you will see a smart object symbol in the corner of each layer thumbnail). Smart Objects are non-destructive containers (the original PSD file is enclosed in each). You can Transform the shape and size of the embedded image repeatedly, without lowering the quality as the final image - a great feature for compositing work. If you need to change the size or position of the truck, however, you will also want to change the shadow at the same time. Select both Layers (hold down the Shift key and click on each layer) and then click on the Link layers icon in the Layers panel. Now when you transform one layer the other will be modified at the same time.

9. Set the blend mode of the 'Shadow' layer to Multiply. White is a neutral color in the Multiply mode so the area surrounding the truck will now be filled with the background layer. The shadow on this layer will, however, darken the background layer. The truck on the top smart object layer completes the picture. Click on the visibility icon of the Truck smart object a couple of times to see how this layer contributes to the final outcome.

10. Use the keyboard shortcut Ctrl + T (PC) or Command + T (Mac) to access the Free Transform command. Right-click in the Transform bounding box to access the context menu. Choose Flip Layer Horizontal to ensure the lighting direction of the truck image is consistent with the lighting direction of the new location.

11. With the Transform bounding box still active you are now free to reposition the truck layer (click and drag inside the bounding box), scale the image (click and drag one of the corner handles) or rotate the image (click and drag just outside one of the corner handles). Hit the Commit icon or press the Enter key (PC) or Return key (Mac) to apply the transformations.

Note > You can repeat this process many times without the risk of lowering the overall quality.

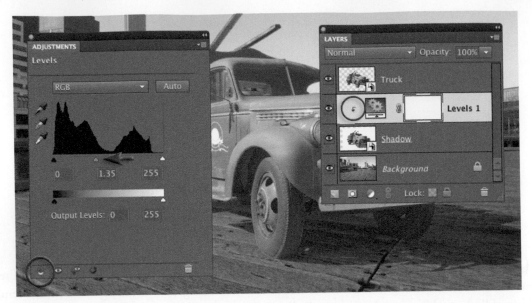

12. The next few steps will ensure each component is optimized so that it looks natural. To adjust the density of the shadow click the Shadows layer and from the Create new fill or adjustment layer menu choose Levels. Click the clipping icon in the bottom left-hand corner of the Adjustments dialog to ensure the changes we are about to make only affect the shadow and not the background. Drag the central Gamma slider beneath the histogram to the left or right to lighten or darken the shadows under the truck until it appears correct.

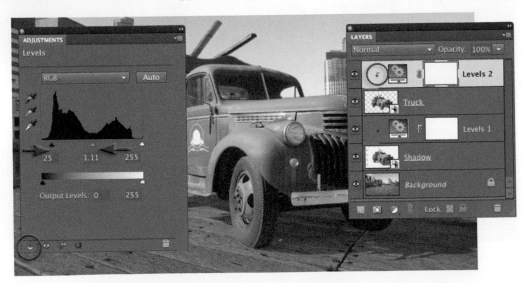

13. To adjust the brightness and contrast of the truck click the Truck layer and from the Create new fill or adjustment layer menu choose Levels again. Click the clipping icon in the bottom left-hand corner of the Adjustments dialog to ensure the changes only affect the truck and not the underlying layers. Raise the Black input slider to increase the density of the dark tones and move the central gamma slider to the left to restore the brightness values.

14. The color temperature (white balance) of the two images is slightly different. To correct this difference add a Photo Filter adjustment layer above the truck and Levels 2 layers. Clip this adjustment layer with the layers below and in the Photo Filter dialog choose a Warming Filter (85) and adjust the opacity until the white balance between the two images appears consistent. The three aspects of this composite file (the location, the truck and its shadow) are now working as one to give realism to the final outcome.

PERFORMANCE TIP

When looking to capture location files that would be useful for compositing techniques, such as the one outlined in this project, try to ensure a broad open space in the foreground of the shot. This can be created by using a wide angle lens or a higher vantage point with the camera angled-down. When capturing the subject for the composite file try to ensure the shadow is cast over a texture that matches the new location. Alternatively, if the shadow is falling over a smooth texture the shadow will take on the texture of the new background. Another factor to consider is sharpness. Try to avoid taking images for compositing that use a wide lens aperture that results in shallow depth of field. This will make the compositing task either more difficult or impossible. If a wide aperture is unavoidable make sure the focus for the location image is centered around the position where the new subject is to be located.

THE BEST TECHNIQUE FOR SUBTLE SHADOWS

The technique to preserve shadows provides to those photographers burdened with a meticulous eye a useful way of retaining and transplanting subtle and complex shadows. Observe the subtle shadow cast by the leaf above that would be virtually impossible to re-create using any other technique. The primary circumstances that prevent this technique from being used are when the shadow falls over a surface with a different texture to the one in the new location, or the surface over which the shadow falls is particularly uneven or moves from a horizontal to a vertical plane over the length of the shadow.

PERFORMANCE TIP

If it is not possible to preserve the original shadow, try to capture a second image from the direction of the light source. This second image will allow you to create a more accurate shadow than simply using the outline of the subject as seen from the camera angle instead of the direction of the light source.

This process would include the following steps:

- Make a mask of your subject and place it on a layer above a background.
- Import the second image captured from the direction of the light source and position it between the subject layer and the background layer.
- Make a selection of the subject in this second image (your shadow resource).
- Create a new empty layer that sits below the actual subject and above the background layer, and then fill this selection with black.
- Hide or delete the layer that the selection was made from.
- Place your new shadow layer in Multiply mode.
- Lower the opacity of your shadow layer and apply the Gaussian Blur filter.
- Use the Free Transform command to distort and move the shadow into position.

Project 8

Displacement

Create a showpiece montage by creating a patriotic background for this classic 1957 Thunderbird using some fiendishly clever digital deeds. Wickedly good stuff! The car was photographed by Shane Monopoli for Exclusive Photography in Australia and prepared for the subsequent montage using the shadow preservation skills from the last project.

1957 Thunderbird by Shane Monopoli for Exclusive Photography

The layer blend modes are an effective way of merging or blending a pattern or graphic with a three-dimensional form. By using the blend modes the flag in this project can be modified to respect the color and tonality of the undulating silk beneath it. The highlights and shadows that give the silk its shape can, however, be further utilized to wrap or bend the flag so that it obeys the material's shape and sense of volume. This can be achieved by using the Displace filter in conjunction with a 'displacement map'. The 'map' defines the contours to which the flag must conform. The final effect can be likened to 'shrink-wrapping' the flag to the 3-D form of the undulating silk.

How it works > The brightness level of each pixel in the map directs the filter to shift the corresponding pixel of the selected layer in a horizontal or vertical plane. The principle on which this technique works is that of 'mountains and valleys'. Dark pixels in the map shift the graphic pixels down into the shaded valleys of the 3-D form while the light pixels of the map raise the graphic pixels onto the illuminated peaks of the 3-D form.

1. A silk dressing gown was photographed using the available light. For this image to act as an effective displacement map the contrast must, however, be expanded. An effective way of expanding contrast in Photoshop Elements is to duplicate the layer and set the top layer to Overlay blend mode. Note the changes to the histogram by viewing it in the Histogram panel.

Note > Duplicate the silk image resource file to ensure the original file is retained as a master and not lost by this manipulation. Either copy the image file before you start the project or go to File > Duplicate before you proceed to Step 2.

2. Go to the Image menu and from the Mode submenu select Grayscale. Choose the option Flatten when the Warning dialog box appears and OK when the Discard Color Information warning appears.

Note > The displacement map must be in Grayscale otherwise the color channels will upset the appropriate displacement effect.

3. To further improve the effectiveness of the displacement map we must blur the image slightly. This effect of blurring the map will smooth out the lines of the flag as it wraps around the contours of the silk. Too much blur and the undulations will be lost; too little and the lines of the flag will appear jagged as they are upset by any minor differences in tone. Go to Filter > Blur > Gaussian Blur and start by selecting a Radius of around 10 pixels. Increase or decrease this radius when working with images of a different resolution.

4. Save the image (displacement map) as a Photoshop (PSD) file. Close the blurred Grayscale file as the map is now complete. You will need to choose this file when the Displacement filter asks for the location of your map, so make a note of where it has been saved to on your computer.

5. Open or select the original RGB silk file. Also open the flag image. With the flag image as the active window choose the 2-up view from the Arrange Documents icon in the Application bar. Drag the thumbnail of the flag image from the Layers panel into the window of the silk image to create a multi-layered file. Close the Flag file.

6. Set the blend mode of the flag layer to Multiply. If you are intending to displace a graphic or a texture it is worth ensuring that you have some elbow room (when we displace the flag it will come away from, and reveal, the edges of the background layer if they are the same size). Use the Free Transform command (Ctrl or Command + T) to enlarge the flag layer so that it is a little larger than the background layer.

7. Go to Filter > Distort > Displace. Enter the amount of displacement in the Horizontal and Vertical fields of the Displace dialog box. The size of the displacement is dependent on the resolution of the image you are working on. Choose amounts of 40 for both fields for the Flag.jpg used in this project. Increasing the amount to greater than 60 for either the Horizontal or Vertical Scale will increase the amount of distortion in this project image, but will also start to break off islands of color from the design of the flag, indicating that the limit of the effect has been exceeded. Select OK in the Displace dialog box and in the Choose a Displacement Map dialog box browse to the displacement map you saved. Select Open and your flag should now miraculously conform to the contours of the silk. If you are not entirely happy with the results go to the Edit menu and choose Undo. Repeat the process choosing smaller or greater amounts in the Displace dialog box.

8. If some of the stars are excessively distorted switch off the visibility of the Background layer and select the Brush tool from the Tools panel. Hold down the Alt/Option key and click on the blue to sample the color. Paint over any parts of a star that have been excessively distorted.

9. Click on the Create new fill or adjustment layer icon in the Layers panel and choose a Levels adjustment layer. Drag the Highlight slider to the start of the histogram to extend the dynamic range and make the highlights and midtones appear brighter.

10. Click on the Create a new fill or adjustment layer icon and choose a Hue/Saturation adjustment layer. Lower the saturation slider to -40. Create a Merge Visible layer using the keyboard shortcut Ctrl + Alt + Shift + E (PC) or Command + Option + Shift + E (Mac).

11. To create a softer looking flag you can apply either a 2-pixel Gaussian Blur to the Merge Visible layer (Filter > Blur > Gaussian Blur) or you could apply one of the Maximum Performance Smooth Tone actions by downloading the action from the supporting website. After placing the action in the appropriate support folder on your computer you can access the action from the Action Player (Edit > Guided > Action Player). Make sure you use one of the Multi-Layer options before hitting the Play Action button. Your dramatic and colorful background is now complete.

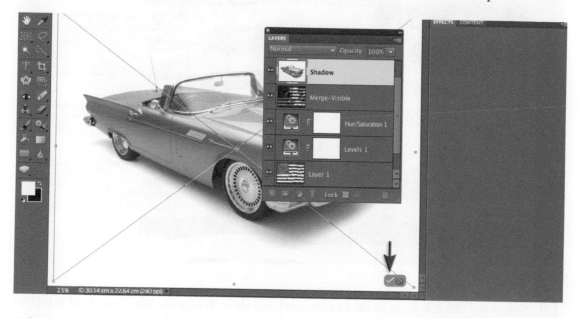

12. Go to File > Place and choose the Shadow image for this project. Commit the scaling when the image appears. Then go to File > Place and choose the Car image for this project. Again commit the scaling. These two images have been prepared using the techniques from the previous project.

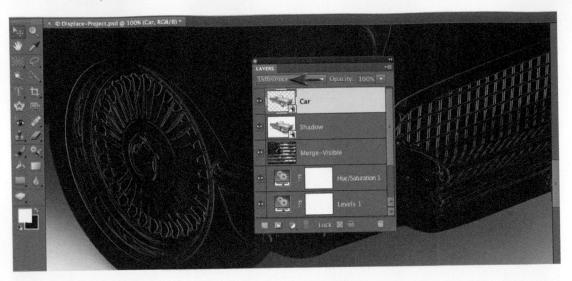

13. Zoom in to 100% Actual Pixels and set the mode of the car layer to Difference. What you should see is an absolute silhouette of the car and there should be no white lines visible around the edges of the detail. If there are white lines select the Move tool from the Tools panel and use the keyboard arrow keys to nudge the top layer into alignment. When perfect alignment has been achieved set the mode of the top layer back to Normal.

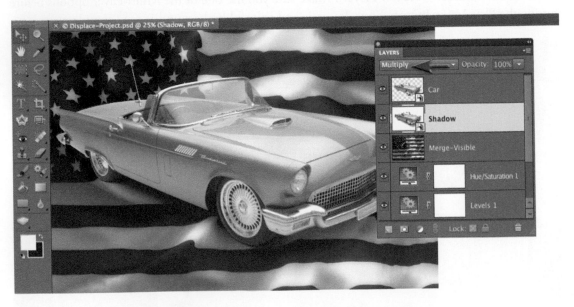

14. Select the Shadow layer in the Layers panel and then change the blend mode of this layer to Multiply. The car should now appear with its shadow above the flag.

Note > The layer mask in the car file has been adjusted to 50% gray in the region of the windscreen to allow the flag to show through at a reduced opacity.

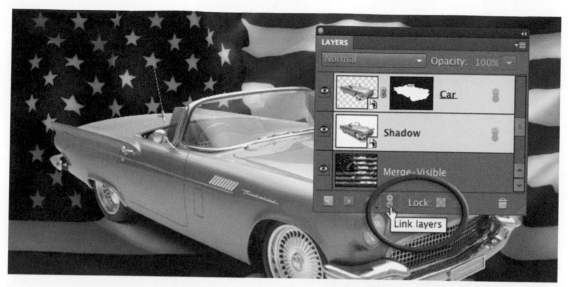

15. Select both the Shadow and the Car layer (Hold down the Shift key as you select them) and then from the base of the Layer panel choose the Link layers option. Select the Move tool from the Tools panel and move the car into the perfect location against the flag. As both these layers are Smart Objects they can also be scaled non-destructively.

16. We will now render the rear of the car slightly darker than the front. From the Create new fill or adjustment layer icon choose a Levels adjustment. Click the clipping icon in the Adjustments panel so the Levels layer is clipped with the car layer underneath. Drag the central gamma slider underneath the histogram to the right to darken the car slightly.

17. Select the Gradient tool from the Tools panel. Select the Black, White gradient from the gradient Picker and the Linear Gradient from the Options bar. Drag a long gradient from the front to the rear of the car to shield the front end of the car from the adjustment.

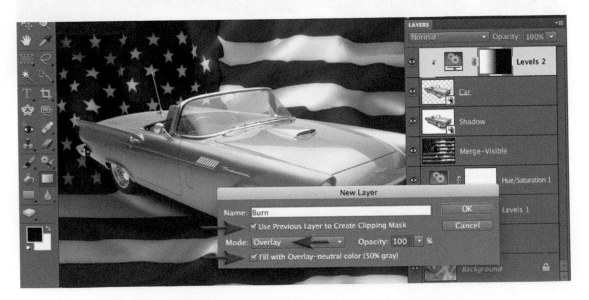

18. As this car was photographed against a bright background, the lighting on the lower panels is a little too light. To modify the lighting so that it looks consistent with the new background we will create a Dodge and Burn layer. Hold down the Alt/Option key and click on the Create a new layer icon. Check the Use Previous Layer to Create Clipping Mask option, set the mode to Overlay and then check the Fill with Overlay-neutral color (50% gray) option.

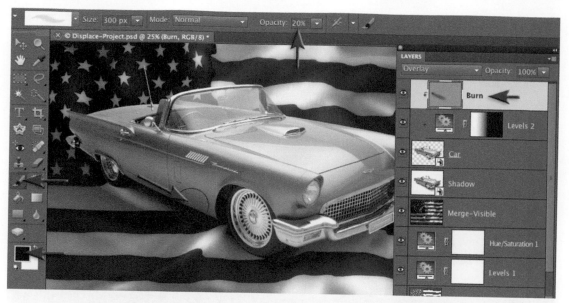

19. Select the Brush tool from the Tools panel and set Black as the foreground color. Set the Brush hardness to 0% by clicking on the Brush in the Options bar. Set the Opacity of the brush to 20%. Paint over the trunk and the lower portions of the panels to darken the car in this region.

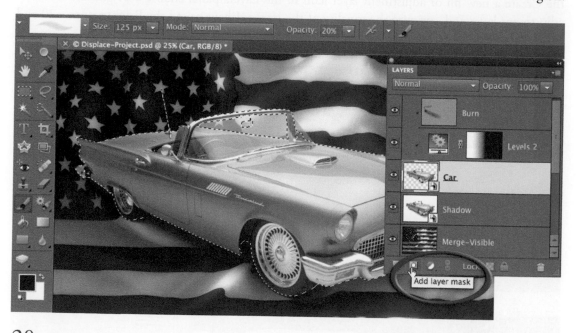

20. The Car layer used a mask in the original Photoshop file. This cannot be accessed inside Photoshop Elements but we can hold down the Ctrl key (PC) or Command key (Mac) and click on the car layer in the Layers panel to load the car as a selection. Click on the Add layer mask icon at the base of the Layers panel to add a new layer mask. This action alone may improve the quality of the edge. If the mask needs fine-tuning go to Select > Refine Edge).

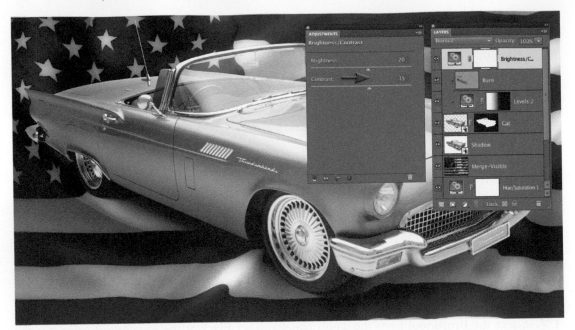

21. To complete the project we will use some Adjustment layers to optimize the final file. From the Create a new fill or adjustment layer icon in the Layers panel choose a Brightness/Contrast adjustment layer and optimize the tonality of the image. I have raised the Brightness to +20 and the Contrast to +15 in this project.

22. Now add a Photo Filter adjustment using a Warming Filter to give the image a classic golden glow. Lower the Density slider slightly if the warming filter is too strong.

23. The third and final adjustment is another Hue/Saturation adjustment layer that is used to drop the overall Saturation levels a little more (-25 in this project) to give the aged look.

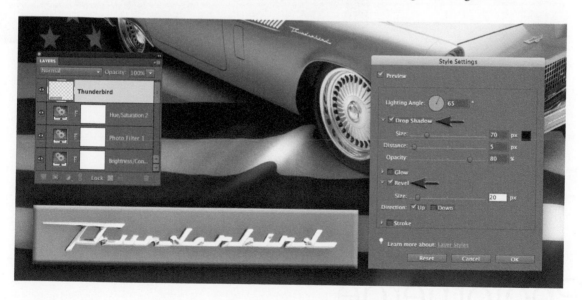

24. A detail photograph from the side of the car can be used to add an emblem to the completed project. Open the supporting file and use the Free Transform command (Ctrl/Command + T) to move and scale the emblem. Go to Layer > Layer Style > Style Settings and check the Drop Shadow and the Bevel check boxes. Fine-tune the sliders of both of these sections and adjust the Lighting angle to around 65° so that it is consistent with the lighting direction for the flag and the car. Your classic make-over is now complete.

Project 9

Photomerge

Photomerge is capable of aligning and blending images without any signs of banding in smooth areas of transition. The new and improved Photomerge first made its appearance in Photoshop CS3 but the maths got even better when it appeared in Photoshop Elements 6 and the stitching is now so clever it will really have you amazed at the quality that can be achieved.

Spot the joins – upgrade to 36 megapixels with seamless stitching

The quality will be even better if you capture vertical images with a 50% overlap using manual exposure, manual focus and Manual White Balance setting (or process the images identically in Camera Raw). The results are now usually seamless – an excellent way of widening your horizons or turning your humble compact camera into a 36 megapixel blockbuster.

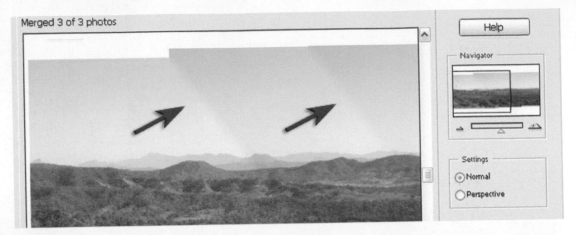

The Photomerge feature in version 5 of Photoshop Elements and the full version of Photoshop CS2 left a lot to be desired. All of the flaws and weaknesses of this feature were removed with the release of Photoshop Elements 6.

Now, the only limitation you may run up against is Photoshop Elements' ability to align and blend strong geometric lines that come close to the camera lens. If the camera is hand-held to capture the component images (i.e. you have not used a specialized tripod head designed for professional panoramic stitching work) then the problem of aligning both foreground and distant subject matter is a big problem for any software (Photoshop Elements handles it better than the rest). The camera should ideally be rotated around the nodal point of the lens to avoid something called parallax error. You will probably not encounter any problems with the new Photomerge feature unless you are working with strong lines in the immediate foreground. Notice how the curved lines in the image above are slightly crooked due to the fact that these images were shot with an 18 mm focal length and the circled lines are very close to the lens. Still pretty good – but not perfect.

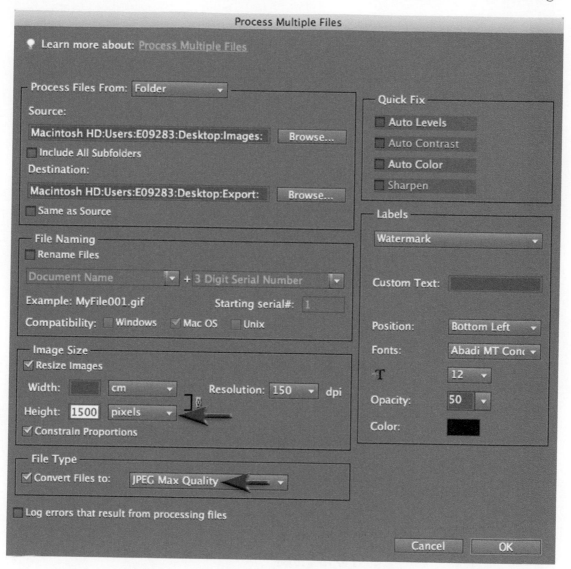

1. The images for this project are available as Camera Raw files but it is strongly recommended when using an older computer or a computer with less than one gigabyte of RAM to downsample the images before attempting this project. To efficiently downsample multiple images go to File > Process Multiple Files. Select the Source folder of the raw images (hit the Browse button) and then select the destination folder where you would like your processed files to be saved. Check Resize Images and select a height of 1500 pixels. Check Convert Files To and choose the JPEG Max Quality option. Select OK to process the images.

Note > If you wish to make a monster panorama (12-megapixel images are used in this project) select all of the Camera Raw files and open them in Adobe Camera Raw (ACR). Choose the Select All option in the top left-hand corner of the dialog box and select OK. Choose Image Settings for these images in ACR and then click Open Images.

2. Select all of the images from the destination folder you created in the Process Multiple Files dialog box. Open the processed images in Photoshop Elements. From the File > New menu choose Photomerge Panorama.

3. In the Photomerge dialog box click on the Add Open Files button and select the Auto radio button in the Layout options. Select OK and let Photoshop Elements do all of the work – and what a lot of work it has to do, aligning and blending all of these images.

Note > Photomerge can also handle multiple exposures and juggle which is the best exposure to use for any given location in the panorama.

4. Prior to Elements 6 many more steps of manual techniques were required to circumnavigate the shortcomings of Photomerge – but as you can see from the results in this project we just about have perfection handed to us on a plate. Fantabulous! (I know that's not in the dictionary but neither is Photomerge – yet.) If you have used the full-resolution images you probably had to go and make a cup of coffee while Photoshop Elements put this one together (all 60 megapixels of it) and will now be considering downsampling your file – but wait, we have a couple of small glitches in this result.

PERFORMANCE TIP

The Auto layout setting gets it right pretty much all of the time. Occasionally you may need to select either the Perspective or Cylindrical options for very wide panoramas. Interactive Layout can be selected when Photoshop Elements is having trouble deciding where one or two of the component images should be placed. This can occur when there is little detail in the image to align, e.g. a panorama of a beach scene where the only obvious line in the image is the horizon. When this occurs you will need to drag the problem file into the best location in the Interactive Layout dialog box.

PERFORMANCE TIP

If you downsample before you flatten your file you will probably encounter hairline cracks after reducing the image size. The solution to this problem is to either flatten the file or stamp the visible content to a new layer (Ctrl/Command + Shift + Alt/Option and then type the letter E) before you reduce the size of the image.

If you hold down the Alt/Option key and click on each layer mask in turn you will notice that Elements uses hard-edged layer masks to hide or reveal the piece of the jigsaw puzzle that makes up the final panorama. The panorama has seamless joins because Photoshop has adjusted or 'blended' the color and tonality of the pixels on each layer. Any pixels concealed by the layer masks have not been subjected to these color and tonal adjustments. This, in effect, means that the user cannot override which bit of each layer is visible as the hidden pixels have not been color-matched.

5. Stamp the visible elements to a new layer (Ctrl + Shift + Alt and then type the letter E on a PC or Command + Shift + Option and then type the letter E on a Mac). Crop away that which is surplus to requirements before flattening the file, be sure to select the No Restriction option in the Options bar and leave the Width and Height fields blank. This is a big image (especially if you used the full-resolution files) so don't be surprised if things are a little slower in computer land right now.

6. There is a small area of transparency at the top of the frame that will need cloning (I did not want to crop too tight at the top of the frame). Select the Clone Stamp tool from the Tools panel and then clone in some new sky from immediately below the transparent area. I have created an empty new layer to clone into and have checked the Sample All Layers option in the Options bar. Only when I am happy with the patch job will I select Merge Down from the Layers fly-out menu.

7. When stitching just two or three images Photomerge Panorama gets it right pretty much all of the time. When stitching much wider panoramas where there is a good deal of foreground detail you may find a couple of alignment errors. These images were captured using a wide-angle lens and the foreground rocks are just in front of the tripod. If I had used a specialized panorama tripod head the effects of parallax error would not be a problem. Photomerge in this instance, however, has met its match. The foreground rocks all match perfectly but that horizon line has a small break and is undulating. We can fix this. Select the Rectangular Marquee tool and make a selection that just touches the horizon line at the lowest point. Make sure the feather option in the Options bar is set to 0. From the Select menu choose Inverse.

Note > The stitching errors may change depending on the resolution (pixel dimensions) of the files you choose for Photomerge to align and blend.

8. Go to Filter > Distort > Liquify. Choose either the Warp tool or the Shift Pixels tool to nudge the horizon line down towards the red frozen area (created from the selection you made in the last step). Increase the size of the brush to 400-500 pixels and decrease the Brush Pressure to a lowly 5 pixels. If using the Warp tool just click and drag to push the pixels into alignment. If using the Shift Pixels tool click and drag to the left in short strokes. When the horizon line is sitting on top of the red rectangle click OK to apply the changes to the image.

9. Pushing the pixels down onto the selection in Liquify will create an unnaturally hard edge to the horizon. This can be fixed by selecting the Blur tool in the Tools panel and a Strength setting of 50% in the Options bar. Zoom in so you can see the effects of your painting and then paint along the edge to soften it.

10. If you find that there are still a few areas of the horizon line that could be nudged straighter you could either repeat the Liquify step or make a selection just below the horizon line again and Inverse the selection (Select > Inverse). Then use the Smudge tool with a very low Strength setting to push the pixels towards the selection edge. Remember that only selected pixels can be moved.

11. If you find a physical break in the horizon line or on the rocks either side of the horizon line you can create a patch to hide the awkward break. Use the rectangular Marquee tool with a feather radius of 10 pixels and make a small selection just next to the break. Choose Copy and then Paste from the Edit menu to put the patch onto its own layer. Then go to Image > Transform > Free Transform. You can now slide and rotate the patch into position. Hold down the Ctrl key (PC) or Command key (Mac) to distort the shape of the patch so that you can achieve a seamless fix.

12. If the Patch does not match the color of the tones then you can create an empty new layer and set the mode of this layer to Color. Select the Brush tool in the Tools panel, hold down the Alt or Option key and click on a more appropriate color to load this into the Foreground Color Swatch in the Tools panel. Then paint over the area that needs adjusting to further perfect the patched area.

13. You can finish this project by stamping the visible layers to a new layer (Ctrl + Shift + Alt + E for a PC or Command + Shift + Option + E for a Mac), setting the mode to *Soft Light* in the Layers panel and removing the color (Enhance > Adjust Color > Remove Color). Then go to Filter > Other > High Pass. Use a generous setting (60 to 70 pixels) to enhance the midtone contrast and then select OK. Lower the opacity of the layer if you want a more subtle effect.

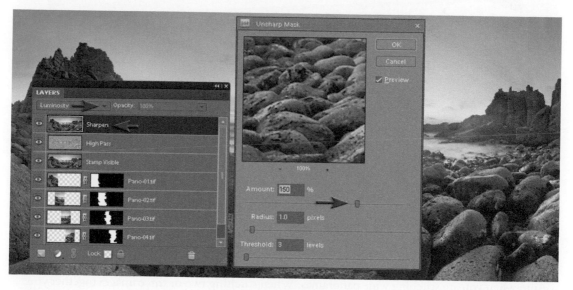

14. To sharpen this project start by stamping the visible layers again and set the mode of the layer to Luminosity in the Layers panel. Go to Enhance > Unsharp Mask and use an appropriate amount of sharpening to enhance the details within the image (I have used settings of 150 for the amount, 1.0 for the Radius and 3 for the Threshold).

PERSPECTIVE OR CYLINDRICAL

When I selected Auto in the Layout section of the Photomerge Panorama dialog, Photoshop elected to use the Cylindrical option. This option is usually preferable and is usually selected by Auto when you are stitching wide panoramas. When stitching two or three images together you may find that Photoshop decides to use the Perspective option or you can choose this option to override the Cylindrical option if it is chosen by Auto. The Perspective option creates a bow-tie effect when stitching three images and is useful for creating a realistic perspective with straight horizon lines. When this option is used for more than three images, however, the distortion required to create the effect tends to be extreme for the images on the edge of the panorama and cannot therefore be considered as a usable option.

PHOTOMERGE GROUP SHOT

Photomerge also has a Group Shot option. This allows you to merge the best aspects of several images into the same image – especially useful when someone in a group has blinked or looked away. In this group shot (if you can call one boy and his dog a group) it has been decided to combine two images (captured hand-held) so both the boy and his dog are looking at the camera. In the Group Shot dialog box you just scribble over the part of the 'source' image that you would like to merge with the 'final' image. Although Photomerge will align and blend the component images with the same skill as the Panorama option, the user will be presented with an additional flattened file when Group Shot has finished weaving its magic.

PHOTOMERGE SCENE CLEANER

One of the most useful Photomerge features is the Scene Cleaner. The Scene Cleaner is designed to rid your scenic shots of tourists. You no longer have to wait for the scene to be empty before capturing your shot. Just take multiple shots (no tripod required) as the people move around and you can then clean the scene using the new Photomerge Scene Cleaner. The process is remarkably simple; just drag one of your images into the Final window and then click on any of the other images in the Project Bin to set it as the source image. Then paint over any tourist in the Final window or any part of the source file on the left that does not have a tourist (no accuracy is required in the painting action) and the scene in the Final window on the right is cleaned automatically. Move your mouse off the image and the strokes will disappear. The auto-align component of the Photomerge dialog means that the patch is seamless.

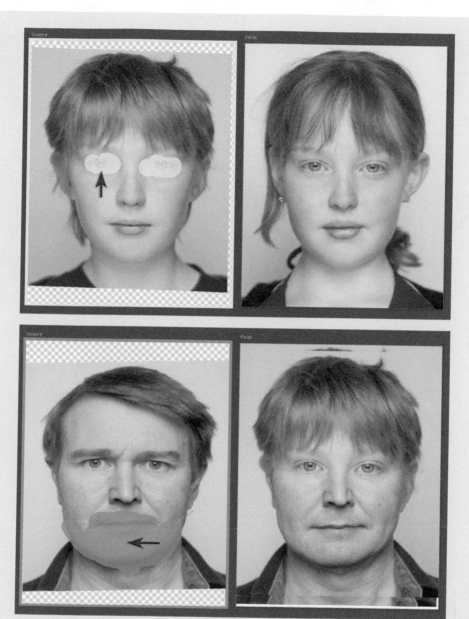

PHOTOMERGE FACES

The strangest of the automated features in the Photomerge bag of tricks is called Photomerge Faces. The results are often delightfully random, even though you are supposed to define the bits you want merged. You must first use the Alignment tool to indicate where the eyes and mouth are in each image and then click the Align Photos button. In the top part of the example above, the boy's eyes have been merged seamlessly into the girl's face, while in the lower examples Photomerge has happily lifted the nose and lower portion of the ears in the source image in order to achieve a seamless stitch. Great fun (if slightly disturbing) – absolutely no commercial value – but will keep the kids amused for hours!

Project 10

Photography by Ed Purnomo

Hair Transplant

One of the most challenging montage or masking jobs in the profession of post-production editing is the hair lift. When the model has long flowing hair and the subject needs to change location many post-production artists call in sick. Get it wrong and, just like a bad wig, it shows. Extract filters, Magic Erasers and Tragic Extractors don't even get us close. The first secret step must be completed before you even press the shutter on the camera. Your number one essential step for success is to first shoot your model against a white backdrop, sufficiently illuminated so that it is captured as white rather than gray.

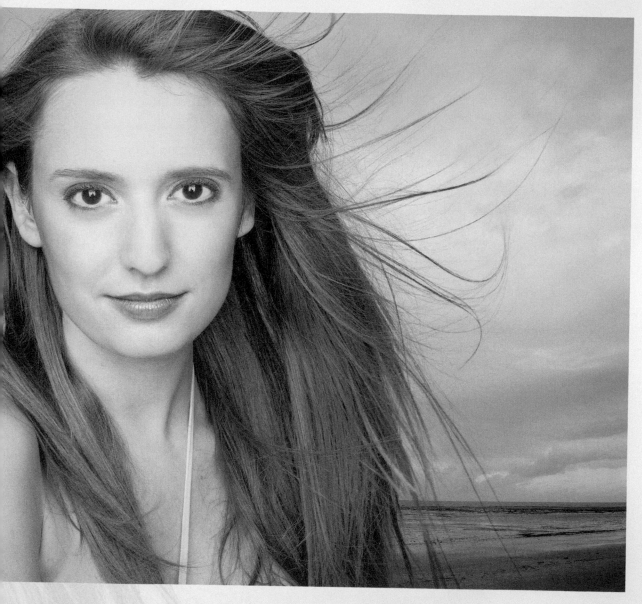

Hair extraction – not as painful as pulling teeth. Image by Ed Purnomo

This important aspect of the initial image capture ensures that the resulting hair transplant is seamless and undetectable. The post-production is the easy bit – simply apply the correct sequence of editing steps and the magic is all yours. This is not brain surgery but follow these simple steps and you will join the elite ranks of image-editing gurus around the world. Celebrity status is just a few clicks away.

Check out the supporting website to access an extensive stock library of royalty-free skies

1. The initial steps of this tutorial are concerned with creating a mask that can be used in the final montage. We need to expand the contrast of a copy layer until the girl appears as a silhouette against a bright background. Start by dragging the background layer to the Create a new layer icon in the Layers panel to duplicate it. Go to Enhance > Adjust Color > Remove Color. Rename this layer Remove Color. Drag this desaturated/monochrome layer to the Create a new layer icon to duplicate it. Set the blend mode of this new layer (now on top of the layers stack) to Overlay mode.

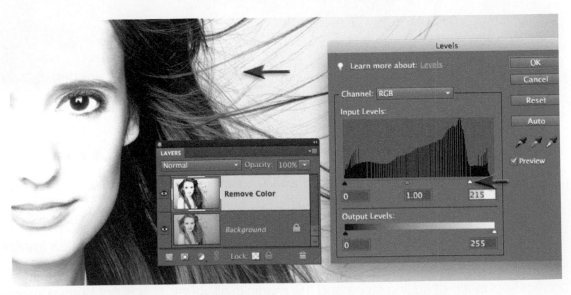

2. From the Layer menu choose Merge Down to create a single high-contrast monochrome layer. Go to Enhance > Adjust Lighting > Levels. Drag the White Input slider underneath the histogram in the Levels dialog to the left to brighten the background. Zoom in to 100% Actual Pixels to determine how far this slider can be moved before you start to lose detail in the fine strands of hair.

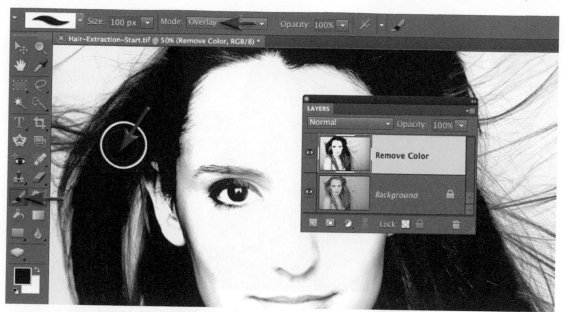

3. Select Black as the foreground color and the Brush tool from the Tools panel. Choose a large brush with a hardness value of 75% and set the opacity of the brush to 100% in the Options bar. Set the mode of the brush to Overlay (also in the Options bar). Painting in Overlay mode will help to preserve the lighter background while rendering the hair black. Avoid painting of any of the hair where you can see background showing through the strands. Painting these individual strands of hair will thicken the hair and may lead to haloes appearing later in the montage process.

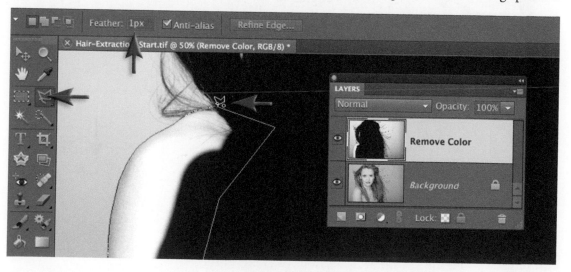

4. Make an accurate selection of the arm using the Lasso or Polygonal Lasso tool with a 1-pixel feather radius set in the Options bar. Zoom in to 100% Actual Pixels so that you can ensure the selection is as accurate as possible. Go to Edit > Fill Selection and choose Black as the contents and then select OK.

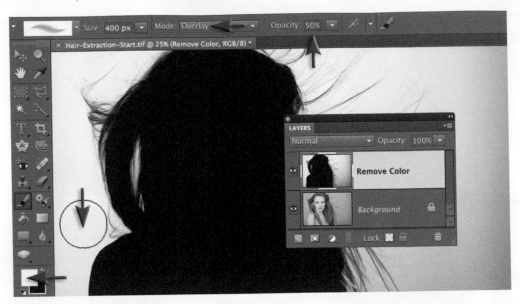

5. Switch the blend mode of the brush in the Options bar to Normal and paint over any bright highlights to render the model as a silhouette. This will ensure a speedy conclusion to the mask-making process. To lighten the background switch the foreground color to White and set the mode of the brush to Overlay again. Reduce the brush hardness to 0% and the Opacity to 50%. Start brushing the gray background to push it back to white. Avoid moving directly over the thin stands of hair.

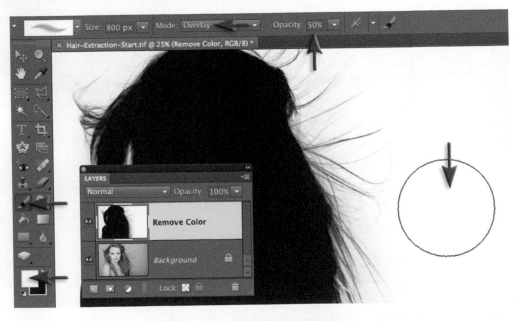

6. It is advisable to leave a small amount of gray in the background between the strands of hair rather than trying to render the background absolute white. Photographing the model against a brighter background (nearly, but not quite, white) would have made this task simpler.

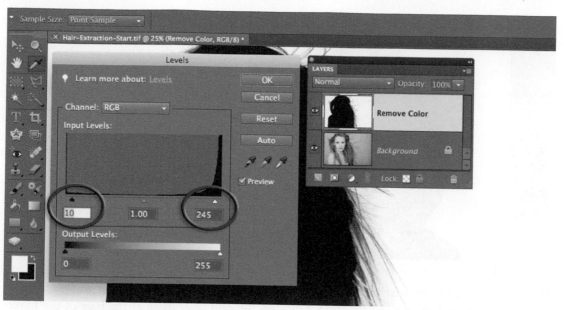

7. To complete the mask building process apply a Level command once again (Enhance > Adjust Lighting > Levels). This time move the black input slider to level 10 and the white input slider to level 245 as a final contrast boost.

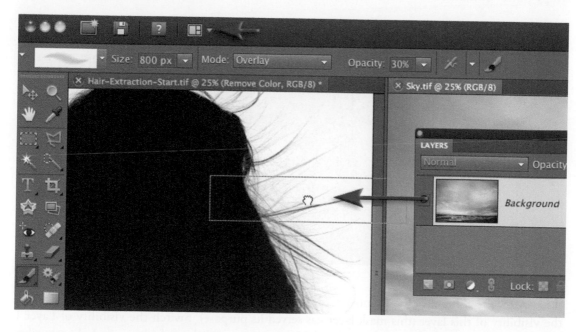

8. The new background is placed on its own layer above the figure and mask layers. Open the sky image and go to the Arrange Documents icon in the Application Bar and choose '2 Up'. Drag the layer thumbnail in the Layers panel of this new file into the image window of your project file. Use the Free Transform command, Ctrl + T (PC) or Command + T (Mac), to adjust the size if necessary.

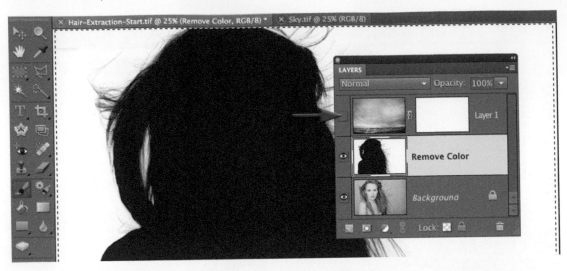

9. Now we need to transfer the mask from the Remove Color layer to a layer mask sitting on the layer containing the new background. Click on the Add layer mask at the base of the Layers panel to add a mask to the sky layer and then click on the Layer visibility icon, just to the left of the layer thumbnail, to hide the layer. Select the Remove Color layer to make this the active layer and from the Select menu choose 'Select All' (Ctrl/Command + A). From the Edit menu choose Copy (Ctrl /Command + C).

10. After the content of the Remove Color layer have been copied to the clipboard, Switch off the visibility of this layer (this mask layer has served its purpose). Switch the visibility of Layer 1 (the sky) back on and then hold down the Alt/Option key and click on the layer mask thumbnail in the Layers panel. The image window will momentarily appear white as you view the empty contents of the layer mask. From the Edit menu choose Paste to transfer the contents of the clipboard to this layer mask. Go to Select > Deselect to lose the active selection. Alt/Option click the layer mask thumbnail to return to the normal view.

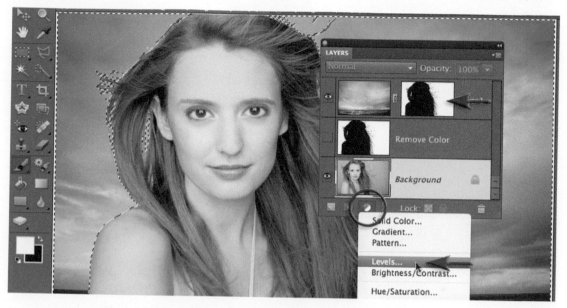

11. At the moment the fine detail of the hair will not be perfect. The Multiply mode would restore the fine detail but if it was applied now the gray background surrounding the model would darken the sky excessively. We can lighten this gray background without affecting the model using the layer mask we have created. Hold down the Ctrl key (PC) or Command key (Mac) and click on the layer mask to load it as a selection. Switch off the visibility of the sky layer, select the background layer in the Layers panel and then from the Create new fill or adjustment layer icon select a Levels adjustment layer.

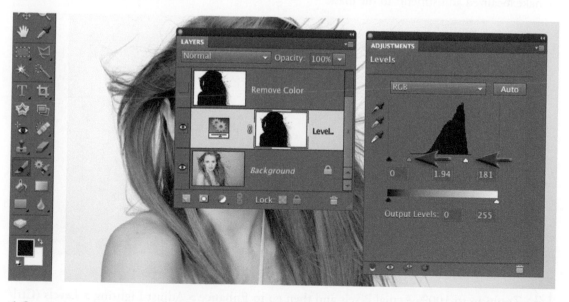

12. Drag the White input slider to the start of the histogram (any further would remove fine detail from the hair) and then drag the central gamma slider to the left to brighten the background tones even further. You should be able to render the gray background nearly white.

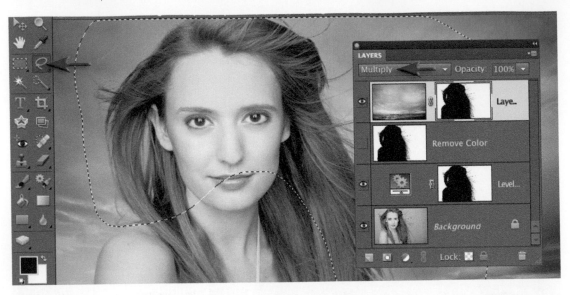

13. Switch the visibility of the top layer back on and set the mode to Multiply. This should restore some of the fine detail to the hair. To restore the rest we will need to fine-tune the mask. Select the Lasso tool from the Tools panel and set the Feather Radius to 20 pixels in the Options bar. This generous Feather Radius will ensure we don't see any 'tide' marks when we adjust the tonality of the mask in the next step. Make a selection around all of the hair but exclude the arm from this selection. We are about to move the edge of the mask and this would have a negative impact on the arm if it was included in the selection. We cannot use the Refine Edge command for this process as we need to make localized adjustments to the mask.

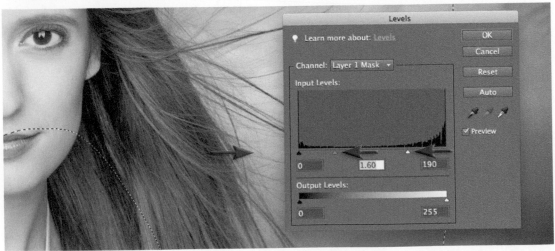

14. Zoom in to 100% Actual Pixels and then go to Enhance > Adjust Lighting > Levels (Ctrl/Command + L). Move the White input slider and the central Gamma slider to the left to remove any traces of the old gray background and restore all of the fine detail in the hair. Select OK when the hair is looking good. From the Select menu choose Deselect.

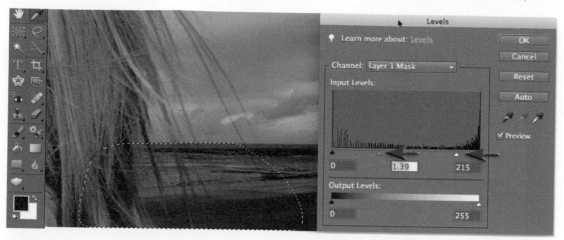

15. We will need to make an additional adjustment to ensure there are lighter halos around any strands of hair that are positioned over very dark tones in the new background. Make another selection and then apply another Levels adjustment to this region (Ctrl or Command + L).

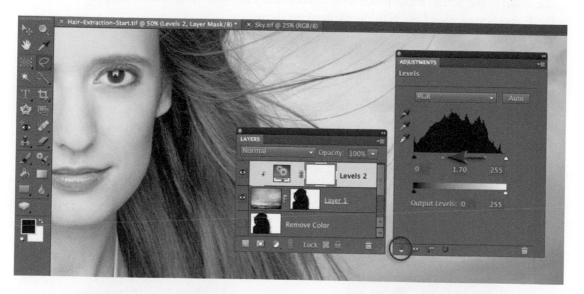

16. The sky is slightly darker after the Multiply blend mode was applied due to the fact that the gray background could not be rendered any lighter without losing fine detail in the hair. We can resolve this problem by clipping an adjustment layer to the sky layer. Click on the Create new fill or adjustment layer icon and choose either a Levels or a Brightness/Contrast adjustment layer. Click on the clipping icon in the bottom left-hand corner of the Adjustments panel to ensure any adjustment only affects the sky and not the model. The secret to success with this technique is to ensure that you have good contrast between the model's hair and the background against which the model is placed. With models with very light hair you can choose to photograph them against a very dark background instead of a light colored background (see the Performance tip over the page).

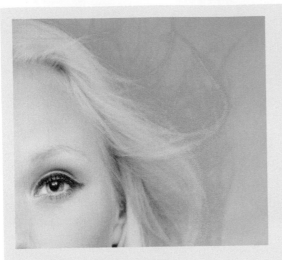

MAXIMUM PERFORMANCE

When masking hair that was shot against a black background, setting the layer (the one holding the mask) to the Screen Blend mode is the secret to success. Note the difference between Normal mode and Screen Blend mode in the illustrations above.

You will need to invert the layer mask when using a model shot against a black background (Filter > Adjustments > Invert). Paint in Overlay mode as in Steps 2 to 6 of the 'Hair Transplant' project. Apply a Levels adjustment to the layer mask and fine-tune the brightness of the hair against the background by moving the Gamma slider.

iStock_000000803940 (Blond Goddess by Iconogenic)

Jargon Buster

A

ACR: Adobe Camera Raw. Raw processing utility supplied with Photoshop Elements.

Adjustment layers: Non-destructive (always editable) image adjustment placed on a layer.

Aliasing: The display of a digital image where a diagonal or curved line appears jagged due to the square pixels.

Anti-aliasing: The process of smoothing the appearance of lines in a digital image.

Artifacts: Pixels that are significantly incorrect in their brightness or color values.

B

Bit: Short for binary digit, the basic unit of the binary language.

Bit depth: Number of bits (memory) assigned to recording color or tonal information.

Blend mode: The formula used for defining the mixing of a layer with those beneath it.

Brightness: The value assigned to a pixel in the HSB model to define the relative lightness of a pixel.

Byte: Eight bits. Standard unit of data storage containing a value between 0 and 255.

C

CCD: Charge-coupled device. A solid-state sensor used in digital image capture.

Channel: A division of color or luminance data.

Clipboard: Place for the temporary storage of something that has been cut or copied.

Clipping group: Two or more layers that have been linked. The base layer acts as a mask, limiting the effect or visibility of those layers grouped with it.

Cloning tool: A tool used for replicating pixels.

Color fringing: Bands of color on the edges of lines within an image.

Color gamut: The range of colors provided by a hardware device, or a set of pigments.

Color management: A system to ensure uniformity of color between the subject, monitor display and final print.

Color Picker: Dialog box used for the selection of colors.

Compression: A method for reducing the file size of a digital image.

Constrain proportions: Retains the proportional dimensions of an image when changing the image size.

Continuous tone: The illusion of smooth gradations between highlights and shadows.

Contrast: The difference in brightness between the darkest and lightest areas of the image or subject.

Crash: The sudden operational failure of a computer.

Crop: Reduce image size to enhance composition or limit information.

Curves: A control, in the full version of Adobe Photoshop only, for adjusting tonality and color.

D

Default: A 'normal' or 'start' setting as chosen by the manufacturer or user.

Depth of field: The zone of sharpness variable by aperture, focal length or subject distance.

DNG: Digital Negative (Adobe's Raw file format).

Dpi: Dots per inch. A measurement of resolution.

E

Editable text: Text that has not been rendered into pixels.

Exposure: Combined effect of intensity and duration of light on a light-sensitive material or image sensor.

Exposure compensation: To increase or decrease the exposure from a meter-indicated exposure to obtain an appropriate exposure.

F

Feather: The action of softening the edge of a digital selection.

File format: The code used to store digital data, e.g. TIFF or JPEG.

File size: The memory required to store digital data in a file.

Format: The orientation or shape of an image or the erasure of a memory device.

Freeze: Software that fails to interact with new information.

G

Galleries: A managed collection of images displayed in a conveniently accessible form.

Gaussian Blur: A filter used for defocusing a digital image.

Gigabyte: A unit of measurement for digital files, 1024 megabytes.

Grayscale: An 8-bit image used to describe monochrome (black and white) images.

H

High Dynamic Range (HDR): A subject brightness range that exceeds the ability of the capture medium (film or sensor) to record both the highlight and shadow information simultaneously.

Highlight: Area of subject receiving highest exposure value.

Histogram: A graphical representation of a digital image indicating the pixels allocated to each level.

Hue: The name of a color, e.g. red or green.

I

Image size: The pixel dimensions, output dimensions and resolution used to define a digital image.

Interpolation: Increasing the pixel dimensions of an image by inserting new pixels between existing ones within an image.

ISO: International Standards Organization. A numerical system for rating the speed or relative light sensitivity of a film or sensor.

J

JPEG (.jpg): Joint Photographic Experts Group. Popular but lossy (i.e. destructive) image compression file format.

K

Kilobyte: 1024 bytes.

L

Lasso tool: Selection tool used in digital editing.

Latitude: Ability of the film or device to record the brightness range of the subject.

Layer mask: A mask attached to an adjustment layer that is used to define the visibility of the adjustment. It can also be used to limit the visibility of pixels on the layer above.

Layers: A feature in digital editing software that allows a composite digital image in which each element is on a separate layer or level.

Levels: Shades of lightness or brightness assigned to pixels.

Luminance adjustment: The ability to adjust the brightness of a color without affecting either the hue or saturation.

M

Magic Wand tool: Selection tool used in digital editing.

Marching ants: A moving broken line indicating a digital selection of pixels.

Marquee tool: Selection tool used in digital editing.

Megabyte: A unit of measurement for digital files, 1024 kilobytes.

Megapixel: A million pixels.

Memory card: A small removable storage device used in digital cameras to save captured images.

Minimum aperture: Smallest lens opening.

Mode (digital image): The tonal and color space of the captured or scanned image.

N

Noise: Electronic interference producing speckles in the image.

O

Opacity: The degree of non-transparency.

Opaque: Not transmitting light.

Optimize: The process of fine-tuning the file size and display quality of an image.

Out-of-gamut: Beyond the scope of colors that a particular device can create, reproduce or display.

P

Pixel: The smallest square picture element in a digital image.

Pixellated: An image where the pixels are visible to the human eye and curved or diagonal lines appear jagged or stepped.

Primary colors: The three colors of light (red, green and blue).

R

RAM: Random access memory. The computer's short-term or working memory.

Reflector: A surface used to reflect light in order to fill shadows.

Resample: To alter the total number of pixels describing a digital image.

Resolution: This term can be applied to optical resolution (how sharply the image was captured), screen resolution (the number of pixels being displayed by your monitor, e.g. 1024 x 768), printer resolution (dots per inch or dpi) or **image** resolution (pixels per inch or ppi).

RGB: Red, green and blue. The three primary colors used to display images on a color monitor.

Rubber Stamp: Another name for the Clone Stamp tool used for replicating pixels.

S

Sample: To select a color value for analysis or use.

Saturation (color): Intensity or richness of color hue.

Save As: An option that allows the user to create a duplicate of a digital file with an alternative name or in a different location.

Scale: A ratio of size.

Scratch disk: Portion of the hard disk allocated to software such as Elements to be used as a working space.

Screen redraws: Time taken to render information being depicted on the monitor as changes are being made through the application software.

Sharp: In focus; not blurred.

Sliders: A sliding control to adjust settings such as color, tone, opacity, etc.

Stamp Visible: The action of copying the visible elements from a number of layers and pasting them onto a new layer.

System software: Computer operating program, e.g. Windows or Mac OS.

T

TIFF: Tagged Image File Format. Popular image file format for desktop publishing applications.

Tone: A tint of color or shade of gray.

Transparent: Allowing light to pass through.

U

Unsharp Mask: A filter used to sharpen images.

W

Workflow: Series of repeatable steps required to achieve a particular result within a digital imaging environment.

Z

Zoom tool: A tool used for magnifying a digital image on the monitor.

Shortcuts (PC)

Action	Keyboard shortcut
Navigate and view	
Fit image on screen	Ctrl + 0
View image at 100% (Actual Pixels)	Alt + Ctrl + 0
Zoom tool (magnify)	Ctrl + Spacebar + click image or Ctrl + +
Zoom tool (reduce)	Alt + Spacebar + click image or Ctrl + -
Show/hide rulers	Shift + Ctrl + R
Hide panels	Tab key
File commands	
Open	Ctrl + O
Close	Ctrl + W
Save	Ctrl + S
Save As	Ctrl + Shift + S
Undo	Ctrl + Z
Redo	Ctrl + Y
Selections	
Add to selection	Hold Shift key and select again
Subtract from selection	Hold Alt key and select again
Copy	Ctrl + C
Cut	Ctrl + X
Paste	Ctrl + V
Paste into selection	Ctrl + Shift + V
Free Transform	Ctrl + T
Distort image in Free Transform	Hold Ctrl key + move handle
Feather	Alt + Ctrl + D
Select All	Ctrl + A
Deselect	Ctrl + D
Reselect	Shift + Ctrl + D
Inverse selection	Shift + Ctrl + I

Painting

Set default foreground and background colors	D
Switch between foreground and background colors	X
Enlarge brush size (with Paint tool selected)]
Reduce brush size (with Paint tool selected)	[
Make brush softer	[+ Shift
Make brush harder] + Shift
Change opacity of brush in 10% increments (with Paint tool selected)	Press number keys 0–9
Fill with foreground color	Alt + Backspace
Fill with background color	Ctrl + Backspace

Image adjustments

Levels	Ctrl + L
Hue/Saturation	Ctrl + U
Group layer	Ctrl + G

Layers and masks

Add new layer	Shift + Ctrl + N
Load selection from layer mask	Ctrl + click thumbnail
Change opacity of active layer in 10% increments	Press number keys 0–9
Add layer mask – Hide All	Alt + click Add Layer Mask icon
Move layer down/up	Ctrl + [or]
Stamp visible	Ctrl + Alt + Shift + E
Disable/enable layer mask	Shift + click layer mask thumbnail
View layer mask only	Alt + click layer mask thumbnail
View layer mask and image	Alt + Shift + click layer mask thumbnail
Blend modes	Alt + Shift + F, N, S, M, O, Y (Soft Light, Normal, Screen, Multiply, Overlay, Luminosity)

Crop

Commit crop	Enter key
Cancel crop	Esc key
Constrain proportions of crop marquee	Hold Shift key
Turn off magnetic guides when cropping	Hold Alt + Shift keys + drag handle

Shortcuts (Mac)

Action Keyboard shortcut

Navigate and view

Action	Keyboard shortcut
Fit image on screen	Command + 0
View image at 100% (Actual Pixels)	Option + Command + 0
Zoom tool (magnify)	Command + Spacebar + click image or Ctrl + +
Zoom tool (reduce)	Option + Spacebar + click image or Command + -
Show/hide rulers	Shift + Command + R
Hide panels	Tab key

File commands

Action	Keyboard shortcut
Open	Command + O
Close	Command + W
Save	Command + S
Save As	Command + Shift + S
Undo	Command + Z
Redo	Command + Y

Selections

Action	Keyboard shortcut
Add to selection	Hold Shift key and select again
Subtract from selection	Hold Option key and select again
Copy	Command + C
Cut	Command + X
Paste	Command + V
Paste into selection	Command + Shift + V
Free Transform	Command + T
Distort image in Free Transform	Hold Command key + move handle
Feather	Option + Command + D
Select All	Command + A
Deselect	Command + D
Reselect	Shift + Command + D
Inverse selection	Shift + Command + I

Painting

Set default foreground and background colors	D
Switch between foreground and background colors	X
Enlarge brush size (with Paint tool selected)]
Reduce brush size (with Paint tool selected)	[
Make brush softer	[+ Shift
Make brush harder] + Shift
Change opacity of brush in 10% increments (with Paint tool selected)	Press number keys 0–9
Fill with foreground color	Option + Backspace
Fill with background color	Command + Backspace

Image adjustments

Levels	Command + L
Hue/Saturation	Command + U
Group layer	Command + G

Layers and masks

Add new layer	Shift + Command + N
Load selection from layer mask	Command + click thumbnail
Change opacity of active layer in 10% increments	Press number keys 0–9
Add layer mask – Hide All	Option + click Add Layer Mask icon
Move layer down/up	Command + [or]
Stamp visible	Command + Option + Shift + E
Disable/enable layer mask	Shift + click layer mask thumbnail
View layer mask only	Option + click layer mask thumbnail
View layer mask and image	Option + Shift + click layer mask thumbnail
Blend modes	Option + Shift + F, N, S, M, O, Y (Soft Light, Normal, Screen, Multiply, Overlay, Luminosity)

Crop

Commit crop	Enter key
Cancel crop	Esc key
Constrain proportions of crop marquee	Hold Shift key
Turn off magnetic guides when cropping	Hold Option + Shift keys + drag handle

Index

Index

Printed and bound by CPI Group (UK) Ltd, Croydon, CR0 4YY

21/10/2024

01777101-0013